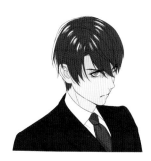

HOW TO CREATE
MANGA

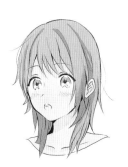

THE ULTIMATE BIBLE
FOR BEGINNING ARTISTS

T0160478

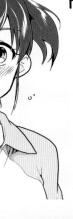

DRAWING
FACIAL
EXPRESSIONS

With Over
1250
Illustrations

NEXTCREATOR HENSHUBU

TUTTLE Publishing

Tokyo | Rutland, Vermont | Singapore

Contents

PART 2 Facial Expressions That Add Color and Detail

PART 3 Animated Expressions

Why We Wrote This Book

When drawing illustrations or manga, facial expressions are key to conveying the characters' thoughts and emotions. In this book, we cover a wide range of facial expressions, starting with the basics such as smiling or getting angry but also looking at those that are a combination of various emotions. Each expression is categorized according to the general emotion it conveys, making it easy to find the one you're looking for.

However, there are countless ways to express emotions; there's more than one facial expression for each emotion. For instance, a simple "smile" could mean smiling through tears, smiling even when something is not funny, or other smiles that differ depending on their accompanying emotions. Many different emotions mix and are revealed via the

face's varied expressions. It could be said that even if drawing the same "smiling face," 10 different characters will wear 10 different smiles, with various techniques making it possible to change the expression completely. For that reason, there are more than 870 illustrations as examples in this book, with accompanying comments to clearly explain areas to focus on and to provide you with ideas for the various appealing aspects and ways of thinking about each expression.

We hope you'll use the book in a variety of ways, copying the facial expressions that you like and reading the whole volume to find hints to help you draw them. We hope this book helps you bring previously untapped emotion to your characters.

—The Artists of NextCreator
(see pages 174–175 for information about them)

How to Use This Book

Structure of the Book

PART 1 Basic Expressions
Here, we cover the six basic expressions of joy, anger, sadness, surprise, dislike and fear. The degrees of emotion and the characteristics of each expression are summarized in this section.

PART 2 Facial Expressions That Add Color and Detail
Here, we analyze the facial expressions used in scenes of romance, eating/drinking and resting. They are divided into scenes or situations that make it easier to visualize their use, along with many other expressions that can be incorporated into other types of scenes.

PART 3 Animated Expressions
Making use of language to evoke images, the expressions in this section are divided into positive and negative. Be aware, however, that some of the illustrated examples may bear both nuances.

Various Types of Page Layout

Basic Expressions pages: These pages introduce the basic expressions of joy, anger, sadness, surprise, dislike and fear.

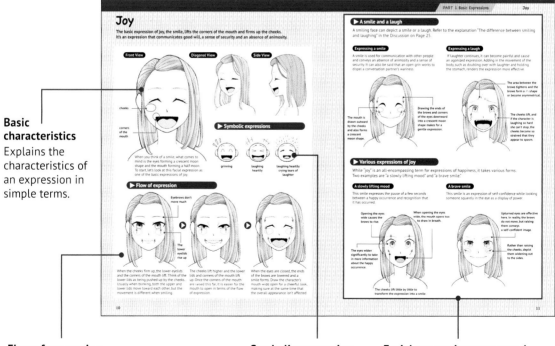

Basic characteristics
Explains the characteristics of an expression in simple terms.

Flow of expression
How the parts of the face move to form an expression.

Symbolic expression
Frequently used symbols and signs.

Facial expressions compared
Explanations about the degree of expression, ways of depicting it in caricature and so on.

Other Expressions pages: Various expressions explained via multiple illustrated examples.

Name of expression and its icon
The name of the expression and an icon that symbolizes it.

Tips
Analyzes the basics of frequently used depictions and the thought processes behind them, providing cues that improve skills in drawing expressions.

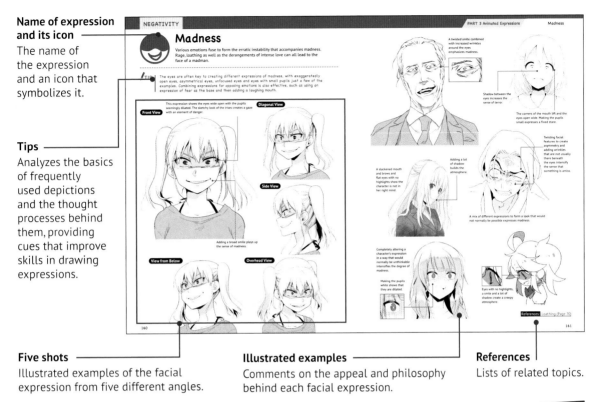

Five shots
Illustrated examples of the facial expression from five different angles.

Illustrated examples
Comments on the appeal and philosophy behind each facial expression.

References
Lists of related topics.

Ideas scrapbook
A collection of rough sketches to help you expand on your ideas.

Variations
Frequently used depictions of the facial expression that vary slightly from the basic version.

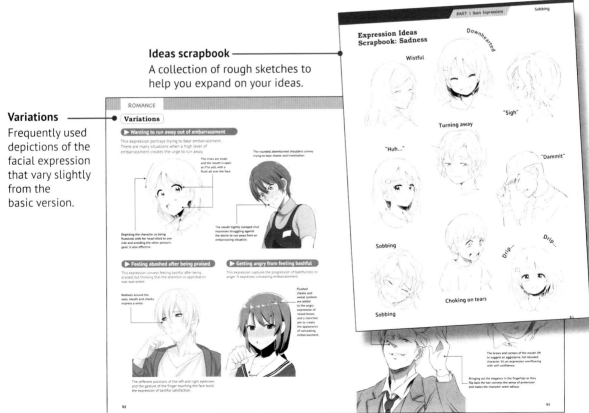

Blue arrows

These indicate the direction of movement of the body part or body as a whole.

Discussions

Analyses of ideas related to the facial expression, how to use the paint tool and so on.

Orange arrows

These indicate where the emotion is heading and the degree of emotion.

EXPERT TIPS

Expert tips

These cover emotional expressions using parts of the body other than the face as well as how to use symbolic expression to convey emotions.

Symbolic expression and distortion

Symbolic expression is a method of representation used in manga and cartoons. In this book, it refers to the stylized symbols often used in manga, such as the symbol for anger, the droplets that denote sweat from panic and the symbol for blood draining from the face (see below). It's easiest to think of them in the same way as the emoji on your smartphone.

Caricaturizing or distortion is the technique of expressing something in a simplified or exaggerated way. In this book, it refers to overlarge eyes, mouths that protrude from the face and other such exaggeration.

Examples of symbolic expressions

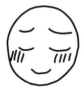

Blush
This expression reddens the face and expresses shyness, excitement, etc.

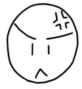

Anger
Captures the veins that protrude from the forehead when angry.

Sweat
Conveys cold sweat and panic.

Turning pale
An expression showing the blood draining from the face.

Basic Expressions

JOY

Basics

Smiling

Enjoyment and
Delight

Laughter

Hearty Laughter

ANGER

Basics

Irritation

Rage

Fury

SADNESS

Basics

Depression

Sadness and
Loneliness

Crying

Sobbing

SURPRISE

Basics

Astonishment

Trembling

Shock

DISLIKE

Basics

Troubled

Repulsion

Loathing

FEAR

Basics

Afraid

Panicked

Terror

Joy

The basic expression of joy, the smile, lifts the corners of the mouth and firms up the cheeks. It's an expression that communicates good will, a sense of security and an absence of animosity.

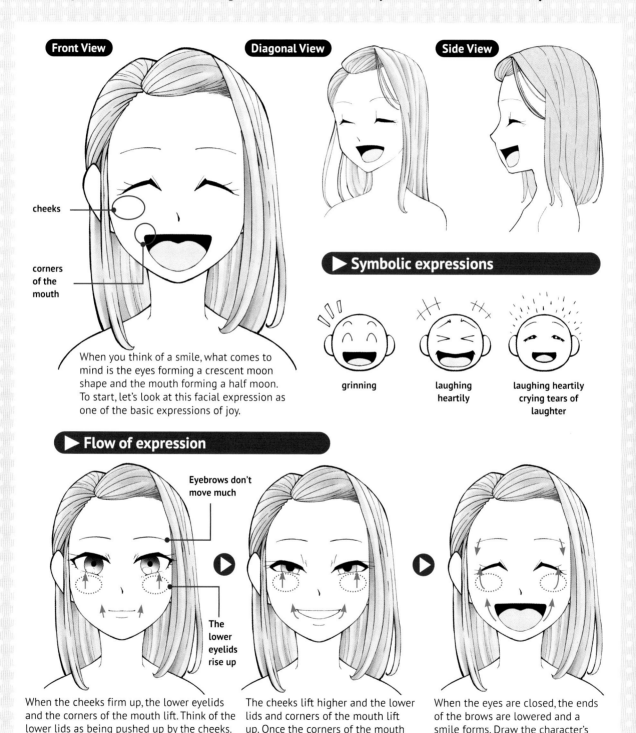

Front View

cheeks

corners of the mouth

When you think of a smile, what comes to mind is the eyes forming a crescent moon shape and the mouth forming a half moon. To start, let's look at this facial expression as one of the basic expressions of joy.

Diagonal View

Side View

▶ Symbolic expressions

grinning

laughing heartily

laughing heartily crying tears of laughter

▶ Flow of expression

Eyebrows don't move much

The lower eyelids rise up

When the cheeks firm up, the lower eyelids and the corners of the mouth lift. Think of the lower lids as being pushed up by the cheeks. Usually when blinking, both the upper and lower lids move toward each other, but the movement is different when smiling.

The cheeks lift higher and the lower lids and corners of the mouth lift up. Once the corners of the mouth are raised this far, it is easier for the mouth to open in terms of the flow of expression.

When the eyes are closed, the ends of the brows are lowered and a smile forms. Draw the character's mouth wide open for a cheerful look, making sure at the same time that the overall appearance isn't affected.

▶ A smile and a laugh

A smiling face can depict a smile or a laugh. Refer to the explanation "The difference between smiling and laughing" in the Discussion on Page 25.

Expressing a smile

A smile is used for communication with other people and conveys an absence of animosity and a sense of security. It can also be said that an open grin works to dispel a conversation partner's wariness.

Expressing a laugh

If laughter continues, it can become painful and cause an agonized expression. Adding in the movement of the body, such as doubling over with laughter and holding the stomach, renders the expression more effective.

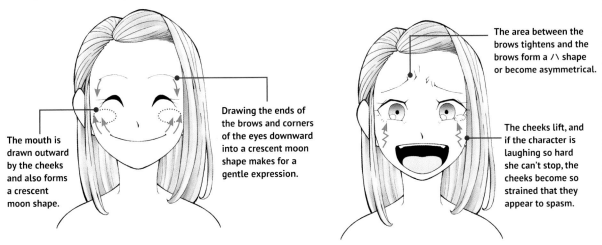

The mouth is drawn outward by the cheeks and also forms a crescent moon shape.

Drawing the ends of the brows and corners of the eyes downward into a crescent moon shape makes for a gentle expression.

The area between the brows tightens and the brows form a /\ shape or become asymmetrical.

The cheeks lift, and if the character is laughing so hard she can't stop, the cheeks become so strained that they appear to spasm.

▶ Various expressions of joy

While "joy" is an all-encompassing term for expressions of happiness, it takes various forms. Two examples are "a slowly lifting mood" and "a brave smile."

A slowly lifting mood

This smile expresses the pause of a few seconds between a happy occurrence and recognition that it has occurred.

A brave smile

This smile is an expression of self-confidence while looking someone squarely in the eye as a display of power.

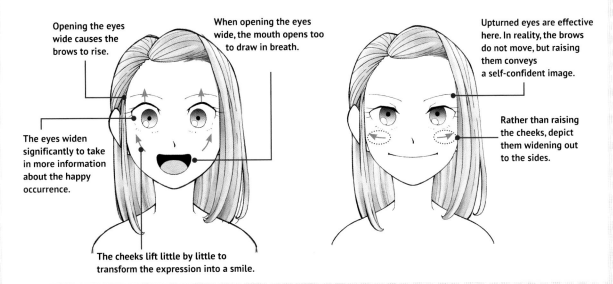

Opening the eyes wide causes the brows to rise.

When opening the eyes wide, the mouth opens too to draw in breath.

The eyes widen significantly to take in more information about the happy occurrence.

The cheeks lift little by little to transform the expression into a smile.

Upturned eyes are effective here. In reality, the brows do not move, but raising them conveys a self-confident image.

Rather than raising the cheeks, depict them widening out to the sides.

Smiling

A smile is an expression that creates a light, gentle impression. Of all the expressions that indicate joy, it is one of the more emotionally low-key. It is a go-to choice of expression for depicting parental affection or when a character doesn't want to cause discomfort or difficulty.

TIP | Create a gentle appearance by not making the mouth and eyes too big. As it is a smiling expression, the cheeks lift together with the corners of the mouth and the lower eyelids lift also, making the eyes slightly narrow. A smile can also be expressed with the eyes and mouth closed in a happy grin.

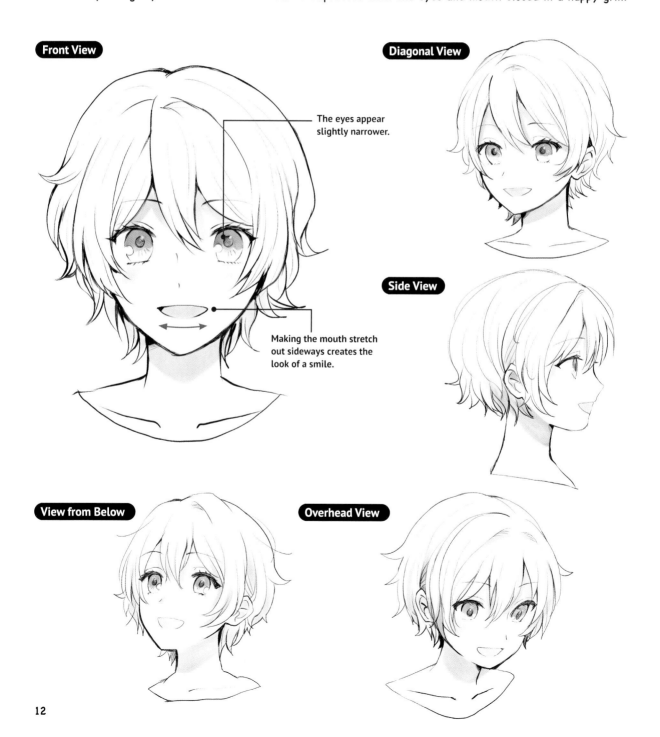

Front View

The eyes appear slightly narrower.

Making the mouth stretch out sideways creates the look of a smile.

Diagonal View

Side View

View from Below

Overhead View

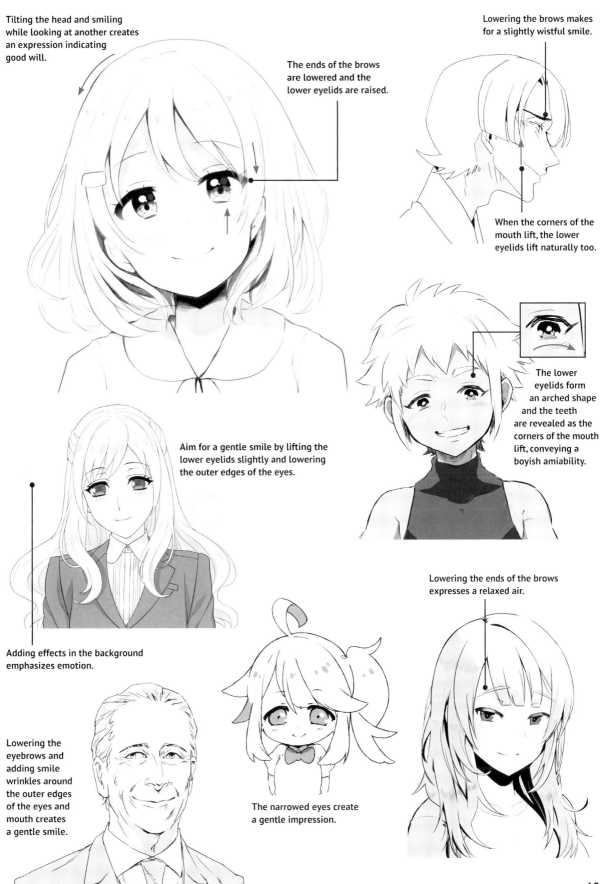

Tilting the head and smiling while looking at another creates an expression indicating good will.

The ends of the brows are lowered and the lower eyelids are raised.

Lowering the brows makes for a slightly wistful smile.

When the corners of the mouth lift, the lower eyelids lift naturally too.

The lower eyelids form an arched shape and the teeth are revealed as the corners of the mouth lift, conveying a boyish amiability.

Aim for a gentle smile by lifting the lower eyelids slightly and lowering the outer edges of the eyes.

Adding effects in the background emphasizes emotion.

Lowering the ends of the brows expresses a relaxed air.

Lowering the eyebrows and adding smile wrinkles around the outer edges of the eyes and mouth creates a gentle smile.

The narrowed eyes create a gentle impression.

13

Enjoyment and Delight

Enjoyment and delight have more subtle registers, revealing themselves slightly as facial expressions. They are used in illustration for expressions of unrestrained joy such as the pleasure and delight experienced when good friends are hanging out together or when a goal has been achieved.

TIP | In the moment of encountering something pleasurable or experiencing delight, the eyebrows lift and the eyes open as they would when surprised. Afterward, the expression changes to a happy smile and the cheeks flush with pleasure, depending on the exact moment to be captured. Lifting the corners of the mouth to make it open wider is a standard method of creating an innocent expression.

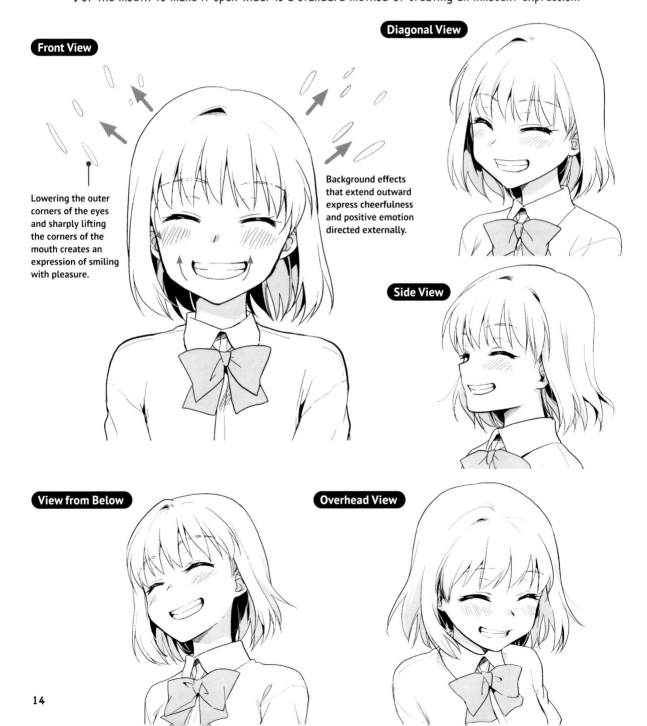

Front View

Lowering the outer corners of the eyes and sharply lifting the corners of the mouth creates an expression of smiling with pleasure.

Diagonal View

Background effects that extend outward express cheerfulness and positive emotion directed externally.

Side View

View from Below

Overhead View

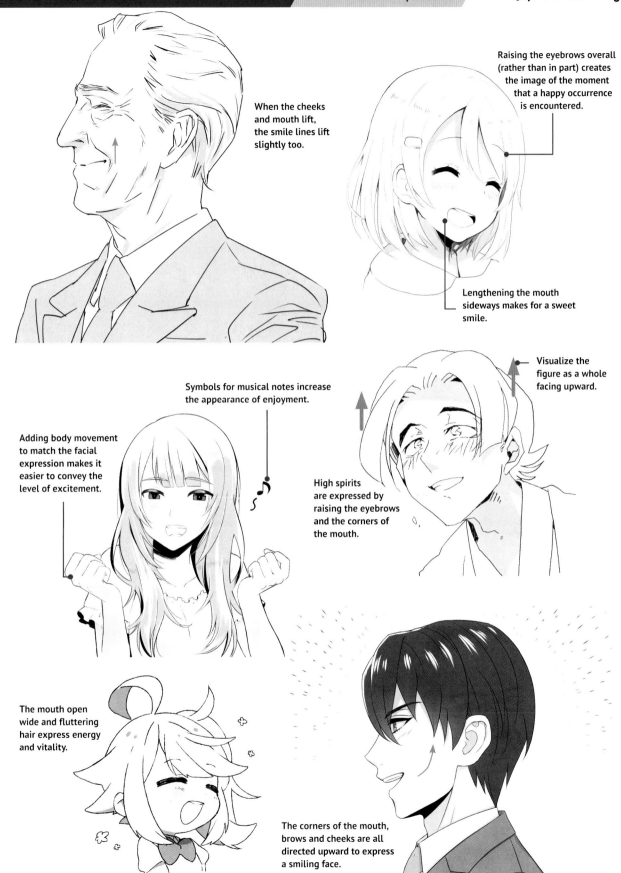

When the cheeks and mouth lift, the smile lines lift slightly too.

Raising the eyebrows overall (rather than in part) creates the image of the moment that a happy occurrence is encountered.

Lengthening the mouth sideways makes for a sweet smile.

Symbols for musical notes increase the appearance of enjoyment.

Adding body movement to match the facial expression makes it easier to convey the level of excitement.

Visualize the figure as a whole facing upward.

High spirits are expressed by raising the eyebrows and the corners of the mouth.

The mouth open wide and fluttering hair express energy and vitality.

The corners of the mouth, brows and cheeks are all directed upward to express a smiling face.

15

Variations

▶ Anticipation

This expression conveys the expectation of something positive happening. The characters are imagining that something enjoyable is about to happen, so their eyes are sparkling and they are smiling.

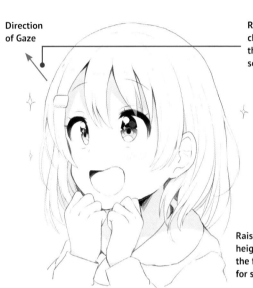

Direction of Gaze

Raising the gaze makes characters look as if they are thinking of something enjoyable.

Direction of Gaze

Raising the hands above chest height in loose fists conveys the feeling of waiting excitedly for something.

This image captures the moment of the character inhaling deeply and holding his breath, with eyes open wide in anticipation. Directing the gaze upward emphasizes the sense of anticipation.

▶ In high spirits

This expression is used when something enjoyable happens or something makes characters happy to the point that they grin uncontrollably. It evokes a heart full to the brim with emotion.

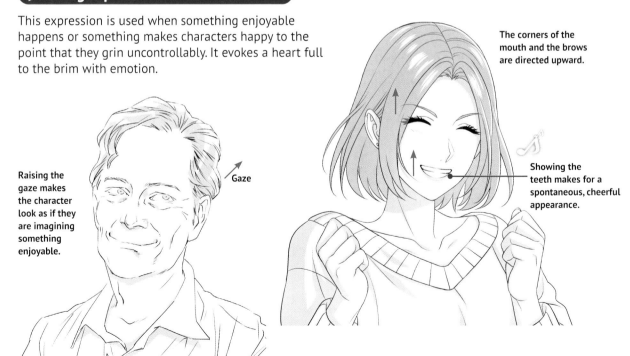

The corners of the mouth and the brows are directed upward.

Raising the gaze makes the character look as if they are imagining something enjoyable.

Gaze

Showing the teeth makes for a spontaneous, cheerful appearance.

Expression Ideas
Scrapbook: Joy

"Yay!"

Grinning

Radiant
Smile

Excited

Winking

Pleased

Guffawing

Laughing

Chuckling

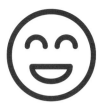

Laughter

We all know the various scenarios where laughter breaks out, rippling through an audience watching a funny movie or isolated in pockets among large gatherings of friends. No matter what prompts it, all manga artists need to master drawing faces twisted and contorted with joy.

TIP | One of the basics for conveying laughter is depicting an open mouth. The shape of the eyebrows changes depending on the intensity of the laugh. The more enthusiastic the laughter, the lower the ends of the brows get, resembling the brows on a troubled face. On a regular laughing face, the brows are raised up, while on a kind laughing face, they form a gentle curve.

Front View

The eyebrows lower and resemble "troubled" brows because the eyes narrow or squeeze tightly shut, drawing the brows down. They express the heightened emotions involved.

Add blush to the cheeks to capture laughter's intensity.

Opening the mouth and lifting the corners creates a laughing expression.

Diagonal View

Side View

View from Below

Overhead View

Lifting the brows and the corners of the mouth up while closing the eyes and laughing evokes an air of softness.

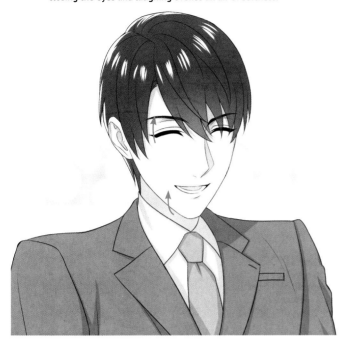

Fluffing out the hair to match the tilt of the neck makes for a more gentle expression of laughter.

Laughing heartily or in enjoyment.

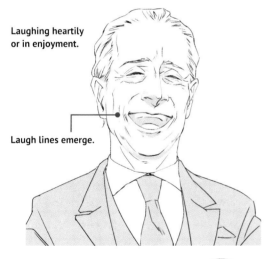

Laugh lines emerge.

Lowering the outer brows and bringing the inner ends together to form wrinkles creates the look of unintentional laughter.

This symbol conveys the shaking of the head that accompanies laughter.

A young girl is embarrassed to be laughing, thus the hint of a troubled expression.

The level of laughter can be expressed by altering the size of the symbols.

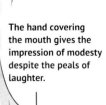

The hand covering the mouth gives the impression of modesty despite the peals of laughter.

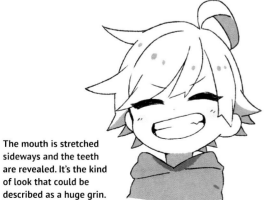

The mouth is stretched sideways and the teeth are revealed. It's the kind of look that could be described as a huge grin.

Variations

▶ Stifling a laugh

These expressions indicate stifling laughter in situations that call for quiet or where it would be rude to laugh. The brows and cheeks are taut from restraint while the mouth loosens to form the expression of laughter. Adding a shaking effect also works well to indicate the effort to stifle the laugh.

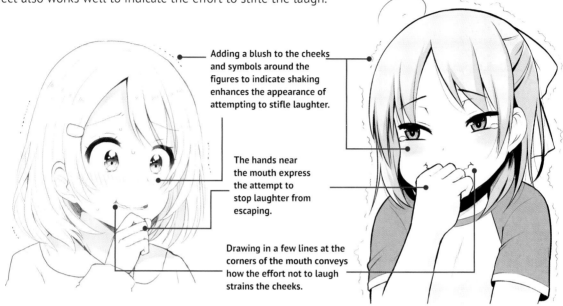

Adding a blush to the cheeks and symbols around the figures to indicate shaking enhances the appearance of attempting to stifle laughter.

The hands near the mouth express the attempt to stop laughter from escaping.

Drawing in a few lines at the corners of the mouth conveys how the effort not to laugh strains the cheeks.

▶ Laughter escaping

This expression shows what happens when laughter can no longer be contained. Drawing the mouth slightly open evokes the image of air—and laughter—escaping from tightly closed lips.

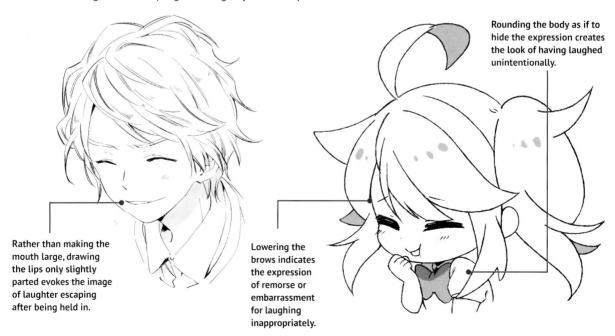

Rounding the body as if to hide the expression creates the look of having laughed unintentionally.

Rather than making the mouth large, drawing the lips only slightly parted evokes the image of laughter escaping after being held in.

Lowering the brows indicates the expression of remorse or embarrassment for laughing inappropriately.

▶ Suggestive laughter

This type of unconscious laughter emanates from thoughts about one's own (evil) schemes. Even when no scheming is involved, a grin may be used as a bluff.

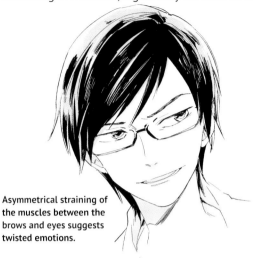

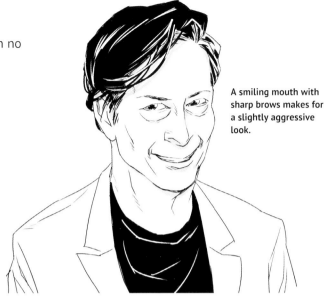

A smiling mouth with sharp brows makes for a slightly aggressive look.

Asymmetrical straining of the muscles between the brows and eyes suggests twisted emotions.

References: Plotting (Page 162)

DISCUSSION The Relationship Between a Character's Personality and Expressions

Although "laughter" is a universal expression, it manifests differently depending on the character's personality. Energetic characters laugh with their mouths wide open; subdued characters laugh quietly without opening their mouths wide, meaning that characters' personalities can be conveyed via their expressions. Furthermore, cool characters may laugh using expressions other than that of traditional "laughter."

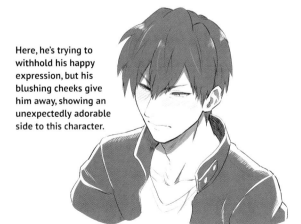

As this character is not given to laughing, his smile seems somewhat drawn out.

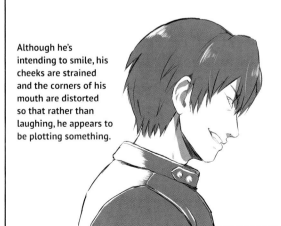

Although he's intending to smile, his cheeks are strained and the corners of his mouth are distorted so that rather than laughing, he appears to be plotting something.

Here, he's trying to withhold his happy expression, but his blushing cheeks give him away, showing an unexpectedly adorable side to this character.

Hearty Laughter

Hearty laughter spills out when someone is unable to control or contain her amusement. Of all the expressions of joy, it's the boldest or most obvious, and is often used to express an exaggerated, uncontrollable reaction.

TIP | When depicting an outbreak of uncontrollable, hearty laughter, troubled brows play a key role. This is laughter that can't be restrained, and the more intense it gets, the more difficult it is to draw breath, leading to the tautening of the brows so that they appear troubled. Adding tears around the eyes increases the appearance of pain from laughing.

Front View

Escaping tears add to the overly exaggerated expression. The lowered brows give the impression of slight pain from laughing so hard that breathing is difficult.

The mouth is open as wide as possible.

Diagonal View

Side View

View from Below

Overhead View

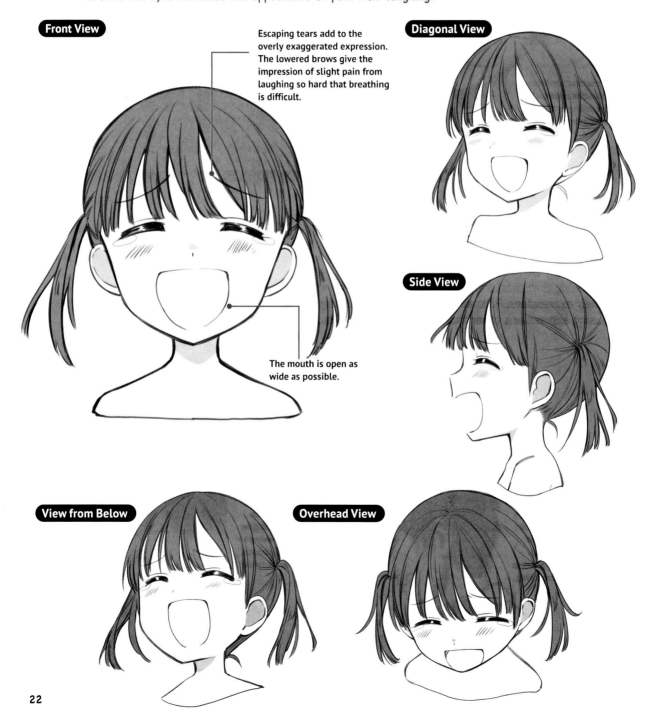

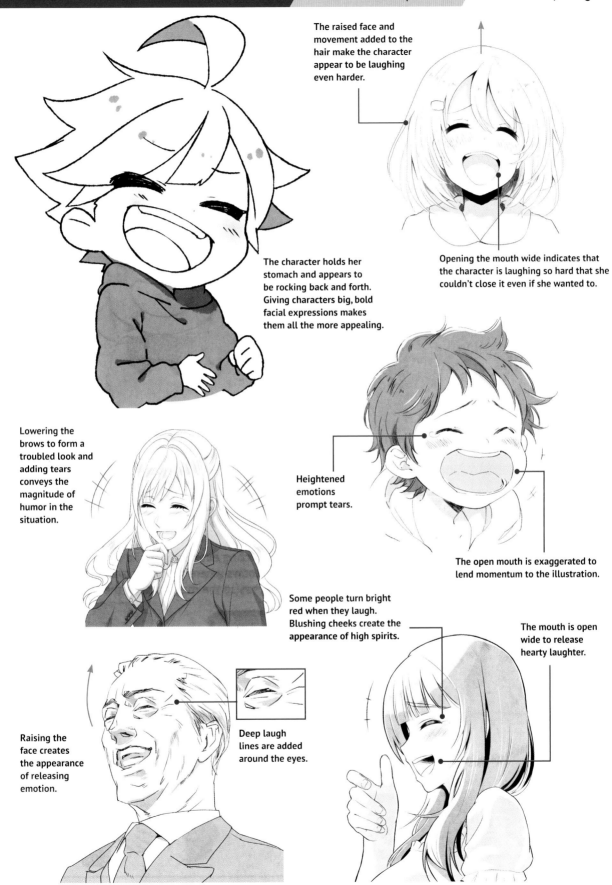

The raised face and movement added to the hair make the character appear to be laughing even harder.

Opening the mouth wide indicates that the character is laughing so hard that she couldn't close it even if she wanted to.

The character holds her stomach and appears to be rocking back and forth. Giving characters big, bold facial expressions makes them all the more appealing.

Lowering the brows to form a troubled look and adding tears conveys the magnitude of humor in the situation.

Heightened emotions prompt tears.

The open mouth is exaggerated to lend momentum to the illustration.

Some people turn bright red when they laugh. Blushing cheeks create the appearance of high spirits.

The mouth is open wide to release hearty laughter.

Raising the face creates the appearance of releasing emotion.

Deep laugh lines are added around the eyes.

Variations

▶ Crying from laughter

This expression depicts tears forming from laughing too hard, with a smiling face as the base to which lowered brows are added. When laughing to an extreme, the face uses different muscles from a typical run-of-the-mill laugh, which can cause tears to form in the same way as they may when yawning. Adding tears makes it easy to convey the intensity of the character's laughter.

This expression depicts catching one's breath in the moment after intense laughter.

Lowered brows and tears convey the expression following a fit of laughter.

Lowering the ends of the brows and adding blush to the cheeks and tears at the eyes builds the appearance of being unable to control laughter.

DISCUSSION / Using the Body to Express Emotion

Using not only the face but the whole body is effective for depicting expression. Build up your understanding of this by watching situations in movies or TV shows where the actors are laughing. The following examples show overreactions, where tears emphasize the magnitude of the laughter.

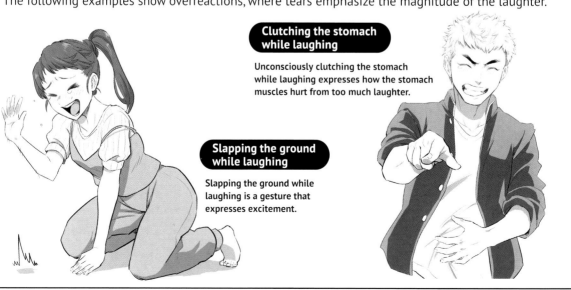

Clutching the stomach while laughing

Unconsciously clutching the stomach while laughing expresses how the stomach muscles hurt from too much laughter.

Slapping the ground while laughing

Slapping the ground while laughing is a gesture that expresses excitement.

DISCUSSION The Difference Between Smiling and Laughing

Facial expressions can be created intentionally in order to communicate with others or appear as the result of emotions welling up. Let's look at the overall facial expression of smiling as an example. This expression can be divided broadly into smiling and laughing.

▶ A smile

A smile is a facial expression that one summons to communicate a positive feeling to others, showing that no harm is intended and that a feeling of familiarity is desired. Even for those who are not studying acting, a smile is a facial expression that should be easy to conjure. In the same way as using language, a smile is an expression created in order to communicate with others, made of one's own volition.

Welcome!

The reason that people in the customer service or sales industries smile is to convey a lack of animosity to others. They create a smiling expression as a means of communication.

▶ A laugh

Have you ever laughed so hard that you became short of breath? It can get so bad that the muscles stiffen and cause you to fall over. A laugh happens as a reaction to something amusing, such as watching a comedian or a skit. Within the range of emotions and expressions, some can be controlled and others cannot. Sometimes it's not possible to control laughter. Keep these points in mind when drawing expressions.

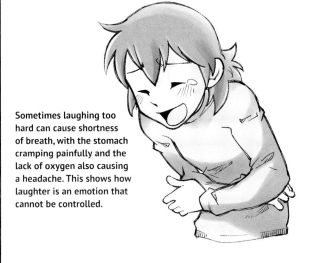

Sometimes laughing too hard can cause shortness of breath, with the stomach cramping painfully and the lack of oxygen also causing a headache. This shows how laughter is an emotion that cannot be controlled.

When the mouth is wide open due to uncontrollable laughter, a hand may be used to cover it. Try using the whole body to express emotion, not just the face.

Anger

Anger is a threat and an emotion that is directed at others. It is often emphasized by being depicted through distortion or symbolic expression, in order to make the emotion easier to read.

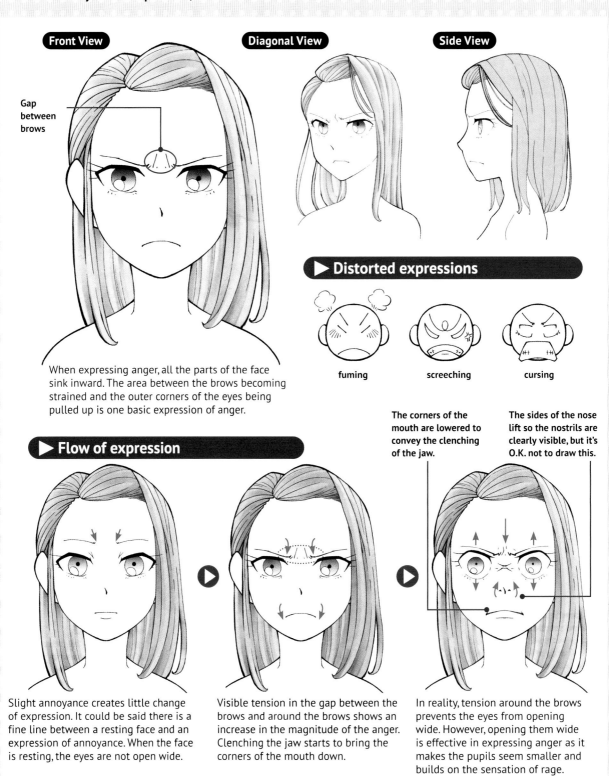

Front View

Gap between brows

Diagonal View

Side View

When expressing anger, all the parts of the face sink inward. The area between the brows becoming strained and the outer corners of the eyes being pulled up is one basic expression of anger.

▶ **Distorted expressions**

fuming screeching cursing

▶ **Flow of expression**

The corners of the mouth are lowered to convey the clenching of the jaw.

The sides of the nose lift so the nostrils are clearly visible, but it's O.K. not to draw this.

Slight annoyance creates little change of expression. It could be said there is a fine line between a resting face and an expression of annoyance. When the face is resting, the eyes are not open wide.

Visible tension in the gap between the brows and around the brows shows an increase in the magnitude of the anger. Clenching the jaw starts to bring the corners of the mouth down.

In reality, tension around the brows prevents the eyes from opening wide. However, opening them wide is effective in expressing anger as it makes the pupils seem smaller and builds on the sensation of rage.

▶ Depicting expressions in different situations

There are various ways to depict anger depending on the situation. Here, we use caricaturized eyes and symbolic expression as examples.

Getting into a huff

The brows knit together and lower, causing the upper lids to lower at the same time.

Revealing anger

The brows form a V shape, and the eyes narrow as a result. The outer corners of the eyes are not actually raised, but give that impression due to the gap between the brows being lowered. Emphasizing this shape and raising the outer corners of the eyes makes for an effective caricaturization.

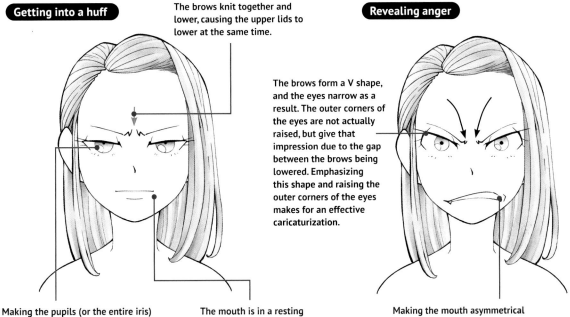

Making the pupils (or the entire iris) small is effective in conveying animosity and other negative emotions. The size of the iris does not change, this is only a caricaturization.

The mouth is in a resting state and remains neutral.

Making the mouth asymmetrical creates the look of clenching the jaw.

Suppressing anger

This symbol for bulging veins and the vertical lines used to indicate turning pale are well-known symbolic expressions.

Exploding with rage

In this expression, all the parts of the face are overly exaggerated. The expression of anger becomes comical if overdone, so striking the right balance is the tricky part.

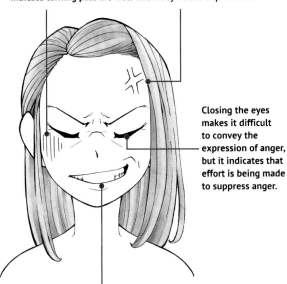

Closing the eyes makes it difficult to convey the expression of anger, but it indicates that effort is being made to suppress anger.

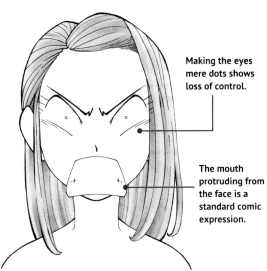

Making the eyes mere dots shows loss of control.

The mouth protruding from the face is a standard comic expression.

The jaws are clenched and the corners of the mouth are raised, but only from considerable effort, forming an extremely distorted expression.

Irritation

Irritation often accompanies other negative emotions, such as anger, panic and unease, swirling around in the mind before manifesting themselves physically. If no other person is present in the situation, it may resemble an annoyed expression, while if others are present it may come across as a slight glare.

✏ **TIP** | The basic expression involves wrinkles forming between the brows and the eyes and the brows drawing closer together in a frown. Anger is being stored up, with the jaw clenching unconsciously and tension forming around the mouth.

Front View

Diagonal View

Shifting the gaze indicates pent-up dissatisfaction.

Side View

The brows knit together in a show of annoyance.

Pulling the mouth to one side to create asymmetry gives the impression of irritation.

View from Below

Overhead View

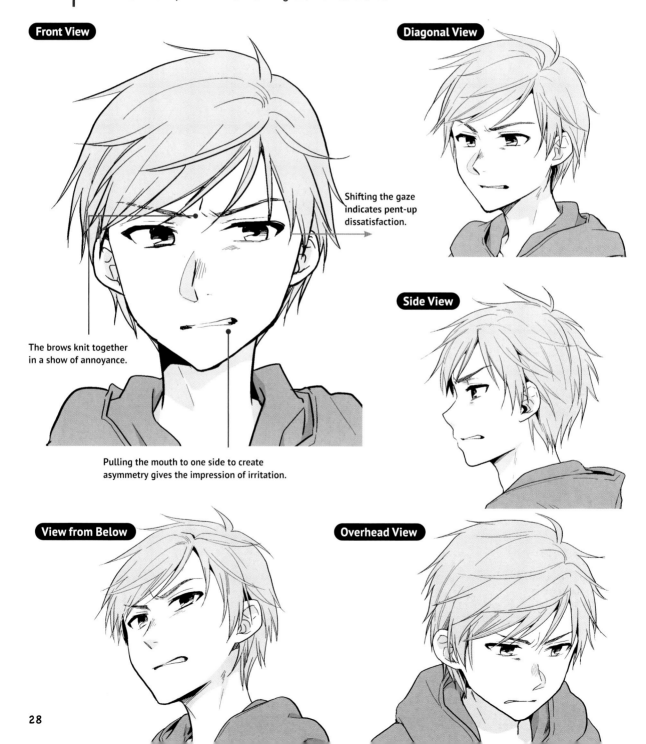

Wrinkles form between the brows and the mouth is a straight line, expressing internal irritation despite the calm outward appearance.

The heads of the eyebrows draw closer to the eyes while the rest of the brows lift.

As this is a middle-aged man, if the mouth is set in a straight line, creases form at the sides.

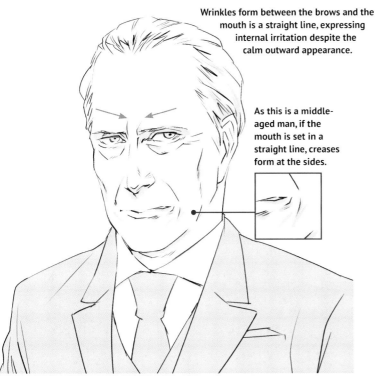

The mouth is pulled out sideways to express irritation.

The attempt to contain increasing impatience causes tension to form in the gap between the brows and in the lower lids.

Wrinkles between the brows, raised brows, narrowed eyes and the wrinkles in the lower lids form the expression of irritation.

Adding crosshatching in the background builds the impression of annoyance.

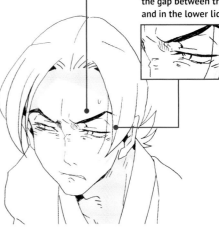

The slightly furrowed brows and mouth lowered at the corners express inner annoyance.

Directing the wrinkles between the brows downward along with the gaze makes for an irritated expression.

gaze

The half-open mouth creates the appearance of clicking the tongue in frustration.

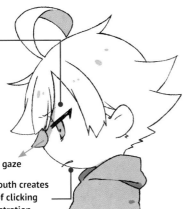

Try also using crossed arms and tapping fingers to express irritation.

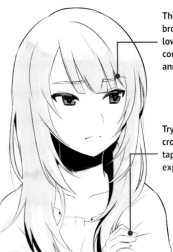

Variations

▶ Getting into a huff

This expression of discomfort appears only for an instant after hearing or seeing something that provokes anger.

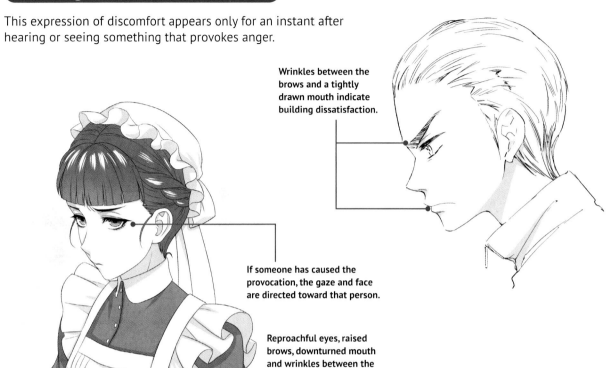

Wrinkles between the brows and a tightly drawn mouth indicate building dissatisfaction.

If someone has caused the provocation, the gaze and face are directed toward that person.

Reproachful eyes, raised brows, downturned mouth and wrinkles between the brows express a bad mood.

▶ Laughing while angry

This expression shows a laughing or smiling face being taken over by pent-up anger. It is often used as a humorous device.

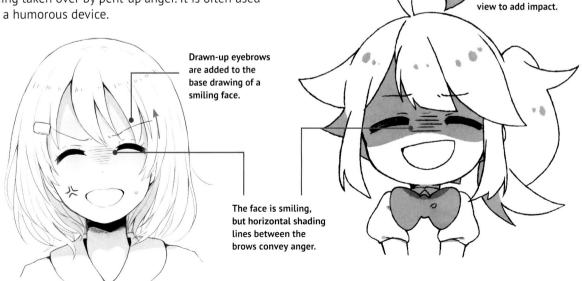

Drawn-up eyebrows are added to the base drawing of a smiling face.

The face is smiling, but horizontal shading lines between the brows convey anger.

Characters that are sweet and small in stature have a tendency to appear cute, so use a slightly overhead view to add impact.

Expression Ideas
Scrapbook: Anger

Puffing up with anger

Fuming Fuming

Exasperated

A jolt of anger

A sharp stare

"What the . . .?!"

"Watch out!"

Provoked

"Say what?"

Rage

An expression of rage can contain an edge of threat to it. In order to convey that sense of aggression, the expression is often drawn in an overly exaggerated manner. In some cases, the expression turns inward, if the character is displeased or angry with himself.

TIP Raising the brows and eyes is a standard expression of rage. The severity or intensity of the rage varies depending on how wide the mouth is open. Creating the look of a slightly clenched jaw evokes the impression of anger that is still but barely being suppressed.

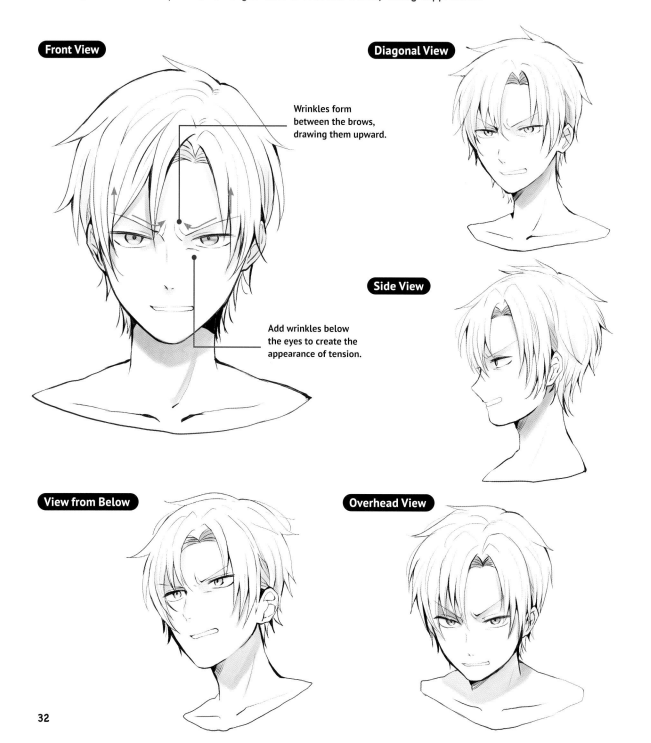

Front View

Wrinkles form between the brows, drawing them upward.

Add wrinkles below the eyes to create the appearance of tension.

Diagonal View

Side View

View from Below

Overhead View

This is the expression that forms when scolding children. It's also an expression used to warn about impending danger or to tell someone to take care in order to prevent harm, so there's only mild or moderate tension between the brows.

Raised brows and upturned eyes indicate the character is glaring at someone.

Drawing several lines across the lower eyelids emphasizes rage.

Using perspective to show the figure from slightly below increases the intensity and tension.

Tension causes wrinkles to form between the brows and around the eyes.

This calls to mind a threatening wild beast. To express the tension in the brows, eyes and mouth, lines are used to create shadow around the eyes.

When people with clear-cut features cast their eyes down, the eyes are hidden in the hollows under the brows, and the eyes and eyebrows seem to draw close to each other. Narrowing the gap between the brows and eyes creates the expression of glaring at someone.

Normally gray shadow would be used, but for an expression of rage, using black deepens the shadow and intensifies the mood.

Tension forms in the facial muscles toward the center of the face.

Rage is expressed via the clenched jaw.

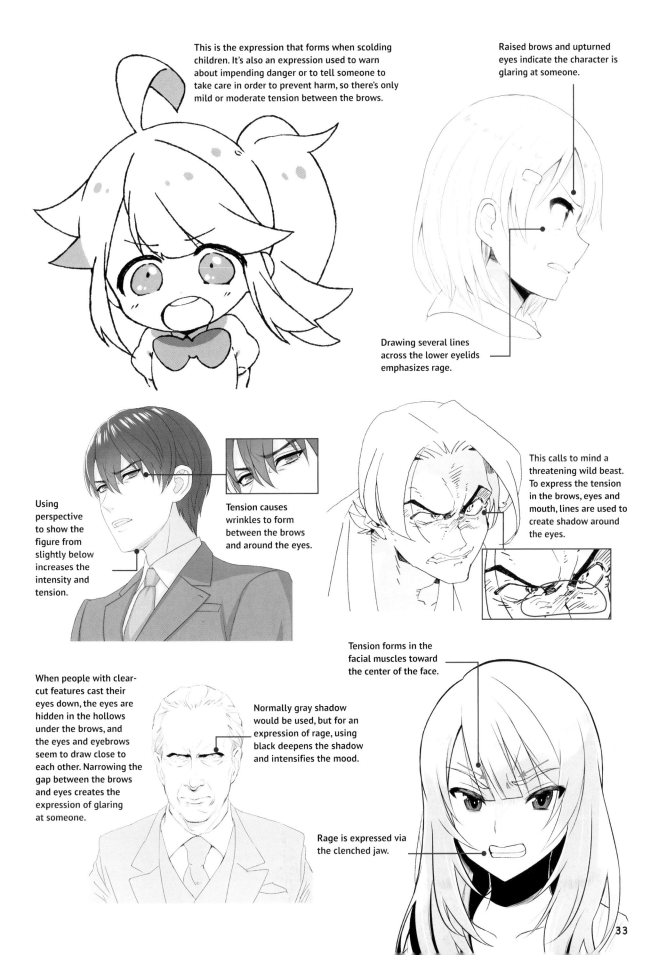

Variations

▶ Fuming

This is used as a comical expression to convey milder, low-grade anger. The puffed-out cheeks make for an expression that is angry yet still soft.

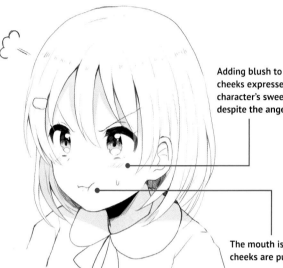

Adding blush to the cheeks expresses the character's sweetness despite the anger.

The mouth is closed and the cheeks are puffed out.

A symbol like a puff of air is effective for expressing slight anger.

A cunning expression can be somewhat jutting. The pouted mouth creates a slightly comical effect.

▶ Tears of anger

This expression depicts rage building to the point of tears. Some people simply cry, while others fume and start crying the more angry they get.

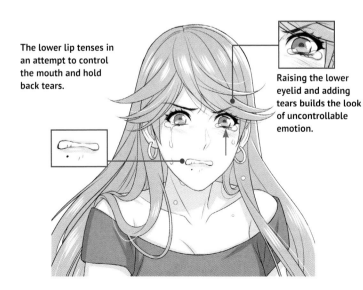

The lower lip tenses in an attempt to control the mouth and hold back tears.

Raising the lower eyelid and adding tears builds the look of uncontrollable emotion.

▶ Quiet rage

This expresses anger building inside while looking down and away from someone who there is no need to threaten, or facing someone whom isn't worth worrying about.

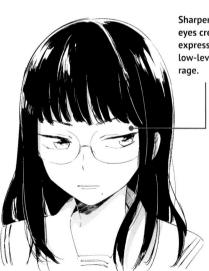

Sharpening the eyes creates the expression of low-level cold rage.

▶ Glaring

This expression shows a gaze directed straight at the other party. It is often used as an expression of rage, but can be used to indicate other emotions too.

The brows tense and the glare is directed toward the object of rage as if attacking it with emotion.

The chin is pulled sharply in to emphasize the face and threaten the other party. The eyes send a strong message in this pose.

The redness above the nose and the lightly puckered mouth indicate that, apart from rage, other emotions are also at play.

If one character is in a far more superior position than another, simply glaring at him can cause him to back down. Keep in mind the authority in the gaze as you draw.

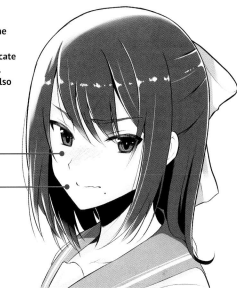

References: Jealousy (Page 96)

DISCUSSION / Rage in a Character with Droopy Eyes

Often, it is not only the brows but also the eyes that are raised to express rage. However, in characters with droopy eyes, care must be taken as simply raising the eyes may change the appearance of the face to the extent that they no longer look like themselves. Of course, raising the eyes does create an angrier expression, so this method may be used depending on the situation.

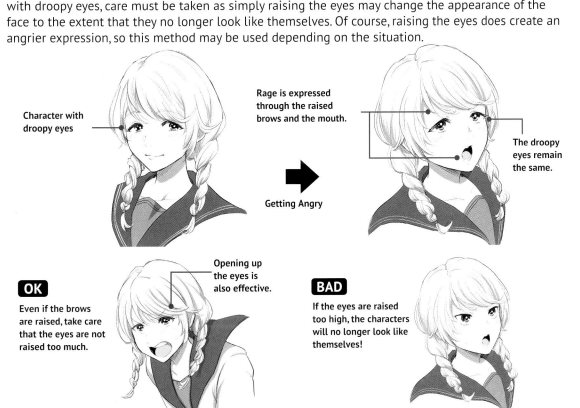

Character with droopy eyes

Rage is expressed through the raised brows and the mouth.

The droopy eyes remain the same.

Getting Angry

OK

Even if the brows are raised, take care that the eyes are not raised too much.

Opening up the eyes is also effective.

BAD

If the eyes are raised too high, the characters will no longer look like themselves!

Fury

Fury is the expression of rage mounting to the point of explosion, with screaming, sputtering, venting and other behavior that lets off steam. It is the transformation of rage, which is intended to be threatening, to a "couldn't care less" attitude strongly taken out on the other person.

TIP | Bringing the wrinkles between the brows firmly together strongly expresses fury. The mouth is open wide to complain, yell or otherwise make noise. All sense of calm has been lost along with the ability to reason and consider others. Drawing the brows and eyes pulled firmly up in a slightly exaggerated way makes for a stronger expression of rage.

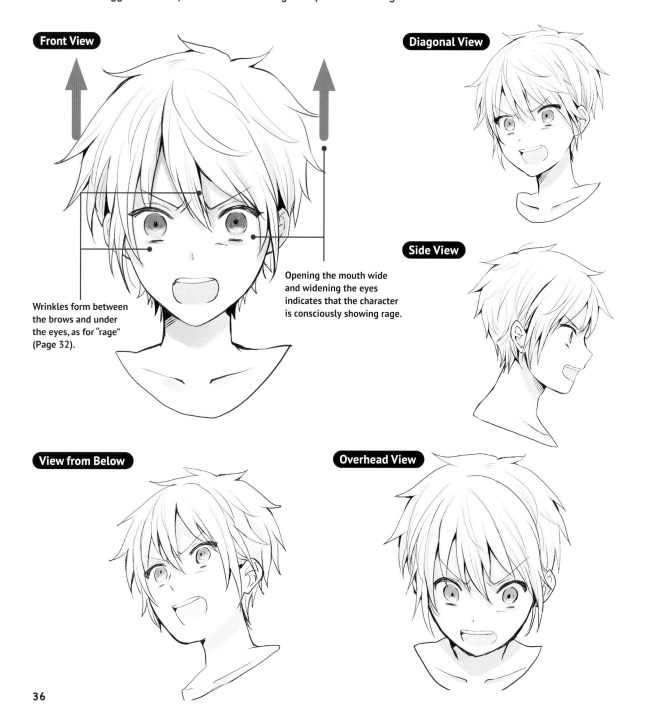

Front View

Wrinkles form between the brows and under the eyes, as for "rage" (Page 32).

Opening the mouth wide and widening the eyes indicates that the character is consciously showing rage.

Diagonal View

Side View

View from Below

Overhead View

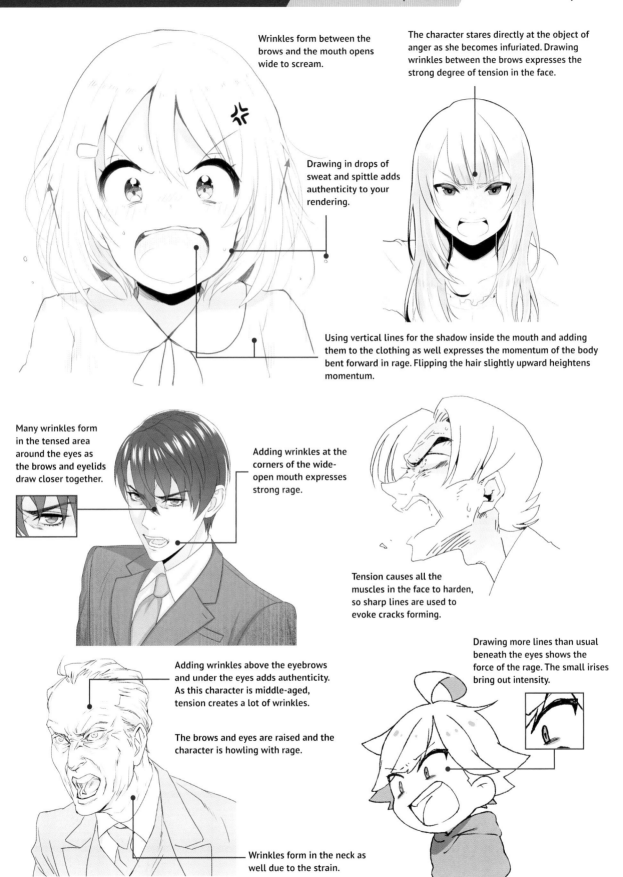

Wrinkles form between the brows and the mouth opens wide to scream.

The character stares directly at the object of anger as she becomes infuriated. Drawing wrinkles between the brows expresses the strong degree of tension in the face.

Drawing in drops of sweat and spittle adds authenticity to your rendering.

Using vertical lines for the shadow inside the mouth and adding them to the clothing as well expresses the momentum of the body bent forward in rage. Flipping the hair slightly upward heightens momentum.

Many wrinkles form in the tensed area around the eyes as the brows and eyelids draw closer together.

Adding wrinkles at the corners of the wide-open mouth expresses strong rage.

Tension causes all the muscles in the face to harden, so sharp lines are used to evoke cracks forming.

Adding wrinkles above the eyebrows and under the eyes adds authenticity. As this character is middle-aged, tension creates a lot of wrinkles.

The brows and eyes are raised and the character is howling with rage.

Drawing more lines than usual beneath the eyes shows the force of the rage. The small irises bring out intensity.

Wrinkles form in the neck as well due to the strain.

Sadness

Maybe your character's pondering a tragic situation or has just received bad news. Maybe she just got fired! Devastation sets in, an expression of sadness creeping into the eyes and edging into the rest of the face. Unless your characters have the gift of eternal bliss, it's essential to know the nuances of sadness.

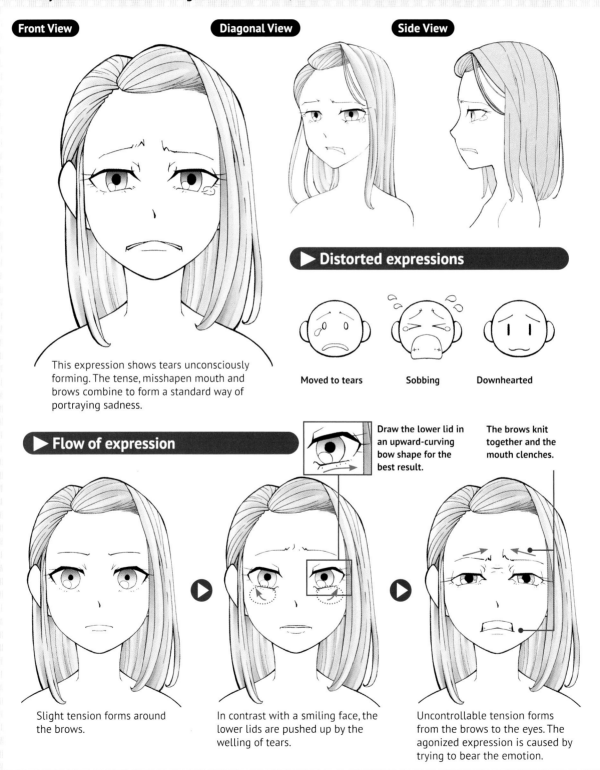

Front View

This expression shows tears unconsciously forming. The tense, misshapen mouth and brows combine to form a standard way of portraying sadness.

Diagonal View

Side View

▶ Distorted expressions

Moved to tears Sobbing Downhearted

▶ Flow of expression

Draw the lower lid in an upward-curving bow shape for the best result.

The brows knit together and the mouth clenches.

Slight tension forms around the brows.

In contrast with a smiling face, the lower lids are pushed up by the welling of tears.

Uncontrollable tension forms from the brows to the eyes. The agonized expression is caused by trying to bear the emotion.

▶ Depicting expressions in different situations

When something unfortunate has happened

This expression incorporates the stylized downhearted eyebrows that symbolize sadness. Of all the expressions of sadness, this is one that shows it to a lesser degree. It is an expression of slight emotion used for communication when someone else is present. Exaggerated expressions do not form when alone.

Expression after hearing of a sad occurrence

Sad occurrences are never wished for. Sometimes, the expression of accepting the truth resembles a reaction of surprise. In the stage before emotions overflow, the expression does not reflect forbearance, but rather shows the negative feelings being processed as the character absorbs the impact of the news.

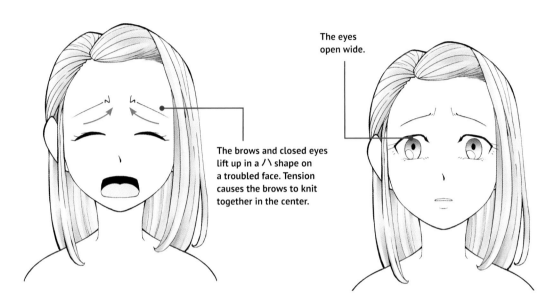

The brows and closed eyes lift up in a ╱╲ shape on a troubled face. Tension causes the brows to knit together in the center.

The eyes open wide.

The expression of anguish as tears start to fall

This expression shows emotion building and tears falling. Once emotion overflows, it's difficult to hold back. Trying to stop sobbing doesn't work, resulting in an expression of anguish.

When emotions can't be held back

This expression shows emotion building to the point where it can no longer be held back and tears cannot be stopped. Once sobbing starts and tears start to fall, they cannot be stopped for a while. Continued crying is followed by a feeling of relaxation and, once the tears stop, a feeling of release.

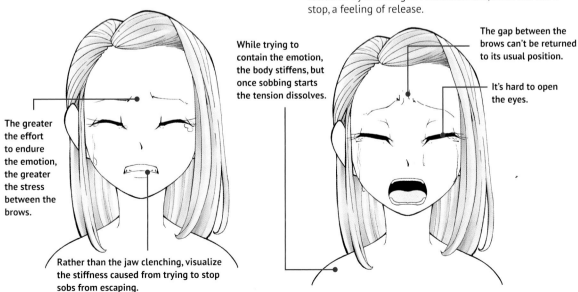

The greater the effort to endure the emotion, the greater the stress between the brows.

Rather than the jaw clenching, visualize the stiffness caused from trying to stop sobs from escaping.

While trying to contain the emotion, the body stiffens, but once sobbing starts the tension dissolves.

The gap between the brows can't be returned to its usual position.

It's hard to open the eyes.

Depression

Depression's accompanying lack of vitality causes spirits to sink, with negative emotions such as sadness, loneliness and uncertainty all weighing on the mind. Getting at the source of your character's emotional discomfort will help you to fine-tune the expression.

TIP | Lowering the brows and corners of the mouth and casting the eyes down creates the look of negative feelings. Using symbols such as sighs and sweat can also be effective.

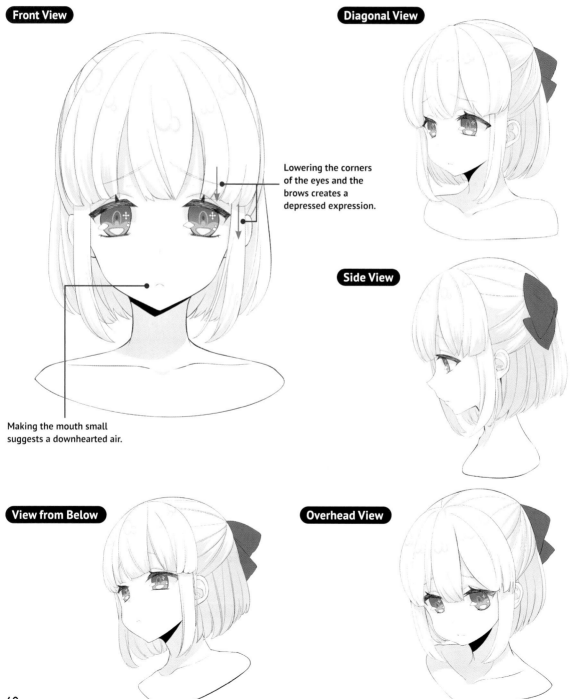

Front View

Diagonal View

Lowering the corners of the eyes and the brows creates a depressed expression.

Side View

Making the mouth small suggests a downhearted air.

View from Below

Overhead View

Using plenty of vertical lines that symbolize turning pale strengthens the expression of depression.

The eyes narrow and the gaze shifts downward.

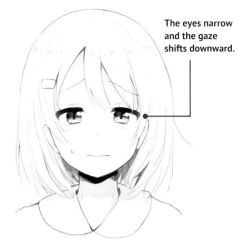

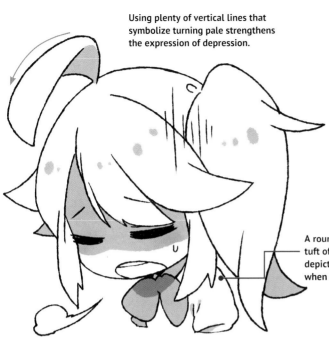

A rounded back and the top tuft of hair falling forward depict the body's appearance when depressed.

Pulling the lips in conveys that the character is not merely sad, but is also moping and depressed.

The ends of the brows and the upper eyelids are lowered, with the slight drooping of the body also working to indicate low spirits.

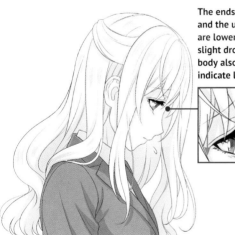

gaze

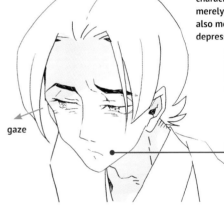

The eyes, corners of the mouth and brows are all lowered.

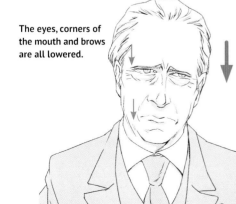

Relaxing the eyes, brows, shoulders and other parts of the body expresses low spirits.

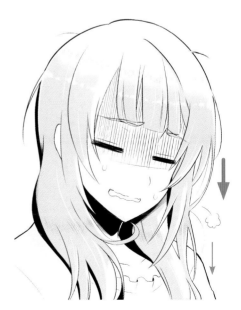

Sadness and Loneliness

Loneliness is an expression that forms when sadness and isolation begin to surface. Tears do not form, but a subtle sense of solitary suffering is clearly communicated.

 TIP | The standard way to depict this expression is to lower the brows and slightly narrow the eyes to convey that they are not bright and clear. Firmly closing the mouth is also effective for creating the expression of trying to endure sadness and loneliness.

Front View

Diagonal View

Reddening the cheeks suggests the inner corners of the eyes becoming wet with tears.

The brows are lowered and the eyes are slightly narrowed.

Side View

The half-open mouth expresses loneliness.

View from Below

Overhead View

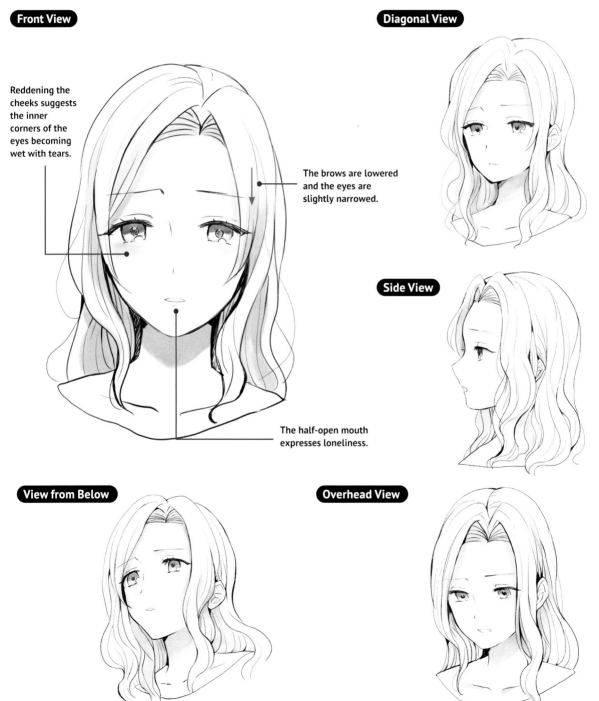

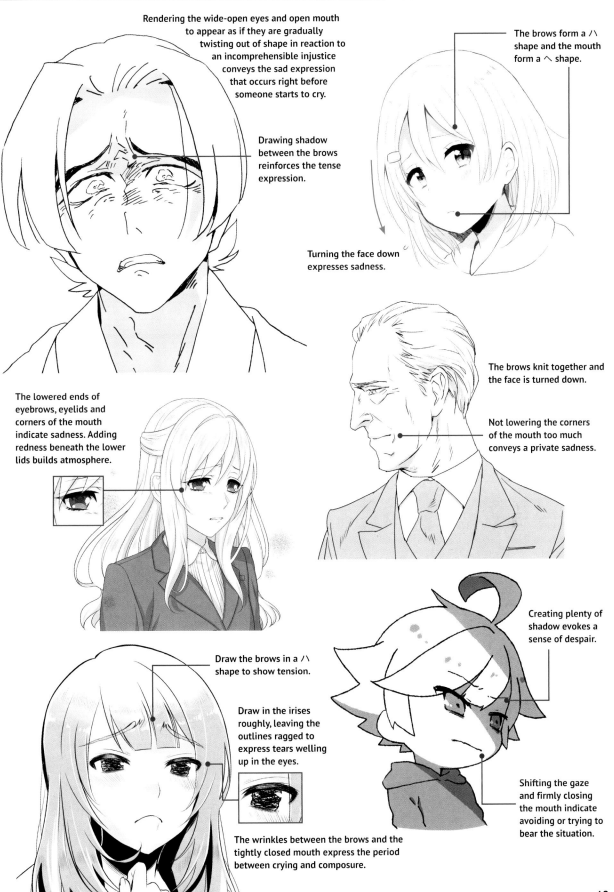

Rendering the wide-open eyes and open mouth to appear as if they are gradually twisting out of shape in reaction to an incomprehensible injustice conveys the sad expression that occurs right before someone starts to cry.

The brows form a /\ shape and the mouth form a ⌒ shape.

Drawing shadow between the brows reinforces the tense expression.

Turning the face down expresses sadness.

The lowered ends of eyebrows, eyelids and corners of the mouth indicate sadness. Adding redness beneath the lower lids builds atmosphere.

The brows knit together and the face is turned down.

Not lowering the corners of the mouth too much conveys a private sadness.

Creating plenty of shadow evokes a sense of despair.

Draw the brows in a /\ shape to show tension.

Draw in the irises roughly, leaving the outlines ragged to express tears welling up in the eyes.

The wrinkles between the brows and the tightly closed mouth express the period between crying and composure.

Shifting the gaze and firmly closing the mouth indicate avoiding or trying to bear the situation.

Crying

As sadness mounts, tears well up in the eyes and the "waterworks" start. Sadness is the emotion that obviously triggers tears, but various other feelings may come into play to result in tears of regret, tears of happiness and so on. Here, we will mainly be looking at tears of sadness.

TIP | When spirits are low, the brows, eyes and corners of the mouth turn down. The greater the tension between the brows and around the mouth, the stronger the feeling of sadness appears. Teardrops forming in the outer corners of the eyes and lines of tears running down the face are standard ways to depict tears.

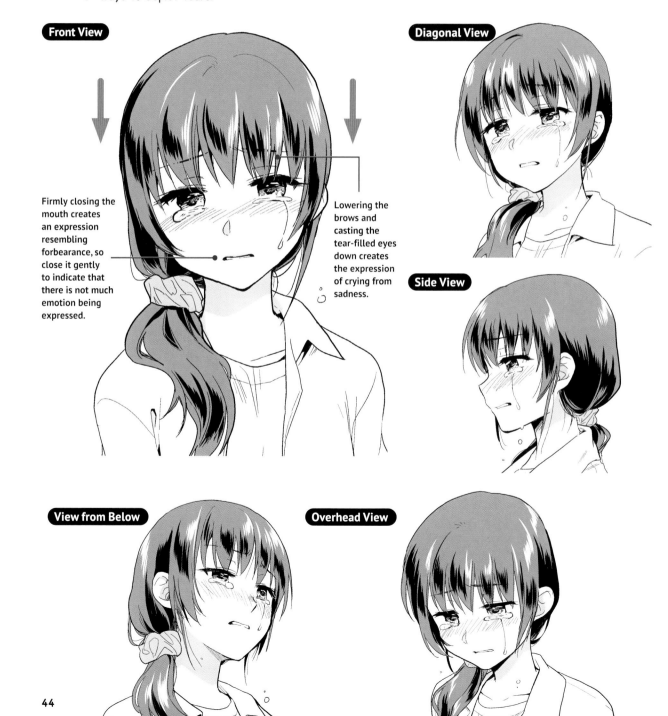

Front View

Firmly closing the mouth creates an expression resembling forbearance, so close it gently to indicate that there is not much emotion being expressed.

Lowering the brows and casting the tear-filled eyes down creates the expression of crying from sadness.

Diagonal View

Side View

View from Below

Overhead View

The crying character turns his face away. The faintly clenched jaw conveys that he was unable to completely hide his emotions.

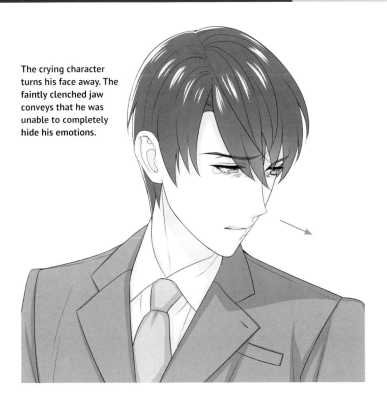

Adding raised eyebrows to a tear-stained face creates the look of crying out of regret.

Drawing the facial features in toward the center of the face creates the expression of trying to hold back overflowing tears. Depict tension in the brows and eyes and a clenched jaw to evoke an expression of forbearance.

Tears are not held back for long, but rather start to well up and fall, so there is no tension and few wrinkles in the space between the brows.

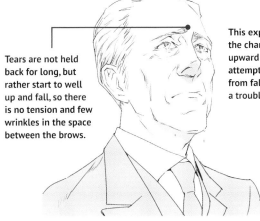

This expression shows the character looking upward in a futile attempt to stop tears from falling, resulting in a troubled expression.

The look of sadness is heightened by letting the top tuft of hair hang down in a listless manner.

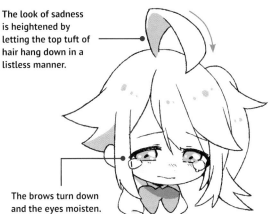

The brows turn down and the eyes moisten.

The raised brows and gesture of wiping away tears indicates not only that the character is crying but also shows her strength to move on.

Variations

▶ Crying from happiness

Tears do not form only in times of sadness. There are many scenarios where they can be used, such as passing an exam, receiving a positive response to a declaration of affection, or welcoming a loved one back unharmed.

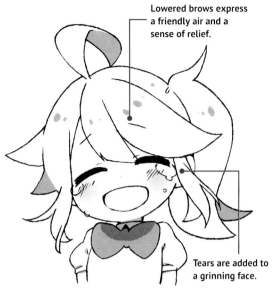

Lowered brows express a friendly air and a sense of relief.

Tears are added to a grinning face.

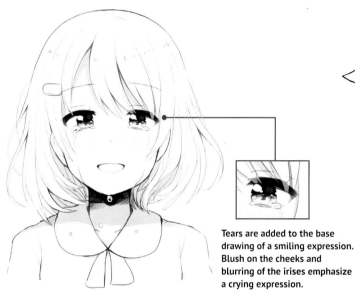

Tears are added to the base drawing of a smiling expression. Blush on the cheeks and blurring of the irises emphasize a crying expression.

References: Being Moved to Tears (Page 50)/ Being Moved (Page 144)

▶ A trail of tears

Tears running down the cheek in a single line can make an attractive impression. Sobbing is audible, with emotion used to plead one's case. However, even when patiently bearing and suppressing emotion, it can be impossible to control a trail of tears. As they can be perceived as tears not intended for public display, they are particularly moving.

Depending on the person's expression, crying may come across as something different. Knitting the brows together with tension in the area between them creates the expression of reining in emotion.

Downcast eyes and a downturned face express quiet sobbing.

DISCUSSION / Loss of Spirit

This expression depicts the stage beyond sadness when motivation has been lost. The eyes appear empty and the facial features are all downcast.

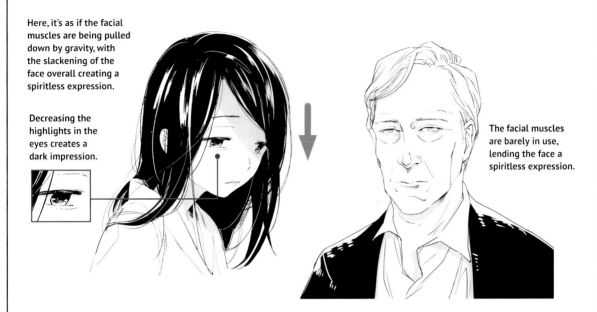

Here, it's as if the facial muscles are being pulled down by gravity, with the slackening of the face overall creating a spiritless expression.

Decreasing the highlights in the eyes creates a dark impression.

The facial muscles are barely in use, lending the face a spiritless expression.

▶ Expressions when unmotivated

Sometimes a loss of spirit brings emotions to the face involuntarily. Regardless of the expression, the eyes appear hollow and the gaze does not settle.

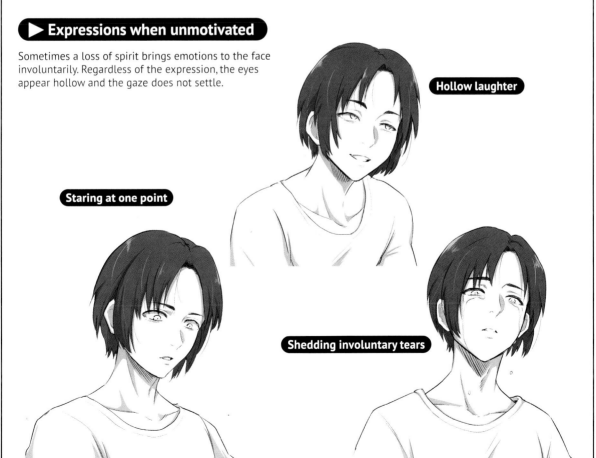

Hollow laughter

Staring at one point

Shedding involuntary tears

Sobbing

Sobbing is an expression of being unable to stop an overflow of sadness, such as being unable to hold back tears, giving up on holding back tears or feeling relieved after releasing tears. It's often used to show the force of a character's emotions in situations such as venting to someone or crying in public.

TIP | Often, when trying to hold back tears, the face is turned down in order to conceal the expression, but when vocalizing as happens when someone is sobbing, the chin is raised. The wide-open mouth, tense brow area and tightly squeezed or narrowed eyes scrunch up the face. Some people's faces also turn red when they are worked up.

Front View

The raised ends of the brows and wrinkles bunched together between the brows depict the magnitude of emotion.

The mouth open wide shows vocalization while crying.

Diagonal View

Side View

View from Below

Overhead View

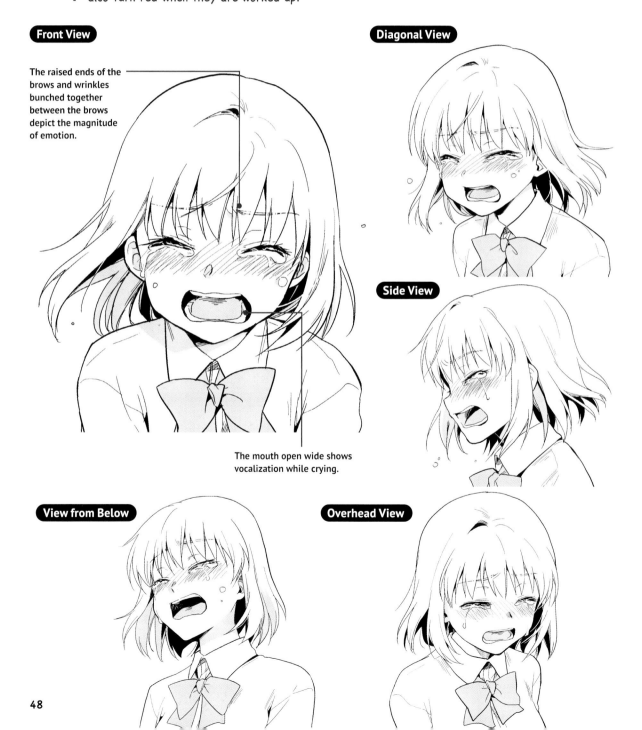

48

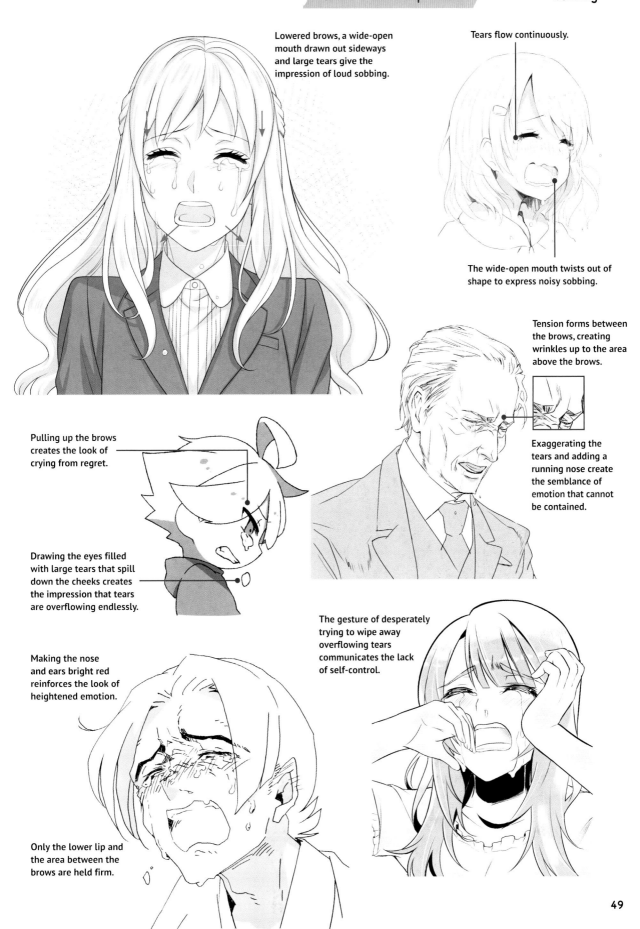

Lowered brows, a wide-open mouth drawn out sideways and large tears give the impression of loud sobbing.

Tears flow continuously.

The wide-open mouth twists out of shape to express noisy sobbing.

Tension forms between the brows, creating wrinkles up to the area above the brows.

Pulling up the brows creates the look of crying from regret.

Exaggerating the tears and adding a running nose create the semblance of emotion that cannot be contained.

Drawing the eyes filled with large tears that spill down the cheeks creates the impression that tears are overflowing endlessly.

The gesture of desperately trying to wipe away overflowing tears communicates the lack of self-control.

Making the nose and ears bright red reinforces the look of heightened emotion.

Only the lower lip and the area between the brows are held firm.

49

Variations

▶ Crying from anger

Once anger peaks, tears may form due to the heightening of emotion.

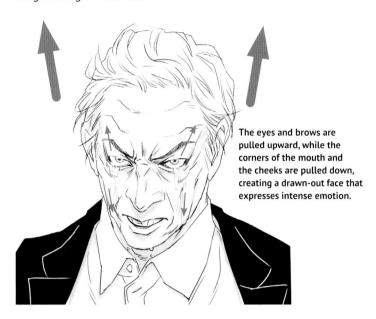

The eyes and brows are pulled upward, while the corners of the mouth and the cheeks are pulled down, creating a drawn-out face that expresses intense emotion.

Extreme strain between the brows and around the eyes indicates that both regret and rage are on full display.

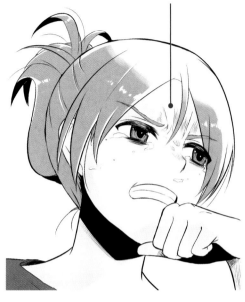

▶ Being moved to tears

People shed tears when they are moved. Adding tears to the expression of being moved emphasizes the depth of emotion.

Heightened emotion is expressed via the tear-filled eyes and the ragged outlines of the pupils.

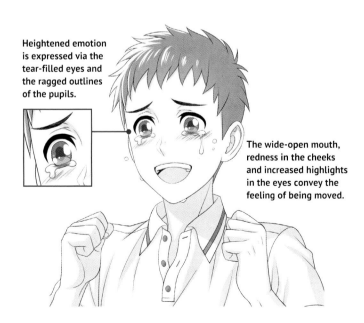

The wide-open mouth, redness in the cheeks and increased highlights in the eyes convey the feeling of being moved.

Reddening the cheeks and adding excessive sparkle and huge tears to the eyes expresses deep emotion.

References: Crying from Happiness (Page 46)/ Being Moved (Page 144)

Expression Ideas
Scrapbook: Sadness

Downhearted

Wistful

"Sigh"

Turning away

"Huh..."

"Dammit"

Sobbing

Drip...

Drip...

Choking on tears

Surprise

Surprise is an expression in reaction to something unexpected happening. When surprised, it is as if the facial features elongate and the eyes and mouth open wide. Raising the eyebrows makes for a realistic look.

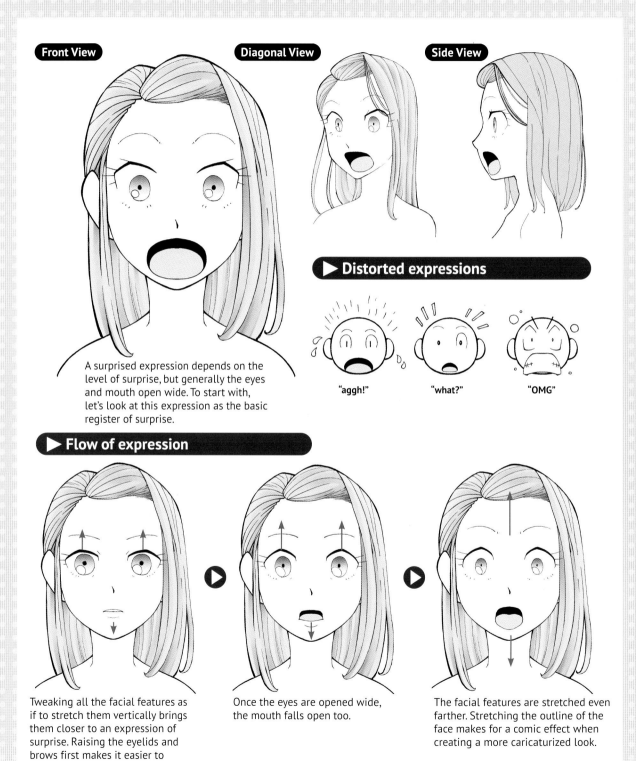

Front View

Diagonal View

Side View

A surprised expression depends on the level of surprise, but generally the eyes and mouth open wide. To start with, let's look at this expression as the basic register of surprise.

▶ **Distorted expressions**

"aggh!"

"what?"

"OMG"

▶ **Flow of expression**

Tweaking all the facial features as if to stretch them vertically brings them closer to an expression of surprise. Raising the eyelids and brows first makes it easier to achieve a balanced look.

Once the eyes are opened wide, the mouth falls open too.

The facial features are stretched even farther. Stretching the outline of the face makes for a comic effect when creating a more caricaturized look.

▶ Expressions preceding surprise

Dazed expression

This expression appears at the stage when trying to process a lot of information to understand what has happened. At this point when the brain is struggling to get up to speed with sudden events, the eyes open up wide.

Recognizing a dangerous situation

This is the expression created at the moment of vocalizing surprise ("huh?" "eh?" etc). Breath is inhaled inadvertently when uttering noises, so draw the mouth to appear rigidly set in order to communicate surprise.

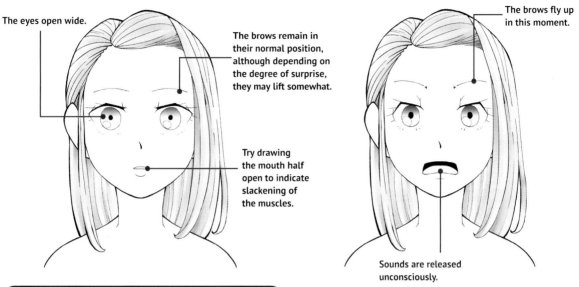

The eyes open wide.

The brows remain in their normal position, although depending on the degree of surprise, they may lift somewhat.

Try drawing the mouth half open to indicate slackening of the muscles.

The brows fly up in this moment.

Sounds are released unconsciously.

▶ Distorted expressions of surprise

Slightly distorted expression

Allowing the essential elements of each facial feature to remain but drawing them to be much larger creates an expression of surprise. Making the irises smaller is also effective.

Significantly distorted expression

Facial features are stretched vertically, far beyond their original form. As for the expression of anger "exploding with rage" (Page 27), making the irises mere pinpricks results in a comic effect.

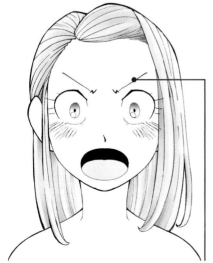

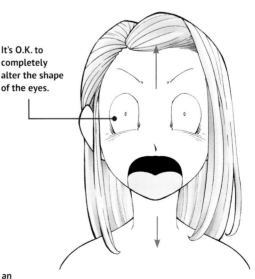

It's O.K. to completely alter the shape of the eyes.

Opening the eyes wide and lifting up the brows results in an expression that is not possible in reality, but "angry brows" can also be used to create a surprised expression.

Astonishment

This expression appears only fleetingly. Apart from being used for reactions to unforeseen events, it can also be used alongside expressions of fear in heart-pounding or mysterious scenarios.

TIP | Raised brows, wide-open eyes and a wide-open mouth are the basics of this expression. The body may shift up or backward when surprised, so keep this in mind to reinforce the expression. Use of symbolic expressions such as those for sweat or being startled is also effective.

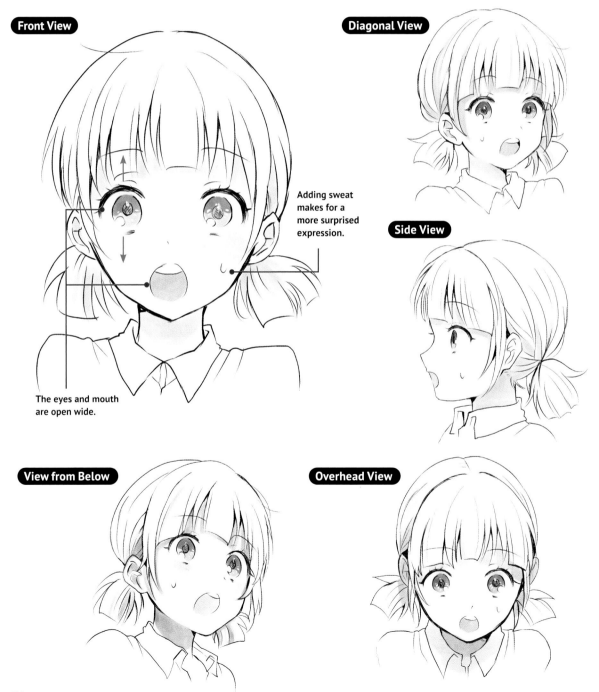

Front View

Adding sweat makes for a more surprised expression.

The eyes and mouth are open wide.

Diagonal View

Side View

View from Below

Overhead View

Small irises and a large gap between the eyes and brows make for an astonished expression.

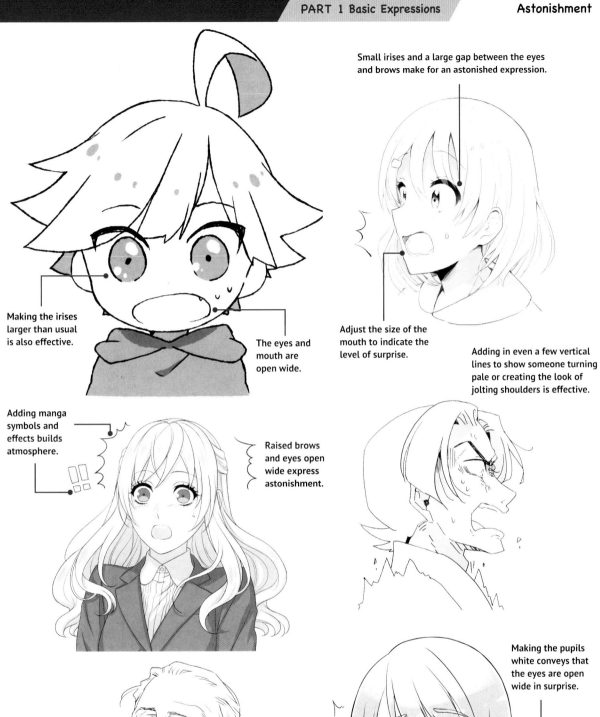

Making the irises larger than usual is also effective.

The eyes and mouth are open wide.

Adjust the size of the mouth to indicate the level of surprise.

Adding in even a few vertical lines to show someone turning pale or creating the look of jolting shoulders is effective.

Adding manga symbols and effects builds atmosphere.

Raised brows and eyes open wide express astonishment.

Shifting the body backward at the same time as opening the eyes and mouth wide expresses the magnitude of surprise.

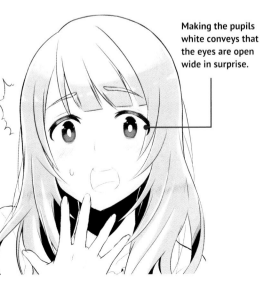

Making the pupils white conveys that the eyes are open wide in surprise.

Trembling

Trembling occurs when someone is shaken up or jolted by an intense experience. It's often used to indicate being unable to remain calm, such as in situations where one's secret is about to be uncovered or when someone guesses exactly what one is thinking.

✏️ **TIP** | While in some cases the eyes open wide in an expression similar to surprise and it's obvious that the character is shaken up, trembling can also be rendered so that the character appears quite calm but is panicking on the inside. It's an expression that can be quite different depending on the character's personality and situation.

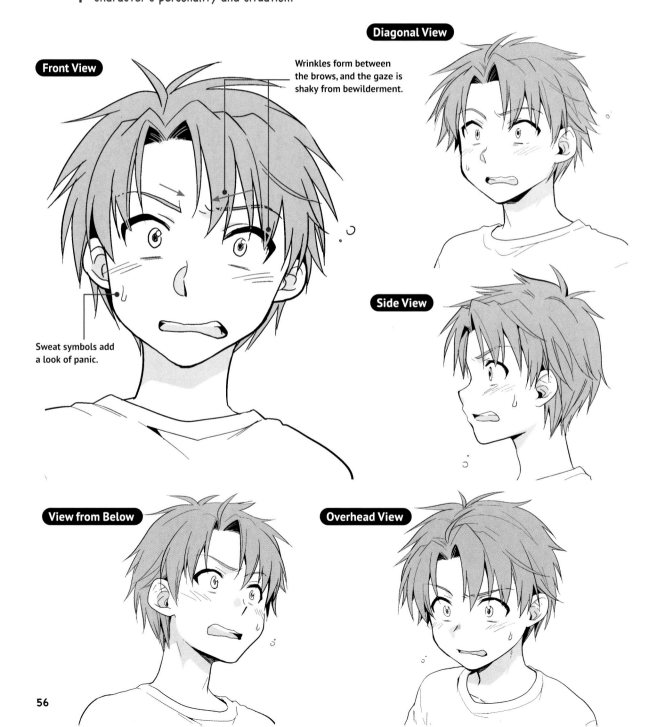

Diagonal View

Front View

Wrinkles form between the brows, and the gaze is shaky from bewilderment.

Sweat symbols add a look of panic.

Side View

View from Below

Overhead View

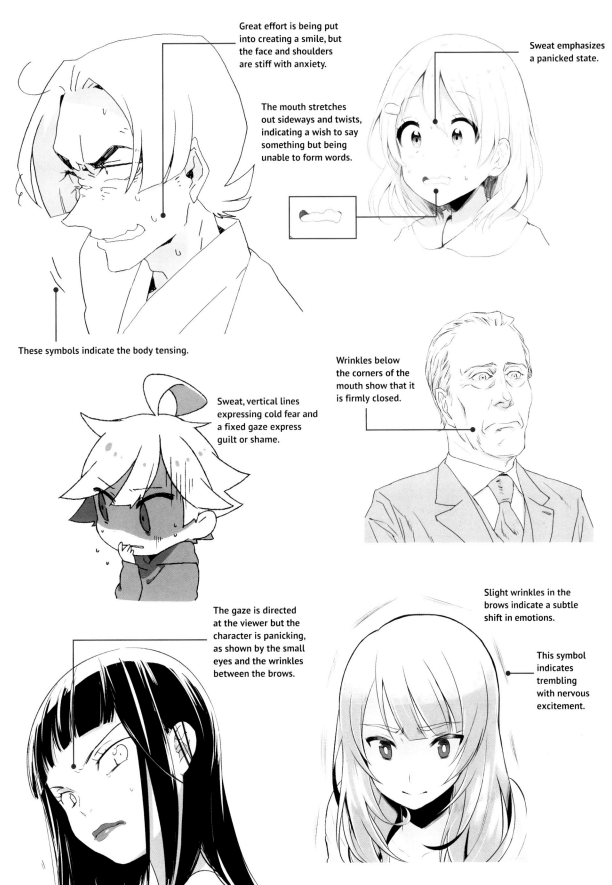

Great effort is being put into creating a smile, but the face and shoulders are stiff with anxiety.

The mouth stretches out sideways and twists, indicating a wish to say something but being unable to form words.

Sweat emphasizes a panicked state.

These symbols indicate the body tensing.

Sweat, vertical lines expressing cold fear and a fixed gaze express guilt or shame.

Wrinkles below the corners of the mouth show that it is firmly closed.

The gaze is directed at the viewer but the character is panicking, as shown by the small eyes and the wrinkles between the brows.

Slight wrinkles in the brows indicate a subtle shift in emotions.

This symbol indicates trembling with nervous excitement.

Variations

▶ Being startled

This expression is one of realization. Adding focus lines and symbols of surprise to an expression of astonishment makes it clearer.

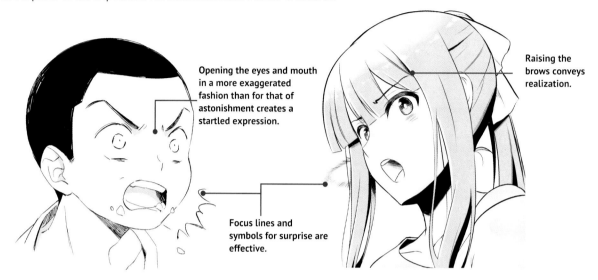

Opening the eyes and mouth in a more exaggerated fashion than for that of astonishment creates a startled expression.

Raising the brows conveys realization.

Focus lines and symbols for surprise are effective.

▶ Heart skipping a beat/being alarmed

This expression captures the moment when something shameful or embarrassing is revealed or the character is being singled out. It is similar to the expression of being startled, but differentiation can be achieved by adding symbols for sweat or turning pale to indicate the shock of being found out.

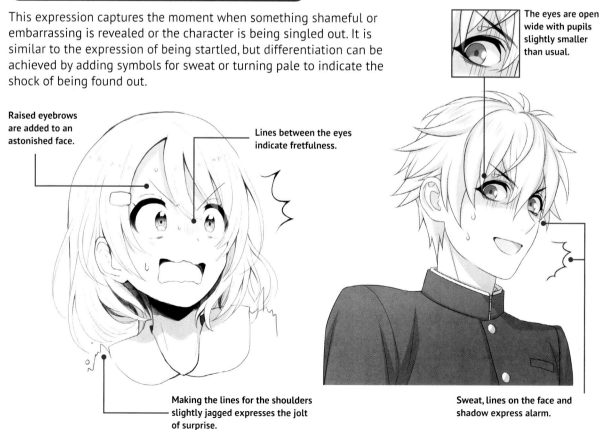

The eyes are open wide with pupils slightly smaller than usual.

Raised eyebrows are added to an astonished face.

Lines between the eyes indicate fretfulness.

Making the lines for the shoulders slightly jagged expresses the jolt of surprise.

Sweat, lines on the face and shadow express alarm.

▶ Becoming flustered

This expression conveys being unable to settle down after a sudden event. An open mouth indicates a flustered state, with sweat symbols also being effective.

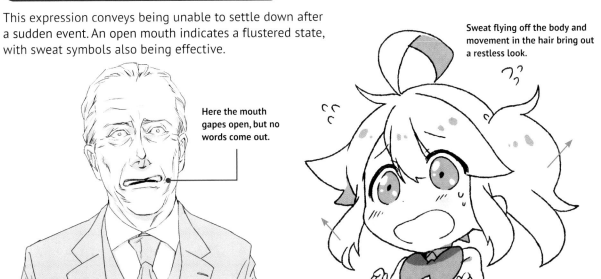

Here the mouth gapes open, but no words come out.

Sweat flying off the body and movement in the hair bring out a restless look.

DISCUSSION | An Expression Changing from Surprise to Concern

Sometimes an expression changes from one of being surprised by something to one of panic or worry. The expression of concern differs depending on its cause.

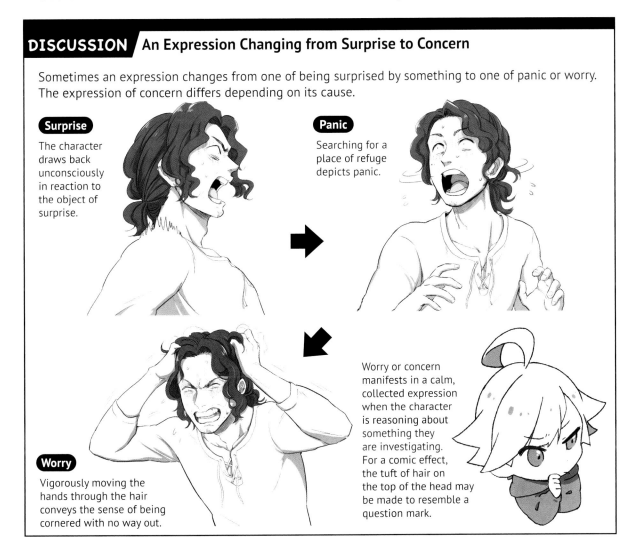

Surprise

The character draws back unconsciously in reaction to the object of surprise.

Panic

Searching for a place of refuge depicts panic.

Worry

Vigorously moving the hands through the hair conveys the sense of being cornered with no way out.

Worry or concern manifests in a calm, collected expression when the character is reasoning about something they are investigating. For a comic effect, the tuft of hair on the top of the head may be made to resemble a question mark.

Shock

Surprise, rage and sadness combine to form the expression of shock. From a momentary expression of surprise, the expression changes, modulating as the reaction to the shock is absorbed and processed.

TIP | When the emotion mixed with shock is one of anger, the brows lift, while if it is one of sadness, the brows lower. It is common to express the degree of shock via the number of lines that depict turning pale or the amount of shadow on the face.

Diagonal View

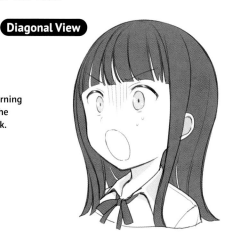

Front View

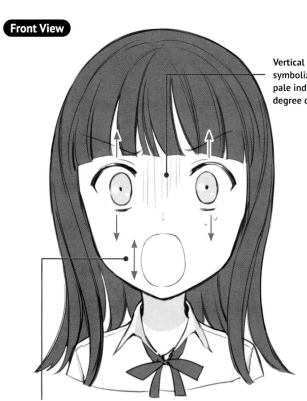

Vertical lines symbolizing turning pale indicate the degree of shock.

The mouth and eyes open wide vertically to express shock.

Side View

View from Below

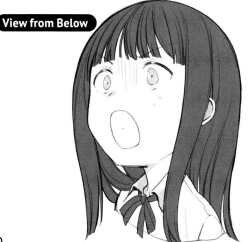

Overhead View

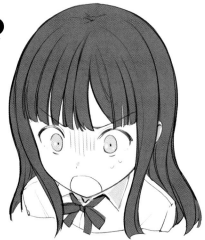

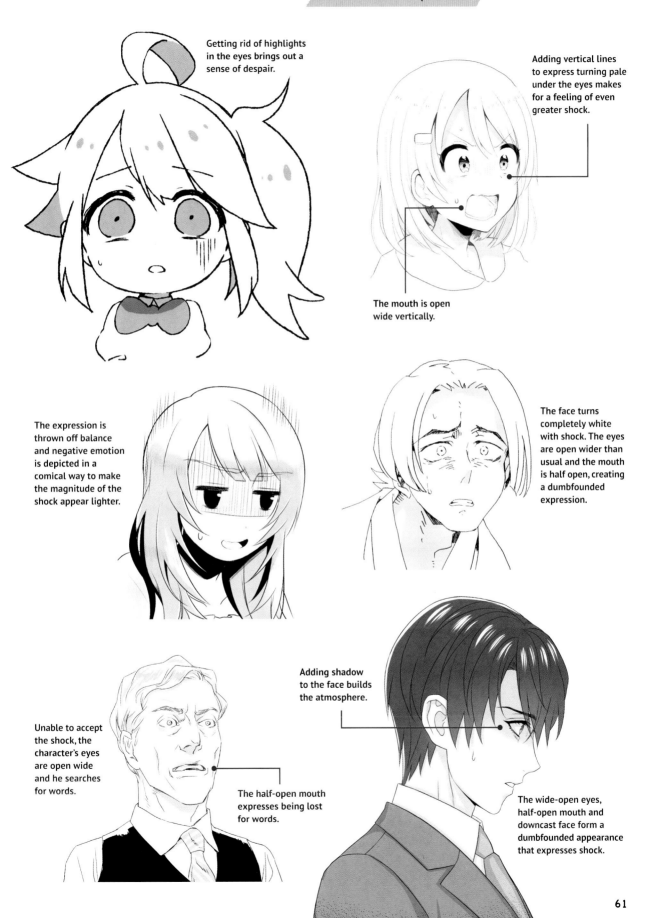

Getting rid of highlights in the eyes brings out a sense of despair.

Adding vertical lines to express turning pale under the eyes makes for a feeling of even greater shock.

The mouth is open wide vertically.

The expression is thrown off balance and negative emotion is depicted in a comical way to make the magnitude of the shock appear lighter.

The face turns completely white with shock. The eyes are open wider than usual and the mouth is half open, creating a dumbfounded expression.

Adding shadow to the face builds the atmosphere.

Unable to accept the shock, the character's eyes are open wide and he searches for words.

The half-open mouth expresses being lost for words.

The wide-open eyes, half-open mouth and downcast face form a dumbfounded appearance that expresses shock.

61

Variations

▶ "Oh, my goodness!"

This is also an expression of shock with exaggerated movement and facial features.

The wide-open eyes and mouth indicate the magnitude of the shock.

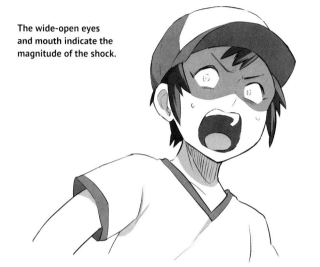

Sadness and surprise combine in this expression. Lowering the brows makes for a slightly worried look.

DISCUSSION / Depicting the Pupils

Human pupils contract in bright situations and dilate in darkness. However, they also contract and dilate depending on emotions, dilating in frightening, exciting or surprising situations. This is true of real life, but when creating manga, anime and other such illustrations, it's common to make the pupils smaller to express surprise, for reasons such as:

- It depicts pupils getting smaller in reaction to light being allowed in when the eyes are open wide.
- The tendency is to draw the irises to be smaller in expressions where the eyes are open wide, with the result that the pupils within the irises are also smaller.

There may be other reasons too, but regardless, it seems to be widely accepted that the pupils should be made small in expressions of surprise. In pictures and illustrations, it's possible to express things that cannot happen in reality. For example, substituting hearts for eyes when a character is in love, completely leaving out the pupils and irises. Don't get too weighed down by reality, but rather feel free to express your own ideas in your drawing.

The pupils made small

The pupils made large

Expression Ideas
Scrapbook: Surprise

"Huh?"

Wincing

"You've got to be kidding..."

"Uh-oh"

"Oh, no!"

Eyes snapping open

Screaming in fright

Squealing

"What the....?!"

Dislike

Dislike can be seen as the flip side of relief. Letting dislike show on the face is a sign that there is no risk or danger present. The area between the brows tenses, but unlike in the expression of anger, the emotion does not take over the face.

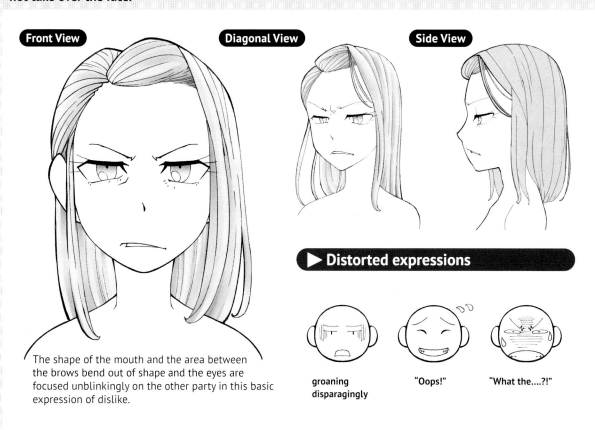

Front View

Diagonal View

Side View

The shape of the mouth and the area between the brows bend out of shape and the eyes are focused unblinkingly on the other party in this basic expression of dislike.

▶ **Distorted expressions**

groaning disparagingly

"Oops!"

"What the....?!"

▶ **Flow of expression**

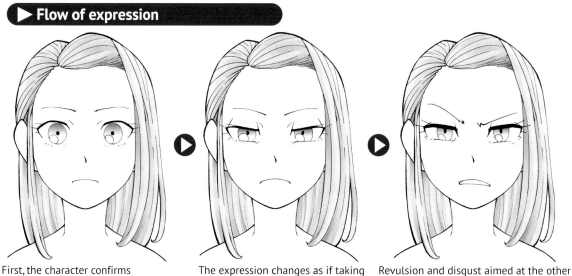

First, the character confirms whether the other party (or object) is beneficial to her. At this stage, if there are any suspicions, the expression stiffens slightly.

The expression changes as if taking the measure of the other party.

Revulsion and disgust aimed at the other party show on the face. Openly displaying disgust can prompt attacks, so it is only because the character feels safe that she is able to do so.

▶ Depicting expressions in different situations

Concealing repulsion

Although hiding one's true emotions, the feeling of disgust is not entirely concealed in this expression. If aversion is not revealed in a troubled look, it tends to manifest itself in a misshapen smile.

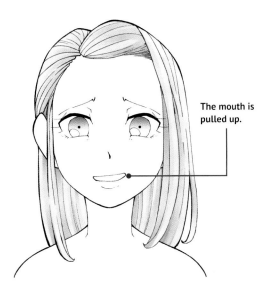

The mouth is pulled up.

Tolerating feelings of repulsion

When it's not possible to escape a repulsive situation, an expression of forbearance forms.

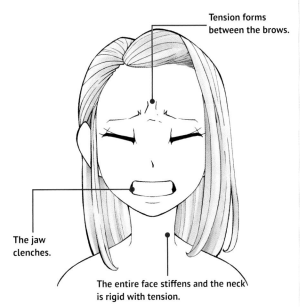

Tension forms between the brows.

The jaw clenches.

The entire face stiffens and the neck is rigid with tension.

Screaming from repulsion

As the object of disgust draws nearer, the character screams in an effort to attract help. If the character doesn't even want to see the object of disgust, the eyes will be squeezed tightly shut.

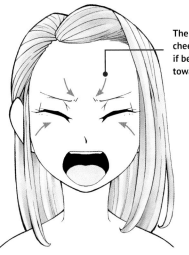

The forehead and cheeks shift as if being pulled toward each other.

Troubled by something repulsive

When it's not possible to fend off the object of disgust, a troubled expression forms on the face. Try using easily understandable symbols to express this.

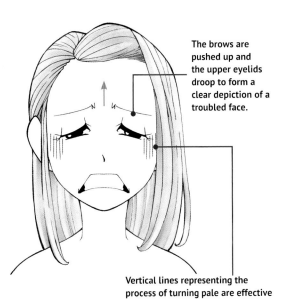

The brows are pushed up and the upper eyelids droop to form a clear depiction of a troubled face.

Vertical lines representing the process of turning pale are effective in expressing negative emotions.

65

Troubled

A troubled expression is the state one step before repulsion takes hold, so if it's overdone, this expression begins to resemble repulsion instead. It's best used to capture the state of confusion at receiving sudden and unsettling news.

TIP | Lowered brows and lowered corners of the mouth are the fundamentals of this expression. Altering some facial features enables the expression of complicated emotions, such as raising the brows to indicate distrust and forcing the mouth into a fake smile to express repulsion.

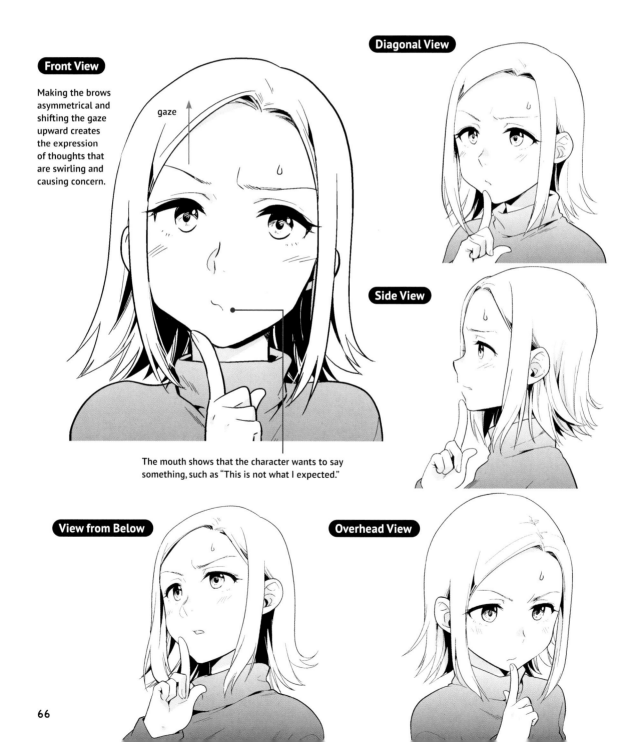

Front View

Making the brows asymmetrical and shifting the gaze upward creates the expression of thoughts that are swirling and causing concern.

gaze

The mouth shows that the character wants to say something, such as "This is not what I expected."

Diagonal View

Side View

View from Below

Overhead View

Lowered brows, cold sweat, upturned eyes and a fake smile build the appearance of a troubled face unsure of what to do.

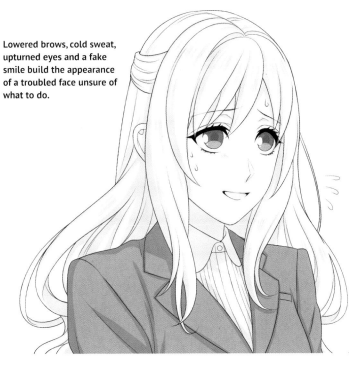

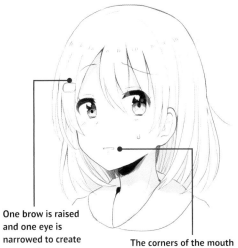

One brow is raised and one eye is narrowed to create asymmetry.

The corners of the mouth are drawn down to suggest slightly pulling back or away.

Focusing wrinkles between the brows makes for a troubled look.

The brows are lowered to create a troubled appearance.

Flying droplets of sweat are an effective device.

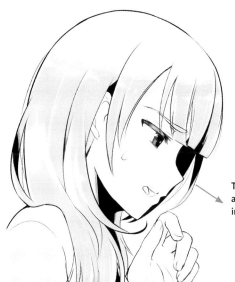

The eyebrows are raised, but the pulled-up mouth and numerous droplets of sweat make for a troubled expression.

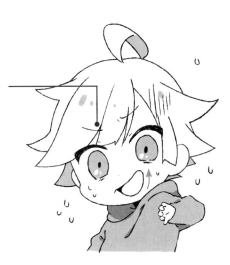

The downturned gaze and vague point of focus indicate deep thought.

67

Repulsion

Repulsion is an open expression of dislike. It's ideal for situations that require unpleasant emotion to be clearly communicated, such as when feeling abhorrence or awkwardness.

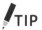**TIP** Wrinkles of tension between the brows are the foundation for this expression. It is usual to narrow the eyes, creating tension between the brows, and when also expressing rage, the gaze can be rendered as a fierce glare directed toward another party.

Front View

The brows are raised and wrinkles form between them.

The mouth is drawn out sideways to express a feeling of disgust.

The vertical lines that are also used to depict turning pale bring out the sense of repulsion when added beneath the eyes.

Diagonal View

Side View

View from Below

Overhead View

The sense of repulsion directed at the other person changes depending on the expression in the eyes. Here, rage is added to form the appearance of threatening the other person.

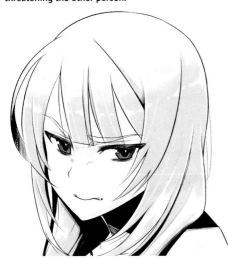

The eyes narrow and the brows are pulled up. Making the brows uneven in height conveys the sense of disgust.

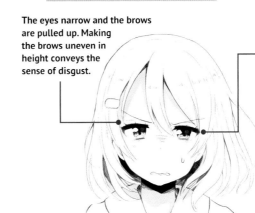

Bunching wrinkles together between the brows and adding lines along the lower eyelids and above the nose emphasize the sense of disgust.

Tension between the brows, around the eyes and around the mouth and the slight glare in the eyes bring out the feeling of rejecting the other person.

gaze

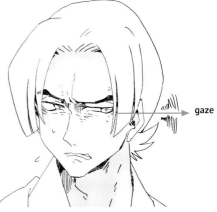

Averting the face and casting the eyes down creates the gesture of avoiding looking at the object of disgust.

The sense of unpleasantness is brought to the fore via the drawn-in chin and the glare directed outward.

The corners of the mouth are lowered and wrinkles form beneath the mouth.

The brows and mouth twist out of shape and the gaze is directed downward as if looking at something unpleasant.

Feelings of repulsion cause wrinkles of tension to gather in the brows and around the eyes. The lower eyelids rise and the eyes narrow.

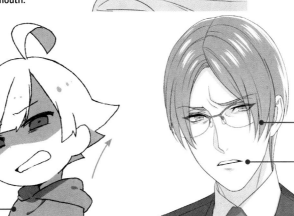

Depicting the body as pulling slightly backward indicates the character's desire to put even a small distance between himself and the object of disgust.

Twisting the mouth out of shape portrays unpleasantness.

Loathing

Something like a mix of repulsion and rage forms an expression of loathing. The sources of loathing are varied—resentment, jealousy and humiliation, to name a few—and its subtle registers require practice to get it just right.

TIP | The basic expression of loathing involves wrinkles of tension forming between the brows, muscles straining around the eyes and directing a glare at the other party. Adding shadow in the face and lines resembling bags under the eyes allow the degree of loathing to be emphasized.

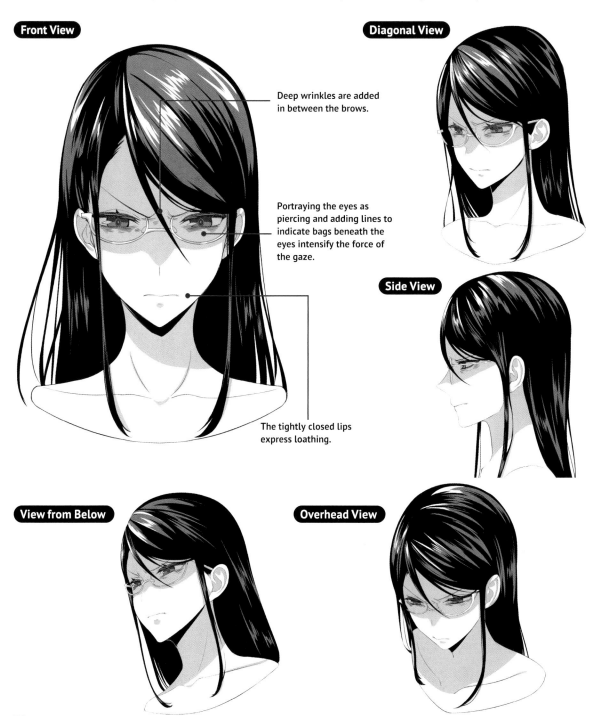

Front View

Deep wrinkles are added in between the brows.

Portraying the eyes as piercing and adding lines to indicate bags beneath the eyes intensify the force of the gaze.

The tightly closed lips express loathing.

Diagonal View

Side View

View from Below

Overhead View

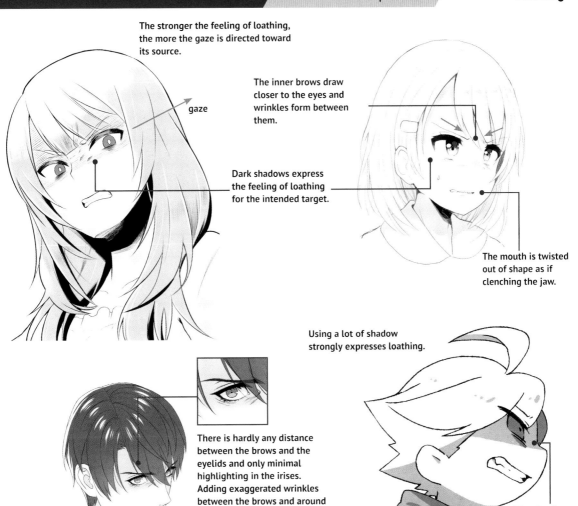

The stronger the feeling of loathing, the more the gaze is directed toward its source.

gaze

The inner brows draw closer to the eyes and wrinkles form between them.

Dark shadows express the feeling of loathing for the intended target.

The mouth is twisted out of shape as if clenching the jaw.

Using a lot of shadow strongly expresses loathing.

There is hardly any distance between the brows and the eyelids and only minimal highlighting in the irises. Adding exaggerated wrinkles between the brows and around the eyes conveys glaring at the object of loathing.

The piercing eyes suggest the expression of glaring at someone.

This expression shows pent-up emotion being repressed by grinding the teeth. The pulled-in chin adds to the feeling of power being stored up in the back of the jaw.

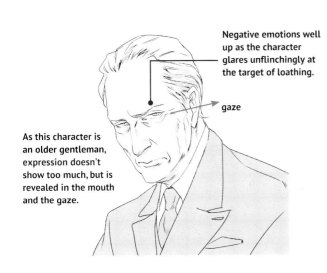

Negative emotions well up as the character glares unflinchingly at the target of loathing.

gaze

As this character is an older gentleman, expression doesn't show too much, but is revealed in the mouth and the gaze.

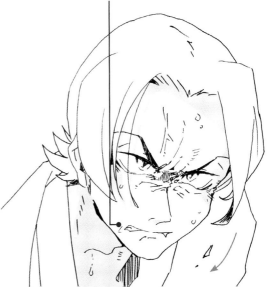

Variations

▶ Instinctive dislike

This expression conveys a physiological dislike, expressed by the brows and mouth twisted out of shape.

The brows are raised and slightly distorted.

Lines to indicate turning pale along with added shadow make the sense of repulsion obvious.

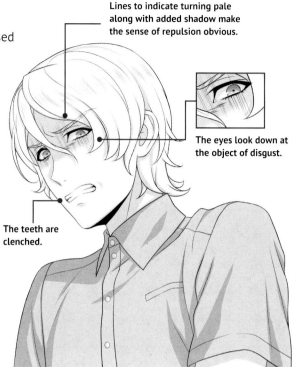

The eyes look down at the object of disgust.

The teeth are clenched.

Adding vertical lines representing turning pale beneath the eyes emphasizes the air of dislike. In this case, rather than turning pale, the lines express being fed up.

▶ Murderous intentions

Repulsion and loathing mix to create the expression of murderous intentions. Strongly focused eyes reinforce the sense of animosity and hatred.

Imbuing a sense of determination into the eyes makes for a more realistic expression.

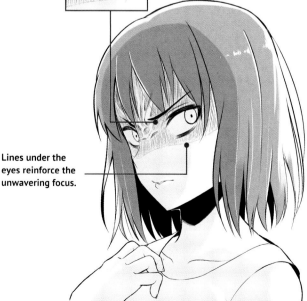

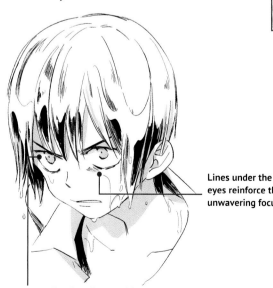

Lines under the eyes reinforce the unwavering focus.

The irises are even smaller than they would be if merely glaring at someone, thereby expressing the overwhelming urge to kill.

Expression Ideas
Scrapbook: Dislike

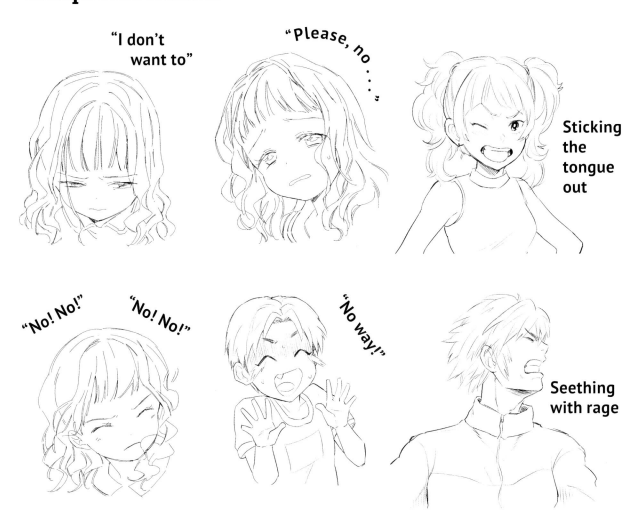

"I don't want to"

"Please, no . . . ,"

Sticking the tongue out

"No! No!" "No! No!"

"No way!"

Seething with rage

DISCUSSION / **Using the Brush to Draw Background Digital Effects**

Various types of brushes can be selected from the Decoration Tool **to add crosshatching and other effects.**

Fear

Feelings of fear can stem from negative experiences in the past, or be triggered by witnessing or experiencing something frightening. When faced with something for the first time, the expression takes on a look of uncertainty, the person unsure whether to be scared or not.

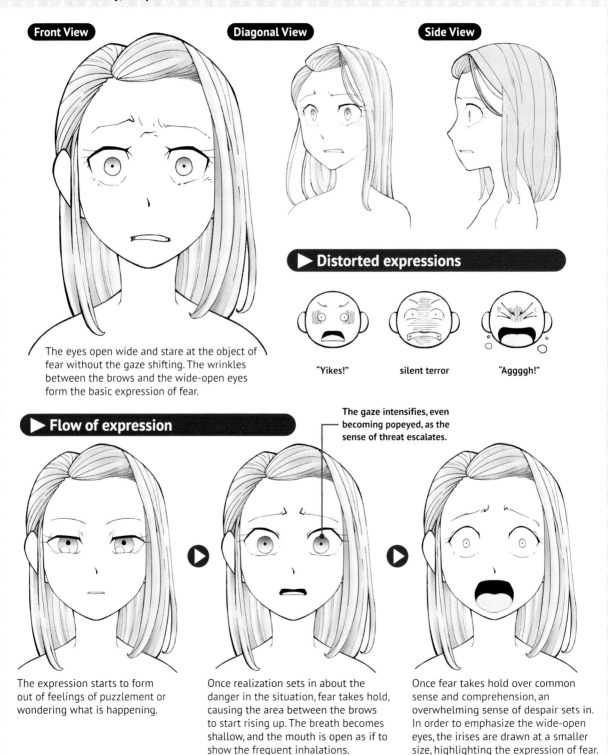

Front View

Diagonal View

Side View

The eyes open wide and stare at the object of fear without the gaze shifting. The wrinkles between the brows and the wide-open eyes form the basic expression of fear.

▶ Distorted expressions

"Yikes!"

silent terror

"Aggggh!"

▶ Flow of expression

The gaze intensifies, even becoming popeyed, as the sense of threat escalates.

The expression starts to form out of feelings of puzzlement or wondering what is happening.

Once realization sets in about the danger in the situation, fear takes hold, causing the area between the brows to start rising up. The breath becomes shallow, and the mouth is open as if to show the frequent inhalations.

Once fear takes hold over common sense and comprehension, an overwhelming sense of despair sets in. In order to emphasize the wide-open eyes, the irises are drawn at a smaller size, highlighting the expression of fear.

▶ Depicting expressions in different situations

A frozen smile

Incomprehensible fear dulls the body's responses, making it difficult to properly express emotion.

The lower eyelids twitch and the cramps in the cheeks may give the impression of a smile.

Feelings of fear and animosity

This expression shows the character fighting back fear and threatening the other party. The brows and mouth stiffen and do not alter much in shape, contrasting with the wide-open eyes.

The face is stiff and inexpressive, but the eyes open wide, searching for information on how to harm the enemy.

Adding sweat symbols is effective.

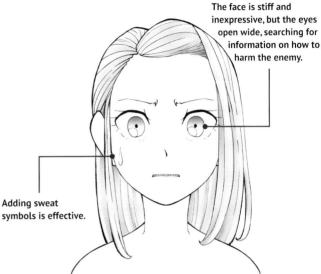

Distorted expression of fear

Vertical blue lines representing turning pale are effective in depicting negative emotions such as feelings of fear. They can also be incorporated into expressions in reaction to something being off color, so simply adding them to a troubled face can be effective.

The vertical lines indicate turning pale.

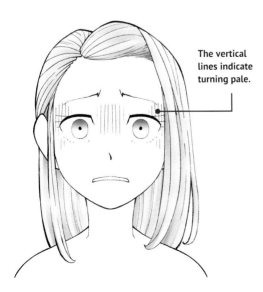

Horror-film style

Opening the mouth wide, dropping the chin and emphasizing that something abnormal is occurring without worrying about how much it alters the character's appearance makes for a horror-film-like expression. Even in reality, people can change radically in appearance during a frightening experience. Negative emotions tend to alter people's looks.

Adding shadows easily recreates a horror-film look.

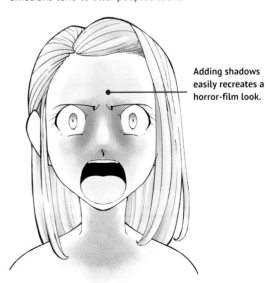

Afraid

The feeling of being afraid occurs just before fear, and the facial expression reflects that mounting apprehension. Of all the expressions of fear, this is the most subdued. It's often used to convey the apprehension that something bad is about to happen.

TIP | Wrinkles gathered between the brows and the searching gaze give the impression of a lack of confidence and of looking for help. Adding downcast movement and sweat symbols is also effective.

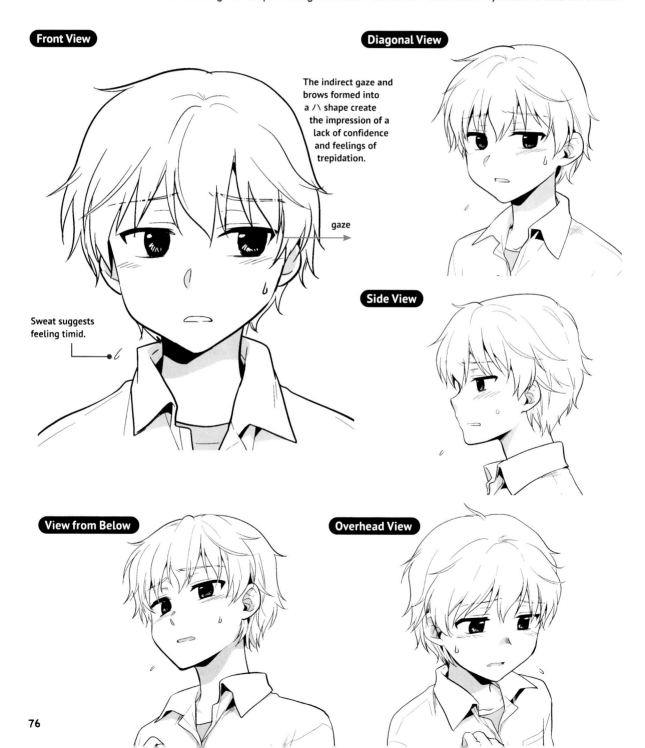

Front View

The indirect gaze and brows formed into a /\ shape create the impression of a lack of confidence and feelings of trepidation.

gaze

Sweat suggests feeling timid.

Diagonal View

Side View

View from Below

Overhead View

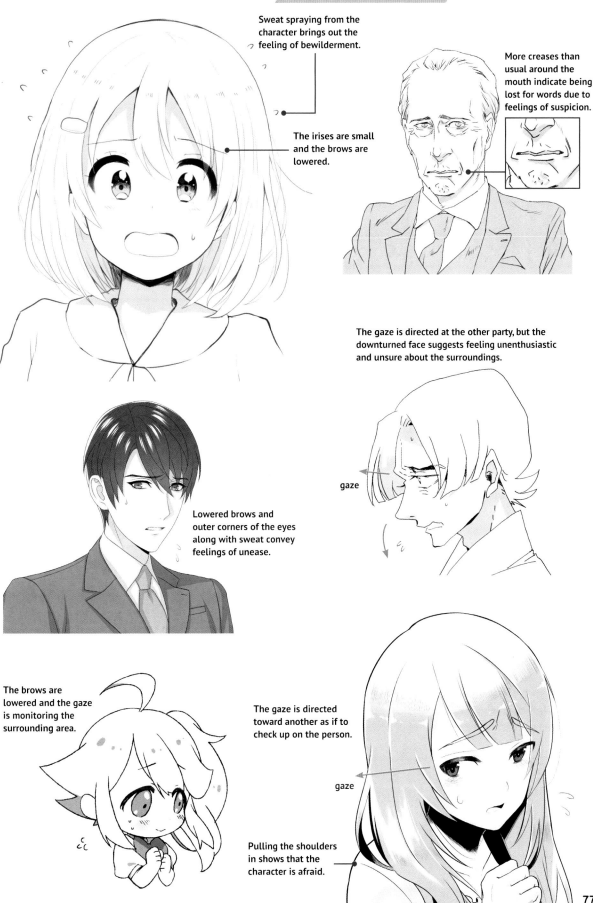

Sweat spraying from the character brings out the feeling of bewilderment.

The irises are small and the brows are lowered.

More creases than usual around the mouth indicate being lost for words due to feelings of suspicion.

The gaze is directed at the other party, but the downturned face suggests feeling unenthusiastic and unsure about the surroundings.

gaze

Lowered brows and outer corners of the eyes along with sweat convey feelings of unease.

The brows are lowered and the gaze is monitoring the surrounding area.

The gaze is directed toward another as if to check up on the person.

gaze

Pulling the shoulders in shows that the character is afraid.

Variations

▶ Feeling fainthearted

This expression shows that there is already something to be afraid of. The unsteady gaze and hunched-over stance express trepidation.

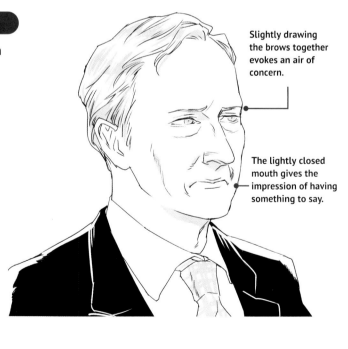

The brows and eyes are directed downward.

Adding drops of cold sweat conveys a state of unease.

Lowered brows, a bent posture and a downturned gaze express a lack of confidence.

▶ Unease

Frightening events or future concerns create an expression of unease. It can also be used when worrying about another person.

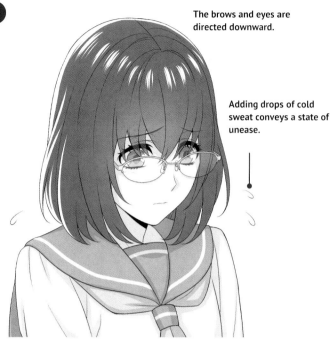

Slightly drawing the brows together evokes an air of concern.

The lightly closed mouth gives the impression of having something to say.

Creating a look of trepidation is effective, as this also expresses unease.

The brows and inner corners of the eyes lower to express unease.

Expression Ideas Scrapbook: Afraid

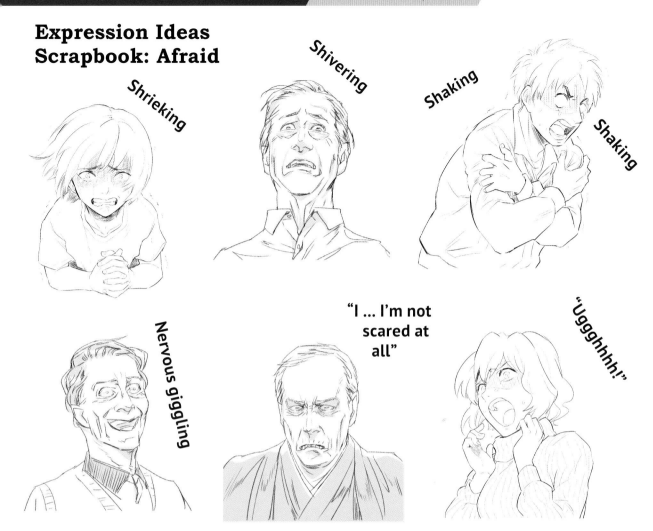

Shrieking

Shivering

Shaking

Shaking

Nervous giggling

"I ... I'm not scared at all"

"Uggghhh!"

DISCUSSION / Changing the Shape of the Brush

The nuance or thickness of the lines used in drawing can alter the feel of the expression. In Clip Studio Paint, the form of lines drawn in the Vector Layer can be readily altered afterward.

Select the lines drawn in the Vector Layer by searching for "Object" in the Tool Palette.

After selecting the lines you want to alter, click on "Brush Shape" in the Tool Properties window and select the brush you want to use from the dropdown menu. You can change the thickness of the line by altering the "Brush Size."

If you cannot find the brush shape you want from the dropdown menu, select the desired subtool and click on the Subtool Details window to get to Brush Shape and then to Preset Records, where it will be displayed.

Felt-Tip Pen Produces an even line for a clean look.

Airbrush Creates an airy, gentle impression.

Panicked

A panicked expression arises from jumbled thoughts when things don't go as planned. Confusion leads to restless movement and awkwardness, and the character starts to break out in a sweat. It can be used in situations where actions can't keep pace with thoughts and things are going round in circles without achieving clarity or resolution.

TIP | This expression is often rendered by clustering wrinkles between the brows and opening the mouth as if to say what's on one's mind. Using a wavy line for the mouth suggests attempting to say something but being unable to get the words out. Dishevelled hair and trickling, flying drops of sweat build further on the sense of emotion.

Front View

Mussing up the hair and adding symbols to depict sweat add to the expression of panic.

Diagonal View

Side View

Drawing spirals inside the irises renders the appearance of thoughts so jumbled that the eyes cannot focus on a single point.

Using a wavy line for the mouth brings out the look of being in a feverish haste.

View from Below

Overhead View

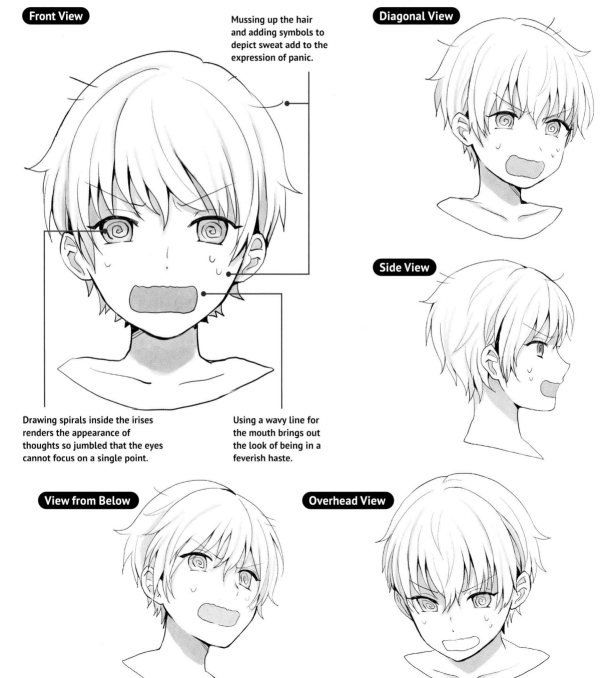

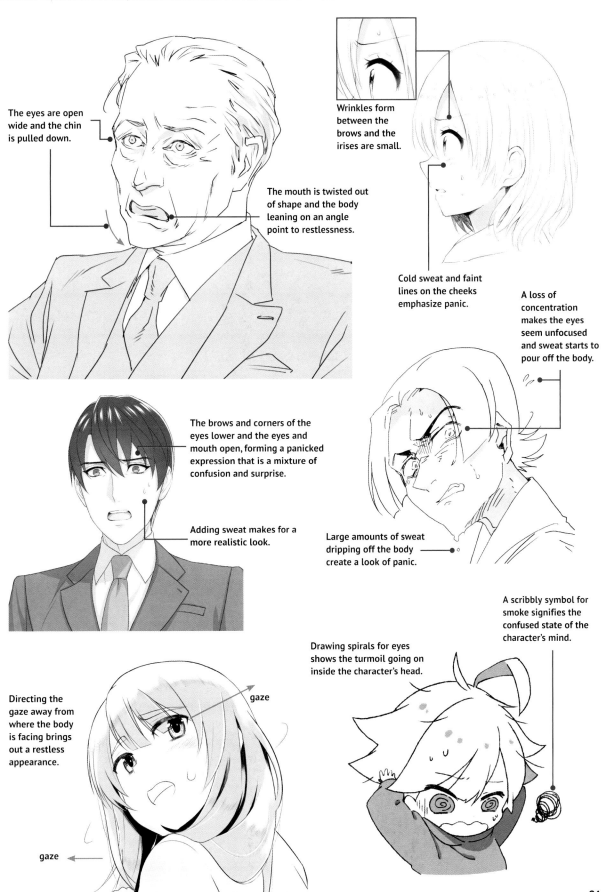

The eyes are open wide and the chin is pulled down.

Wrinkles form between the brows and the irises are small.

The mouth is twisted out of shape and the body leaning on an angle point to restlessness.

Cold sweat and faint lines on the cheeks emphasize panic.

A loss of concentration makes the eyes seem unfocused and sweat starts to pour off the body.

The brows and corners of the eyes lower and the eyes and mouth open, forming a panicked expression that is a mixture of confusion and surprise.

Adding sweat makes for a more realistic look.

Large amounts of sweat dripping off the body create a look of panic.

A scribbly symbol for smoke signifies the confused state of the character's mind.

Drawing spirals for eyes shows the turmoil going on inside the character's head.

Directing the gaze away from where the body is facing brings out a restless appearance.

gaze

gaze

Terror

The expression of terror results in a stiff, cramped-looking face. It's a good expression to have in your facial toolkit, especially if your character has a brush with the supernatural or, even worse, is facing imminent death.

TIP | Tension forms in the brows and the eyes open wide to prepare for danger in the basic expression of terror. Depicting strain in the mouth and cheeks as well makes it even easier to communicate the air of terror.

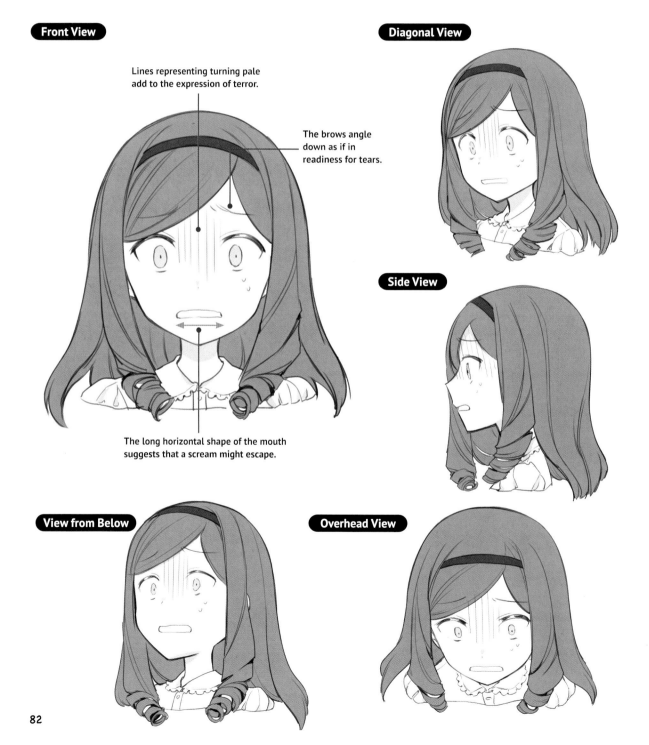

Front View

Lines representing turning pale add to the expression of terror.

The brows angle down as if in readiness for tears.

The long horizontal shape of the mouth suggests that a scream might escape.

Diagonal View

Side View

View from Below

Overhead View

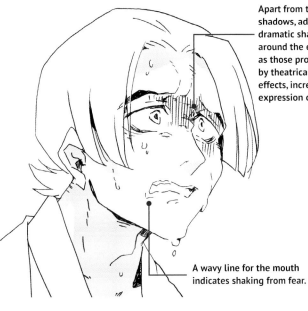

Apart from the usual shadows, adding dramatic shadows around the eyes, such as those produced by theatrical lighting effects, increases the expression of terror.

A wavy line for the mouth indicates shaking from fear.

Wrinkles form between the brows, and the brows and eyes draw closer together.

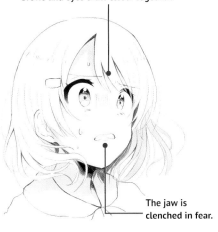

The jaw is clenched in fear.

Adding wrinkles that do not normally stand out around the neck heightens the sense of anxiety.

The irises and highlights in the eyes are small, but the eyes are open wide to express fright.

Horizontal lines of shadow under the eyes, on the bridge of the nose and on the cheeks bring out the air of fear.

Wrinkles between the brows and a tightly drawn mouth result in a grim expression.

The character is unable to avert her gaze and continues to look, despite her fear.

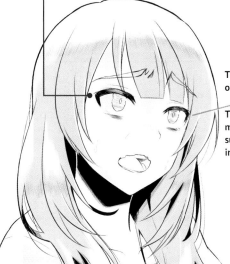

The gaze is directed at the object of fear.

The wobbly line for the mouth and dotted lines surrounding the body indicate trembling.

Bold shadows around the eyes, vertical lines representing turning pale and horizontal lines for shadow between the eyes reinforce the feeling of terror.

Pulling back shows an attempt to distance oneself from the source of terror.

Variations

▶ Screaming in terror

A scream from terror is formed by combining expressions of surprise and fear. The mouth opens wide to release the loud scream.

The mouth is open wide to scream, lifting the cheeks.

The irises are small.

Vertical lines express movement in the body.

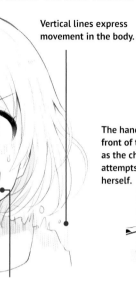

The hand moves in front of the body as the character attempts to defend herself.

The mouth is open wide and the body trembles to express the sense of terror.

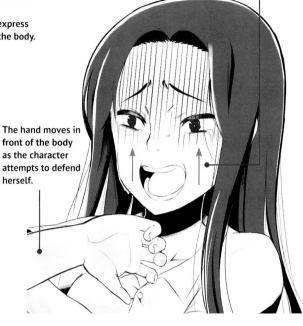

▶ Losing oneself in terror

This expression is used when there are no means of running away from the terror or when stress builds to such a level that thoughts become scrambled in an attempt at escaping from it. The gaze is unsteady and the face takes on a haggard appearance, but extraneous emotions or laughter may also emerge. The brows lift and the eyes open as if the facial muscles are being pulled out and away from the face. Increasing lines around the eyes to form hollows heightens the haggard, crazed look.

The wrinkles and hollows at the corners of the mouth are emphasized to form a look of frozen laughter.

Small irises and bloodshot effects in the eyes suggest not being in one's right mind.

Creating a double line around the pupils shows that the eyes are not focusing properly.

Stubble conveys the passage of time.

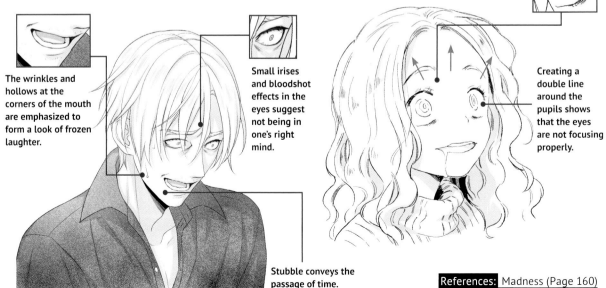

References: Madness (Page 160)

Using Body Parts to Express Emotions

The expression of emotion is not limited to the face. Using the hands, shoulders and other body parts allows for a stronger expression of emotion. The hair can also be used to portray emotion. In reality, hair's movement is not determined by emotion, but try making use of it as a device unique to illustration and visual storytelling.

▶ Method of expression

Let's look at the example of "surprise." The facial expression may be the same, but incorporating hair, hands and shoulders enhances the emotion and adds nuances.

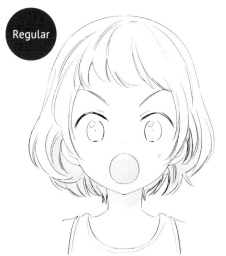

The brows lift and the eyes open wide. Together with the exaggerated open mouth, this creates an expression that quite adequately conveys surprise.

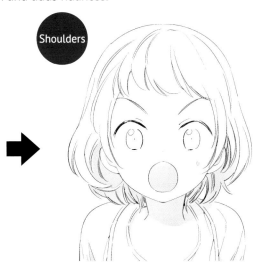

Raising the shoulders gives the impression of leaning slightly forward.

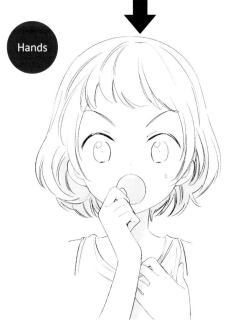

Bringing the hand up to the mouth increases the degree of surprise. As it gives the slight impression of elegance, it can be used to convey a girl's personality.

Even if the facial expression remains the same, adding movement to the hair expresses surprise of such a magnitude that it jolts the body. This allows for a stronger expression of surprise.

▶ Using the shoulders

Emotion can be emphasized by moving the shoulders up or down, making them stiffen and so on. Here are some examples of how to incorporate shoulders into expressions.

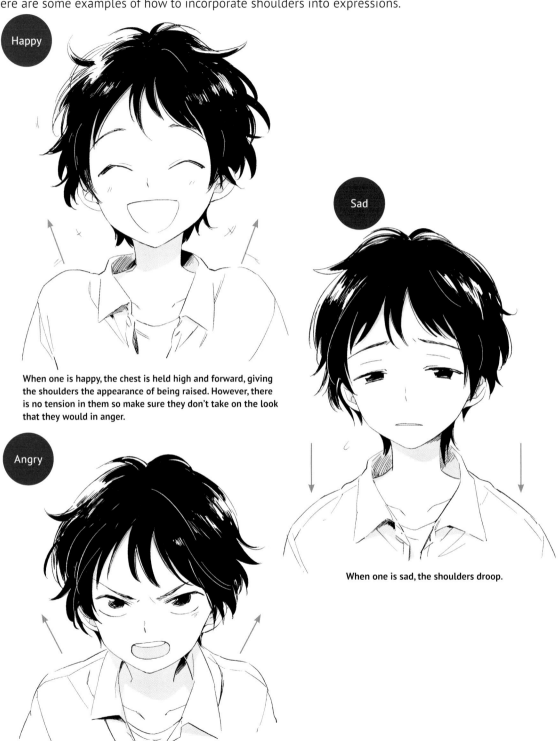

Happy

When one is happy, the chest is held high and forward, giving the shoulders the appearance of being raised. However, there is no tension in them so make sure they don't take on the look that they would in anger.

Sad

When one is sad, the shoulders droop.

Angry

When angry, the entire body stiffens and strain in the shoulders causes them to appear rigid. They take on a square look.

▶ Hand gestures

The entire body is used to convey emotion, not just the face. Some characters "talk with their hands," using gestures to eloquently express their thoughts and feelings.

Happy

Hearing good news or a cause for celebration.

Sad

The character is unable to speak, trying to hold in the hurt.

Contem-plative

A finger held to the mouth adds to the sense of distraction or self-absorption.

Irritated

This captures the difficulty of patiently enduring some form of frustration.

▶ Incorporating the hair

Here, we look at some examples of ways to incorporate hair into expressions. In reality, hair does not move because of emotion, but similarly to the way some animals' tails and ears droop when dejected, hair can be similarly depicted.

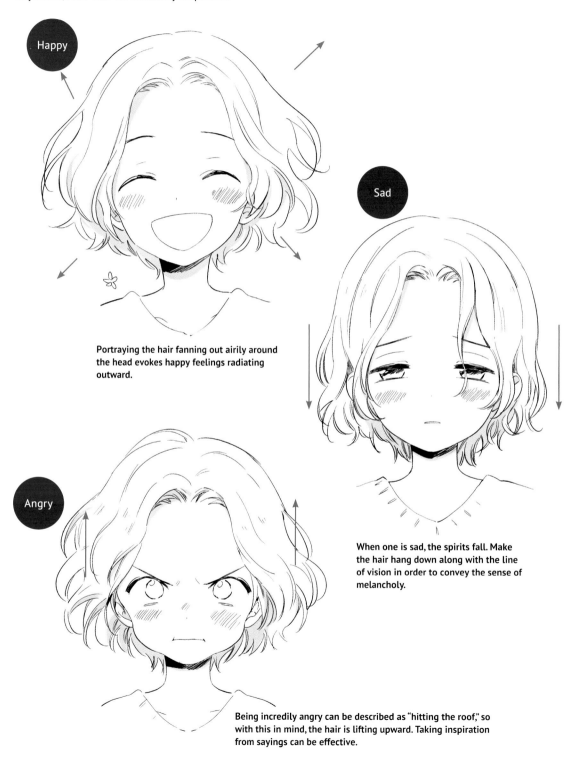

Happy

Portraying the hair fanning out airily around the head evokes happy feelings radiating outward.

Sad

When one is sad, the spirits fall. Make the hair hang down along with the line of vision in order to convey the sense of melancholy.

Angry

Being incredibly angry can be described as "hitting the roof," so with this in mind, the hair is lifting upward. Taking inspiration from sayings can be effective.

Facial Expressions That Add Color and Detail

ROMANCE

Bashfulness

Excitement

Jealousy

Yearning

FOOD AND DRINK

Savoring the Taste

Eating Something That Tastes Bad

Drunk

Hunger

RESTING

Fatigue

Asleep

Just Woken Up

Bashfulness

Bashfulness is expressed by the unintentional reddening of the cheeks that embarrassment causes. It's important to differentiate the source of the mortification when drawing the facial expression—is it because the characters are in the presence of someone they have a crush on, or are they embarrassed due to a personal failure?

TIP | Keep the expression that follows embarrassment in mind as you draw, whether that's laughing, getting angry or sulking. Blood can also rush to the cheeks and turn the face red from embarrassment when being praised in front of other people or being scolded after a mistake. The level of shyness can be reflected by adjusting the amount of redness.

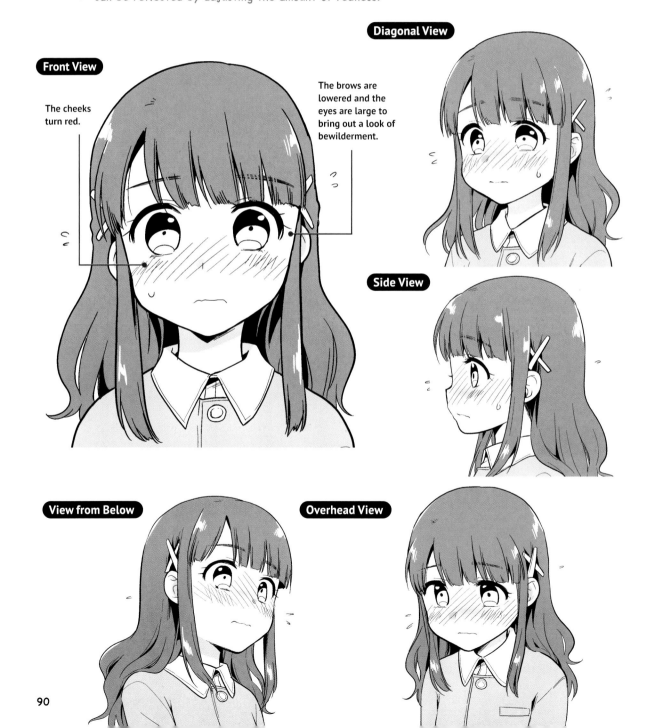

Diagonal View

Front View

The cheeks turn red.

The brows are lowered and the eyes are large to bring out a look of bewilderment.

Side View

View from Below

Overhead View

Shifting the gaze away from the object of affection and adding blush brings out a sense of innocence.

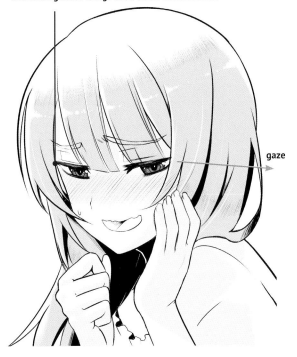

gaze

Making the eyes look moist creates the expression of happy embarrassment. The gaze is averted from the other person's face out of embarrassment.

Adding redness to the cheeks and ears of a softly smiling, downturned face suggests a bashful, hesitant air.

gaze

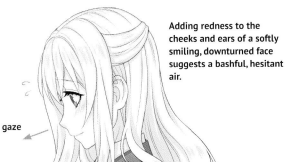

Lowered brows combined with flushed cheeks and a smile suggests being troubled by feeling bashful but grinning regardless.

Smiling despite the troubled look created by lowered brows makes for an incongruent expression.

Lifting the brows and forming the lips into a pout are an attempt to conceal one's sulking.

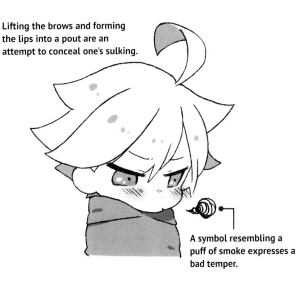

A symbol resembling a puff of smoke expresses a bad temper.

Variations

▶ Wanting to run away out of embarrassment

This expression portrays trying to bear embarrassment. There are many situations when a high level of embarrassment creates the urge to run away.

The rounded, downturned shoulders convey trying to bear shame and humiliation.

The irises are small and the mouth is open as if to yell, with a flush all over the face.

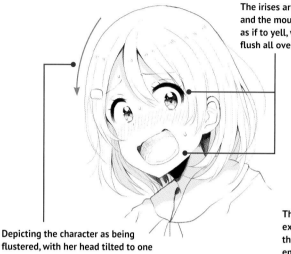
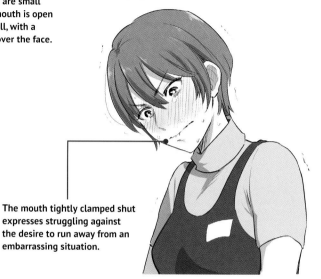

Depicting the character as being flustered, with her head tilted to one side and avoiding the other person's gaze, is also effective.

The mouth tightly clamped shut expresses struggling against the desire to run away from an embarrassing situation.

▶ Feeling abashed after being praised

This expression conveys feeling bashful after being praised, but thinking that the attention or approbation was warranted.

Redness around the eyes, mouth and cheeks pair well with a subtle smile.

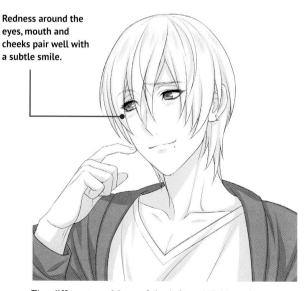

The different positions of the left and right eyebrows and the gesture of the finger touching the face build the expression of bashful satisfaction.

▶ Getting angry from feeling bashful

This expression captures the progression of bashfulness to anger. It expresses concealing embarrassment.

Flushed cheeks and sweat symbols are added to the angry expression of raised brows and a clenched jaw to create the appearance of concealing embarrassment.

▶ Hesitating

This expression captures the feeling of being embarrassed and wanting to say something, but not being able to get the words out.

Slightly different in appearance from bashfulness, this expression shows the character internalizing feelings of expectation and happiness.

The brows and outer corners of the eyes create a gentle impression.

Flushed cheeks and lines to indicate a swaying body express a hesitant air.

Lowered brows and eyes express embarrassment. Adding blush conveys fidgeting from embarrassment.

The brows form a /\ shape and the mouth is closed. It's as if a flush has been added to a troubled face.

▶ Being overexcited

Instead of becoming bashful after being praised, this expression shows overexcitement. There are various ways to depict it, such as exhibiting pride, agreeing with praise or aggressively demanding more praise.

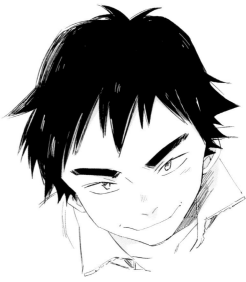

Exaggerating parts of the face make for a comical expression of the feeling.

The brows and corners of the mouth lift to suggest an aggressive, hot-blooded character. It's an expression overflowing with self-confidence.

Bringing out the elegance in the fingertips as they flip back the hair conveys the sense of pretension and makes the character seem odious.

Excitement

In this case, excitement refers to the feeling of nervous expectation that romance brings. It can also be described as the awakening of romantic feelings in the early stages of love. The expression is often used in romantic scenarios to depict the moment of falling in love or to show the heightening of tenderness and regard.

TIP | Plenty of highlights in the eyes add shine, while the raised brows convey excitement and a sense of expectation in this expression. Excitement is usually a sudden emotion, so it is common to depict it as following surprise. Adding flushed cheeks and symbolic expressions of shine is effective in achieving this expression.

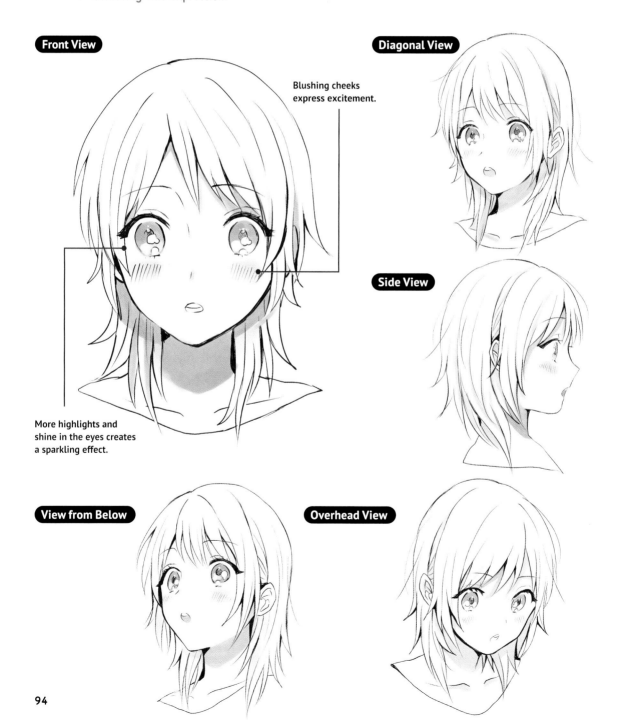

Front View

Blushing cheeks express excitement.

More highlights and shine in the eyes creates a sparkling effect.

Diagonal View

Side View

View from Below

Overhead View

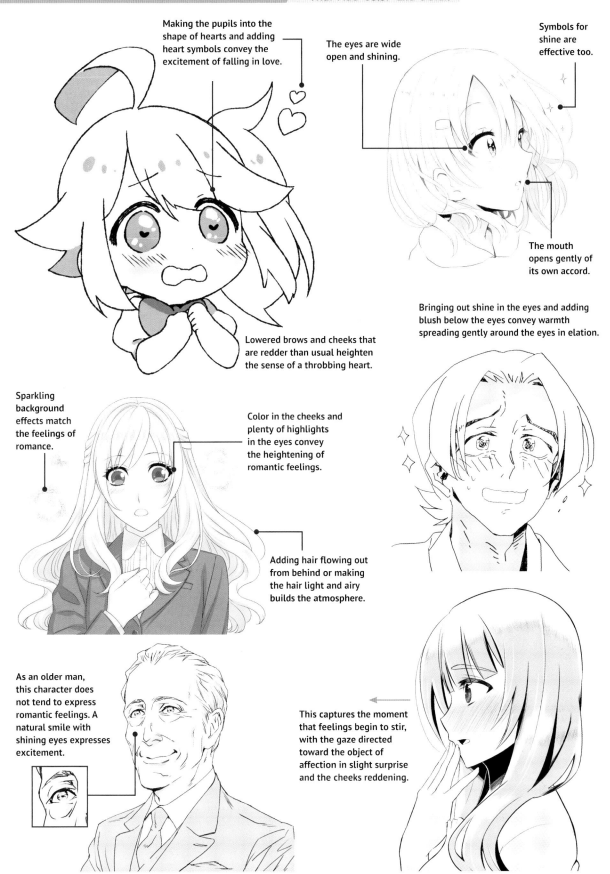

Making the pupils into the shape of hearts and adding heart symbols convey the excitement of falling in love.

The eyes are wide open and shining.

Symbols for shine are effective too.

The mouth opens gently of its own accord.

Lowered brows and cheeks that are redder than usual heighten the sense of a throbbing heart.

Bringing out shine in the eyes and adding blush below the eyes convey warmth spreading gently around the eyes in elation.

Sparkling background effects match the feelings of romance.

Color in the cheeks and plenty of highlights in the eyes convey the heightening of romantic feelings.

Adding hair flowing out from behind or making the hair light and airy builds the atmosphere.

As an older man, this character does not tend to express romantic feelings. A natural smile with shining eyes expresses excitement.

This captures the moment that feelings begin to stir, with the gaze directed toward the object of affection in slight surprise and the cheeks reddening.

Jealousy

Jealousy associated with romance is easily linked with anger and frustration and can be used to pique interest in the behavior and reactions that will follow.

TIP | If it's romantic jealousy, the expression differs depending on the object, ranging from that of a bad mood to exposing animosity and becoming enraged. The expression can be more than adequately communicated even if only the eyes are used to create a glare of hatred.

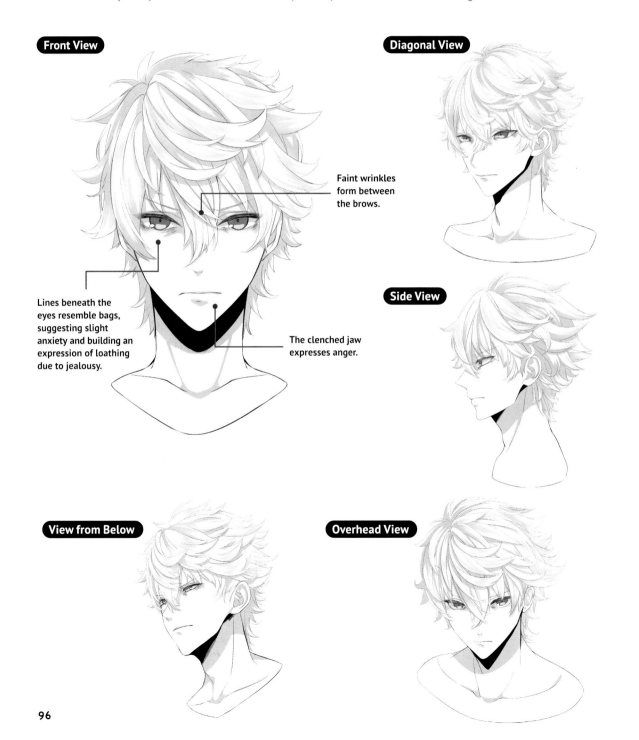

Front View

Diagonal View

Side View

View from Below

Overhead View

Faint wrinkles form between the brows.

Lines beneath the eyes resemble bags, suggesting slight anxiety and building an expression of loathing due to jealousy.

The clenched jaw expresses anger.

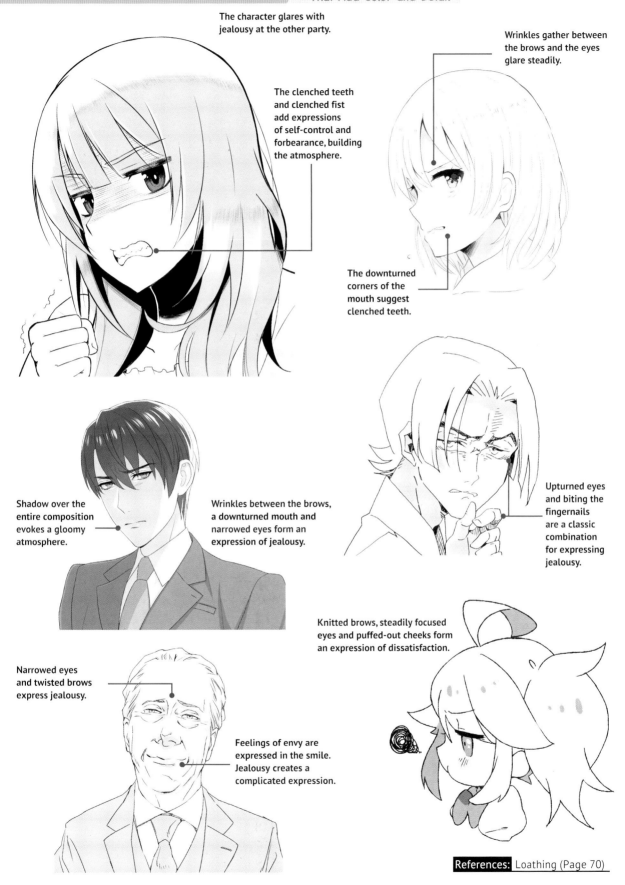

The character glares with jealousy at the other party.

The clenched teeth and clenched fist add expressions of self-control and forbearance, building the atmosphere.

Wrinkles gather between the brows and the eyes glare steadily.

The downturned corners of the mouth suggest clenched teeth.

Shadow over the entire composition evokes a gloomy atmosphere.

Wrinkles between the brows, a downturned mouth and narrowed eyes form an expression of jealousy.

Upturned eyes and biting the fingernails are a classic combination for expressing jealousy.

Knitted brows, steadily focused eyes and puffed-out cheeks form an expression of dissatisfaction.

Narrowed eyes and twisted brows express jealousy.

Feelings of envy are expressed in the smile. Jealousy creates a complicated expression.

References: Loathing (Page 70)

Yearning

When related to romance, yearning encompasses the desire to be adored as well as the frustration that arises when things don't go as expected. It's an internalized sadness, different from feelings of loneliness, making it a somewhat complicated expression.

TIP Yearning is an emotion that accompanies the heartache of loneliness and sadness, so its basic expression involves lowering the brows to create a slightly lonely look. Incorporating symbols such as drops of sweat and blushing communicates that the character is thinking of the person she likes.

Front View

The eyes appear moist and the cheeks are flushed.

Diagonal View

The downturned brows and corners of the mouth evoke loneliness and sadness.

Side View

View from Below

Overhead View

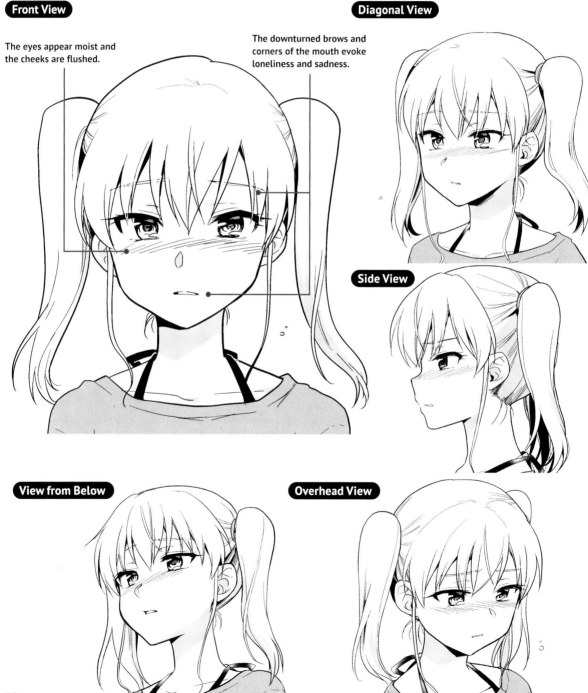

The head is bent but the gaze directed toward another shows that a cautious appeal is being made with the eyes.

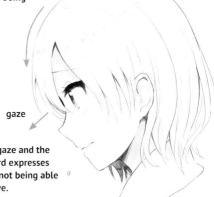

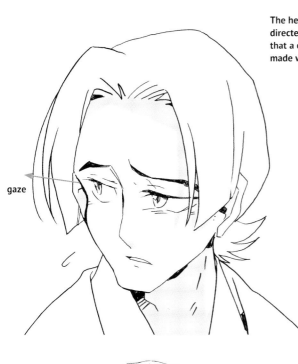

gaze

gaze

Directing the gaze and the head downward expresses the feeling of not being able to make a move.

The indirect gaze creates an expression of being lost in thought, emphasizing the feeling of yearning.

The fractionally lowered brows and the downcast eyes bring out a look of quiet yearning.

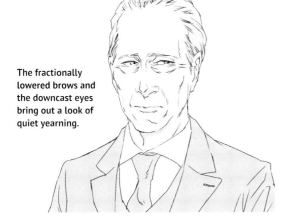

The brows and outer corners of the eyes are turned down. Slightly narrowing the eyes and adding plenty of highlights makes them look moist.

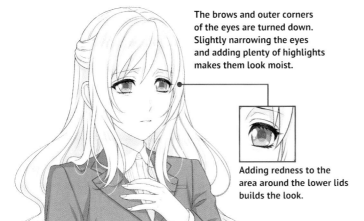

Adding redness to the area around the lower lids builds the look.

gaze

The gaze is directed downward, with the closed mouth indicating the character is trying to bear the feeling of yearning.

Savoring the Taste

The expression of delight that accompanies a delicious meal can also be used in other scenarios where your character is savoring the situation.

TIP The expression of enjoying food forms while eating. It is easier to convey that it is an expression arising during a meal if the character is shown chewing on something or having just finished swallowing food.

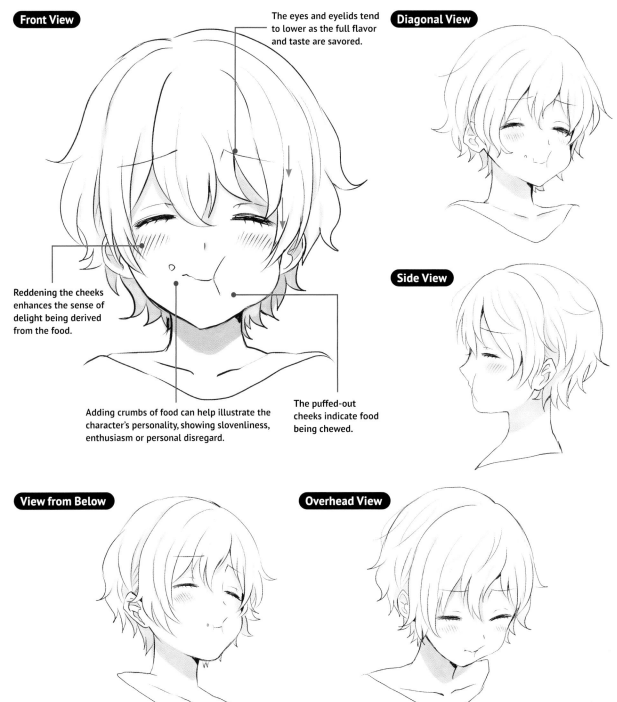

Front View

The eyes and eyelids tend to lower as the full flavor and taste are savored.

Reddening the cheeks enhances the sense of delight being derived from the food.

Adding crumbs of food can help illustrate the character's personality, showing slovenliness, enthusiasm or personal disregard.

The puffed-out cheeks indicate food being chewed.

Diagonal View

Side View

View from Below

Overhead View

Raising the brows and widening the eyes creates the expression of surprise after eating.

The soft smile, full mouth and reddened cheeks create a look of happiness from eating delicious food.

Heart or flower symbols add to the air of happiness.

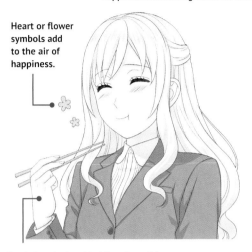

The protruding tongue adds to the impression of a hearty eater who is trying to lick off any tasty morsels remaining around the mouth.

Depicting the hand holding chopsticks or other eating utensils makes it easy to communicate that it is a mealtime scene.

When the brows are raised, wrinkles form around them.

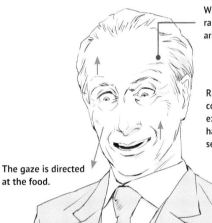

Raising the brows and corners of the mouth expresses the slight happiness felt when seeing something tasty.

The gaze is directed at the food.

Slick shine on the lips creates the appearance of eating something tasty.

Making the gaze indirect brings out the sense of savoring the food.

Puffing out the cheeks and adding a red tinge creates the look of enjoying the food.

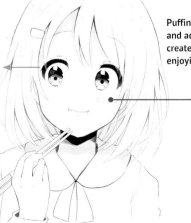

The lowered brows and outer corners of the eyes create a look of ecstasy.

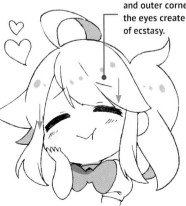

Variations

▶ Enraptured

Eating something delicious prompts an unintentional expression of rapture.
Create this atmosphere by aiming for an ecstatic look.

The character appears to be immersed in the taste and flavors. The brows form a /\ shape and the eyes are closed as if reflecting on the taste.

A smiling face forms the base for this expression, with slight strain in the brows suggesting enjoyment of the food.

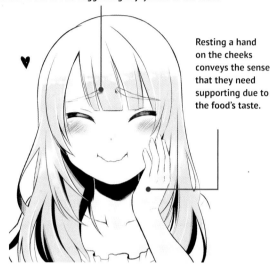

Resting a hand on the cheeks conveys the sense that they need supporting due to the food's taste.

▶ Blowing on food to cool it down

This expression shows blowing on hot food to cool it down before eating it.

The lips purse to direct the air out. You can use a symbol to express the breath.

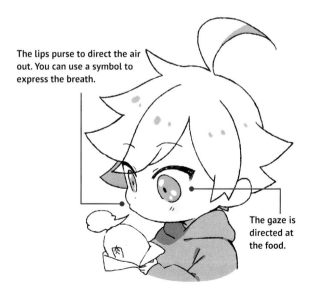

The gaze is directed at the food.

▶ Brain freeze

Eating too much shaved ice or other cold food at once causes brain freeze!

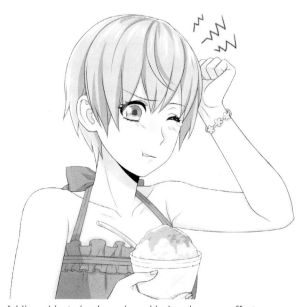

Adding objects (such as shaved ice) and manga effects to moist eyes, tears and redness in the face creates the expression of trying to bear the coldness.

▶ Wolfing food

Being so hungry that the priority is just to get food in one's mouth results in this manner of eating. Rather than savoring the food, the goal is simply to gulp it down.

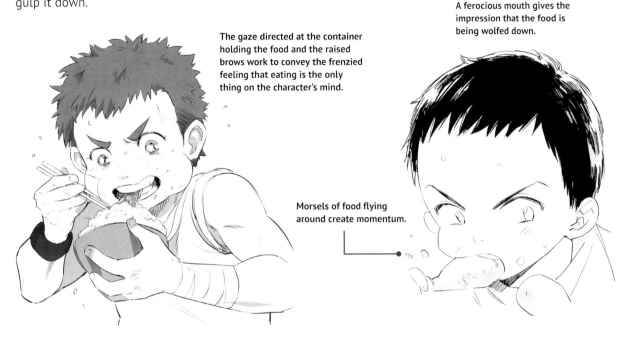

The gaze directed at the container holding the food and the raised brows work to convey the frenzied feeling that eating is the only thing on the character's mind.

A ferocious mouth gives the impression that the food is being wolfed down.

Morsels of food flying around create momentum.

▶ Overexaggerating the tastiness

Typically seen in manga and anime about gourmands, this expression conveys overly exaggerated happiness in response to something delicious. Eating tasty food can result in all kinds of expressions, so have a go at drawing different types.

When relishing food, the brain is focused on the taste sensations to the exclusion of other irrelevant information. Shifting the gaze slightly away from the food evokes the sense of appreciating food even while wolfing it down.

Wide-open eyes and raised brows convey surprise.

A wide-open mouth with the corners lifted gives the appearance of being impressed.

Eating Something That Tastes Bad

Yuk! Swallow that mouthful or spit it out? Your character's face tells the story.

TIP Furrowed brows and a look of dislike are the basics for this expression. If the food is not so bad that it can't be eaten, but anything worse would not be tolerated, an expression resembling forbearance works. If it is something that instinct warns against consuming, the bad taste can be expressed by showing the character spitting the food out.

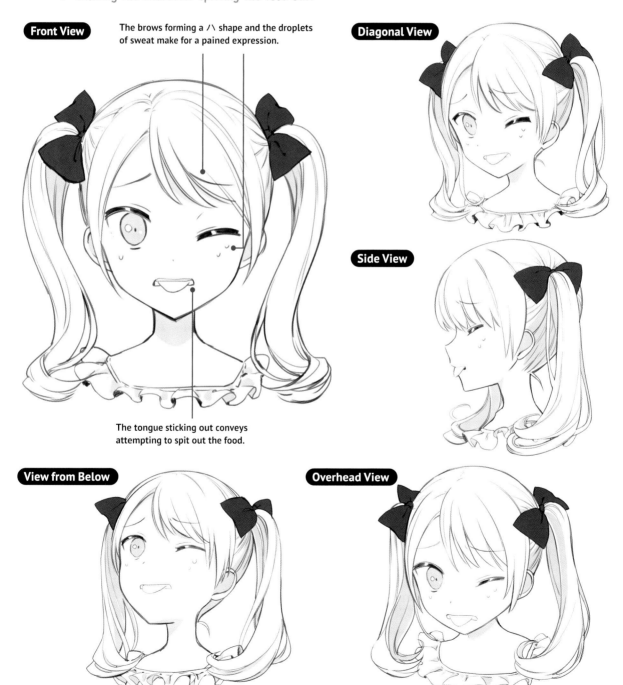

Front View

The brows forming a /\ shape and the droplets of sweat make for a pained expression.

The tongue sticking out conveys attempting to spit out the food.

Diagonal View

Side View

View from Below

Overhead View

The hand covers the mouth to prevent the food from being spat out.

Beads of cold sweat are also effective.

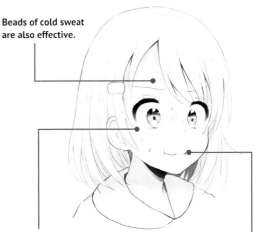

Vertical lines representing turning pale are added around the eyes. The pupils widen and the brows and mouth twist out of shape to form an expression of disgust.

Slightly puffing out the area around the mouth conveys finding it difficult to swallow because the food tastes so bad.

The corners of the mouth turn down and the tongue sticks out to express a taste so bad as to nearly cause vomiting.

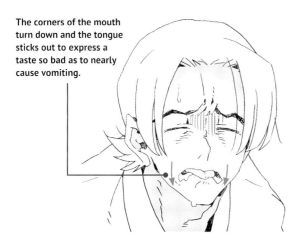

Not wanting to taste the food leads to this spitting expression. Strain in the brows and eyes creates the look of experiencing something unpleasant.

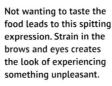

The bad taste causes the face to distort. Mobilizing wrinkles over the whole face indicates just how bad the food tastes.

A multitude of wrinkles above and below the mouth creates an expression of distaste.

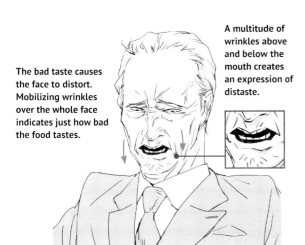

Distorting the outline of the eyes creates the look of moisture forming.

This shows food being held in the mouth as the character is unable to swallow it.

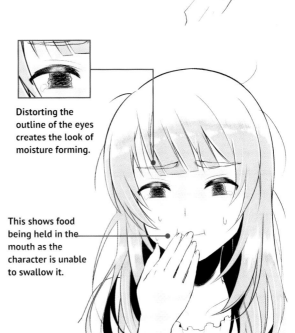

Variations

▶ Spitting food out

The expression of food being so revolting that it is spat out is often used as a comic element. It can be used not only to show food tasting bad, but also in scenarios where food is past its expiration date or improbable ingredients have been used.

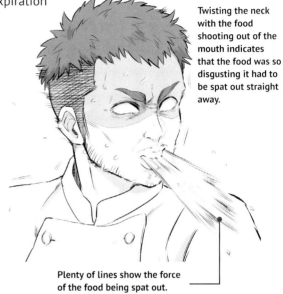

Twisting the neck with the food shooting out of the mouth indicates that the food was so disgusting it had to be spat out straight away.

Plenty of lines show the force of the food being spat out.

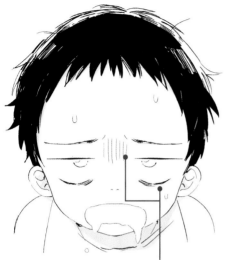

Apart from the lines between the brows that indicate losing color, the lines below the eyes also add an air of being fed up.

▶ Eating despite not wanting to

The scenario of eating unappetizing food because a loved one has made it occurs frequently. Breaking out in a cold sweat while eating expresses struggling to bear the situation.

Depicting the face as turning green (through shadow, turning pale, sweating) builds the atmosphere.

The eyes are squeezed tightly shut and the mouth is downturned to express the strain involved in eating unwillingly.

Shadows and lines in the face representing a loss of color depict a sense of despair.

The breath is irregular, as if trying to delay putting the food in the mouth.

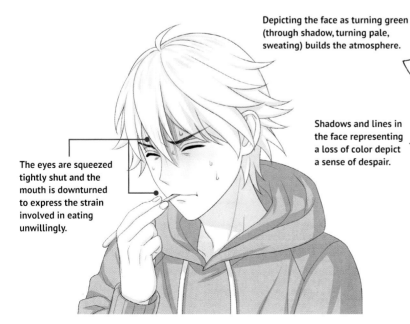

DISCUSSION / Expressions for Different Flavors

Apart from the extremes of food tasting either delicious or disgusting, it can also be sweet, spicy, sour, salty or bitter. The facial expression differs depending on the flavor. Let's take a look at a few examples.

Spicy

When food is so spicy as to be inedible, the tongue becomes numb and breathing becomes ragged, expressed via the widened nostrils. Eating spicy food can bring on sweat, so adding drops of sweat is effective.

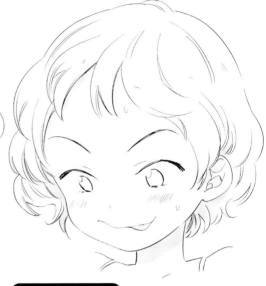

Spicy yet delicious

When the level of heat is just right, the brows lift and a happy expression forms, conveying a sense of anticipation about the next mouthful.

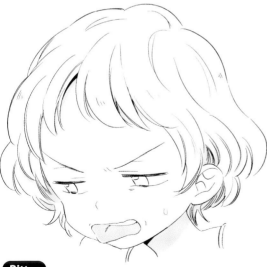

Bitter

Exhaling as much as possible to expel the bitterness and stiffening the area around the eyes evoke a sense of revulsion that expresses the reaction to eating something bitter.

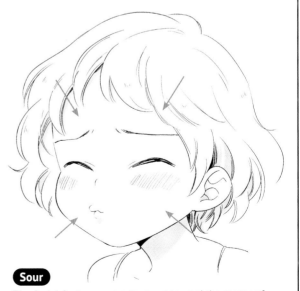

Sour

The facial features seem to move toward the center of the face and shrivel up from the sourness.

Drunk

Flushed cheeks are the most noticeable part of a drunken person's face, but don't forget about the emotions that go with it. Is your character a happy drunk or prone to aggression and anger?

TIP | A flushed face forms the foundation for this expression. The degree of drunkenness can be expressed through unfocused eyes, drooping eyelids and slackened or uncoordinated muscles around the mouth. Round, fuzzy symbols around the head make it easy to convey an air of drunkenness.

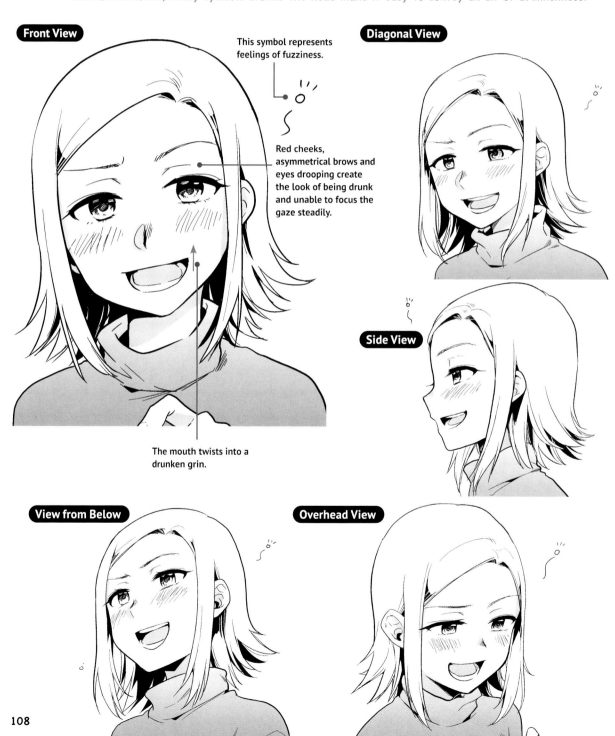

Front View

This symbol represents feelings of fuzziness.

Red cheeks, asymmetrical brows and eyes drooping create the look of being drunk and unable to focus the gaze steadily.

The mouth twists into a drunken grin.

Diagonal View

Side View

View from Below

Overhead View

The wrinkles between the brows and the glare in the eyes indicate that this character is an annoying drunk.

The eyes are half-open in a slack manner and the cheeks are flushed to convey a tipsy look.

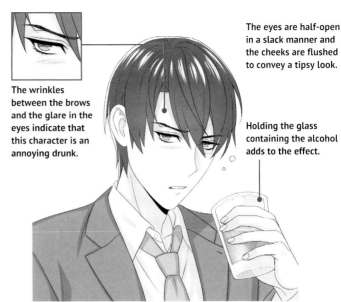

Holding the glass containing the alcohol adds to the effect.

The cheeks flushed from the rush of blood to the face and the drooping eyes make for a facial expression different from usual.

The drowsy eyes and burning cheeks give the impression of losing oneself to the last mouthful of alcohol.

The eyes that are unable to focus and the lengthened upper lip and slack jaw point to the character being blind drunk.

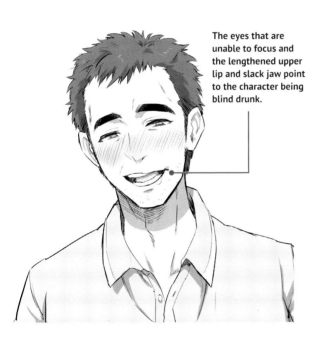

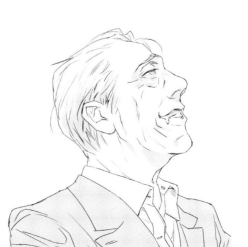

More wrinkles than usual, a smiling mouth from which drool is escaping and hollow eyes express being blind drunk.

Variations

▶ A laughing drunk

This expression is used for a character who gets happy and laughs for no reason when drunk. The drunk appearance can be created by simply adding a flush of red to a laughing face.

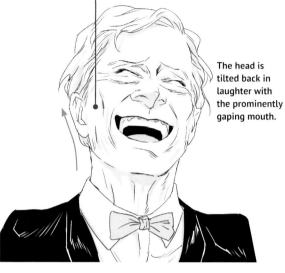

The mouth open wide with laughter creates a lot of wrinkles.

The head is tilted back in laughter with the prominently gaping mouth.

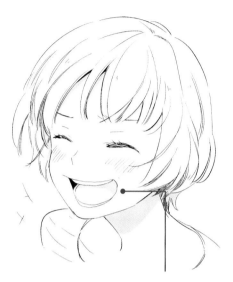

Restraint vanishes and the character laughs with her mouth wide open. It's O.K. to exaggerate this expression a little!

▶ Crying drunk

This expression is used for a character who suddenly gets sad and cries when drunk. In this instance also, flushed cheeks are key.

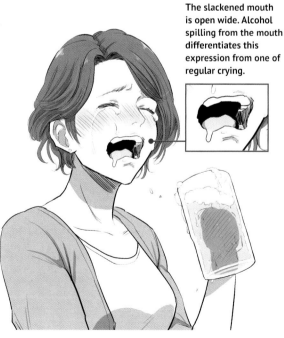

The slackened mouth is open wide. Alcohol spilling from the mouth differentiates this expression from one of regular crying.

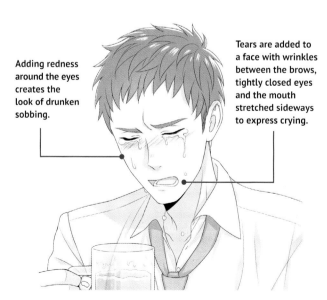

Adding redness around the eyes creates the look of drunken sobbing.

Tears are added to a face with wrinkles between the brows, tightly closed eyes and the mouth stretched sideways to express crying.

▶ Acting drunk

This expression shows that despite the cheeks being flushed from alcohol, the character is still in command of her senses. An unwavering stare at the other person and a slightly sly air build the atmosphere.

The slightly coquettish lean of the body and the flushed look on the face combined with the steady gaze convey that the character is only pretending to be drunk.

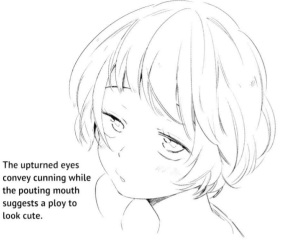

The upturned eyes convey cunning while the pouting mouth suggests a ploy to look cute.

DISCUSSION / Expressing Feelings of Nausea

The expression of feeling nauseated can be used to depict illness or loathing as well as to portray having had too much to drink. The expression changes depending on the progression of the nauseated feelings.

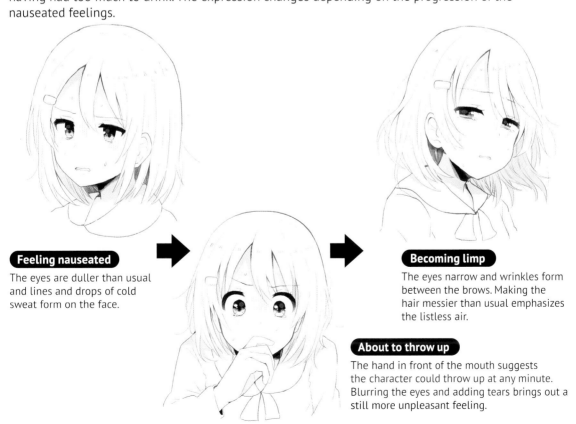

Feeling nauseated

The eyes are duller than usual and lines and drops of cold sweat form on the face.

Becoming limp

The eyes narrow and wrinkles form between the brows. Making the hair messier than usual emphasizes the listless air.

About to throw up

The hand in front of the mouth suggests the character could throw up at any minute. Blurring the eyes and adding tears brings out a still more unpleasant feeling.

Hunger

Remember that there are degrees of hunger. If someone is a little bit hungry, the expression resembles that of a troubled face, but as hunger progresses, energy levels drop and the expression becomes closer to one of fatigue.

TIP | Lowered brows and an expression similar to that of being troubled are commonly used to express regular hunger. When physical strength is dramatically weakened due to hunger, there is no energy to even create a facial expression, and the face takes on a tired look. Symbols such as saliva or those conveying trembling are effective for differentiating types of hunger.

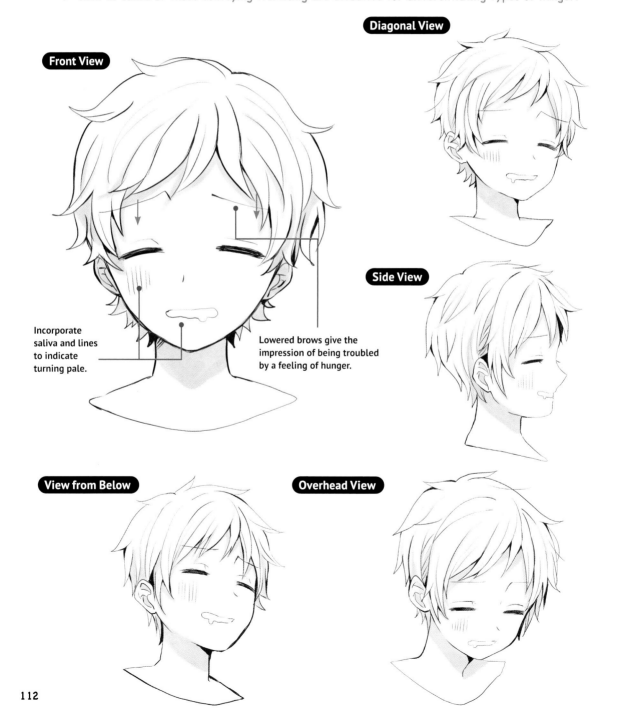

Diagonal View

Front View

Side View

Incorporate saliva and lines to indicate turning pale.

Lowered brows give the impression of being troubled by a feeling of hunger.

View from Below

Overhead View

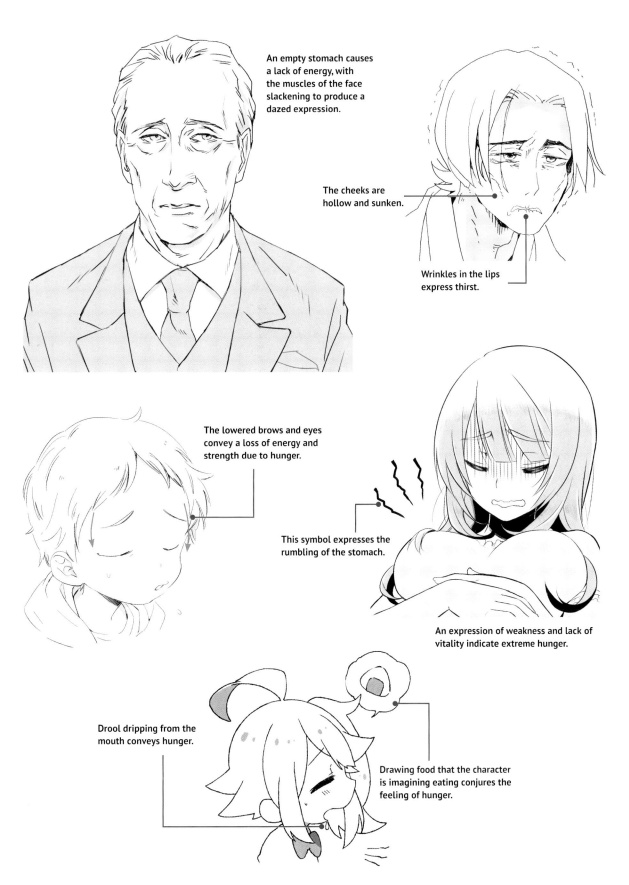

An empty stomach causes a lack of energy, with the muscles of the face slackening to produce a dazed expression.

The cheeks are hollow and sunken.

Wrinkles in the lips express thirst.

The lowered brows and eyes convey a loss of energy and strength due to hunger.

This symbol expresses the rumbling of the stomach.

An expression of weakness and lack of vitality indicate extreme hunger.

Drool dripping from the mouth conveys hunger.

Drawing food that the character is imagining eating conjures the feeling of hunger.

Variations

▶ Feeling snacky or peckish

This expression is used to show that the character isn't exactly starving, but wouldn't mind noshing on something.

Keeping the expression relatively close to the regular expression shows that the feeling of hunger is not severe.

The gaze is directed at the viewer as if appealing to the viewers.

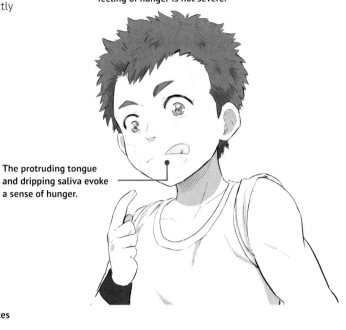

The protruding tongue and dripping saliva evoke a sense of hunger.

The pouting mouth creates a troubled expression.

▶ Starving

This expression depicts not having eaten for a long time so as to be past the point of hunger. The cheeks are sunken and the expression is dull and lifeless.

The brows in a /\ shape, droopy eyelids and slight pout express dissatisfaction due to hunger.

The zigzag symbols convey the noise of a rumbling stomach.

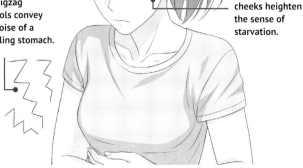

Adding shadow to the face and hollowing out the cheeks heighten the sense of starvation.

▶ "Dying of hunger"

"Dying of hunger" is an expression often used in manga or anime.

The brows and eyes are raised in anger, with the whites of the eyes show to express losing one's mind.

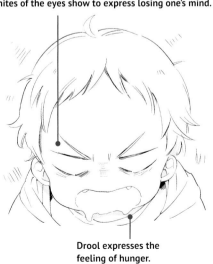

Drool expresses the feeling of hunger.

DISCUSSION | How Opening the Mouth Can Ruin the Look of a Character

▶ Opening the mouth

In reality, when the mouth opens wide, the chin moves with it. However, the eyes and mouth are often boldly distorted in illustrations, manga and the like, making it difficult for them to fit within the outline of the face.

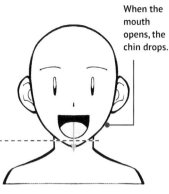

When the mouth opens, the chin drops.

▶ Ruining the look of a character

While it depends on how the character is designed, when characters with large eyes, noses and mouths are depicted with their mouths open, they often do not fit inside the outline of the face. Dropping the chin in an attempt to solve this makes the character look like someone else, leading to a situation called "character collapse."

When the facial features are small, the movements of the mouth are also small, so there is little change to the outline of the face. Character collapse is not of much concern in this case.

When the facial features are large, the movements of the mouth also get bigger, making it difficult to retain a neat outline and leading to a change in the character's appearance.

▶ Examples of countermeasures when drawing large mouths

When drawing large mouths on characters, it's important to watch out for character collapse. Here, we look at two countermeasures, but even if character collapse occurs, if you think it works, then continue with it, as it will be the best means of expression for you. Try your hand at various looks, from cute to cool, comical to realistic.

Example of character collapse

Pulling the outline down in an attempt to replicate reality gives the character the appearance of being a completely different person.

Countermeasure 1

In this method, the outline of the face and the mouth are shown as one, meaning that even if the mouth is open wide, the outline of the face remains the same. In reality, the mouth and the outline of the face are not joined together, a manga-like device, but it tends to prevent illustrations from looking as if character collapse has occurred.

Countermeasure 2

In this method, the mouth extends beyond the outline of the face. This is impossible in reality, but is often used as a means of expression in manga. As it is a comical element, take the character into consideration when employing it.

Fatigue

For a character gripped by deep fatigue, diminished physical strength and the lack of vitality read on his face. The greater the fatigue, the less expressive the face becomes. Consider the level of fatigue to differentiate between its various expressions.

TIP | A lack of vitality from fatigue makes the brows droop and the eyes grow hollow or close altogether. Drawing in lines around the eyes to resemble bags and adding large amounts of shadow make for a fatigued expression. Symbols for turning pale, sighing or being short of breath are also effective.

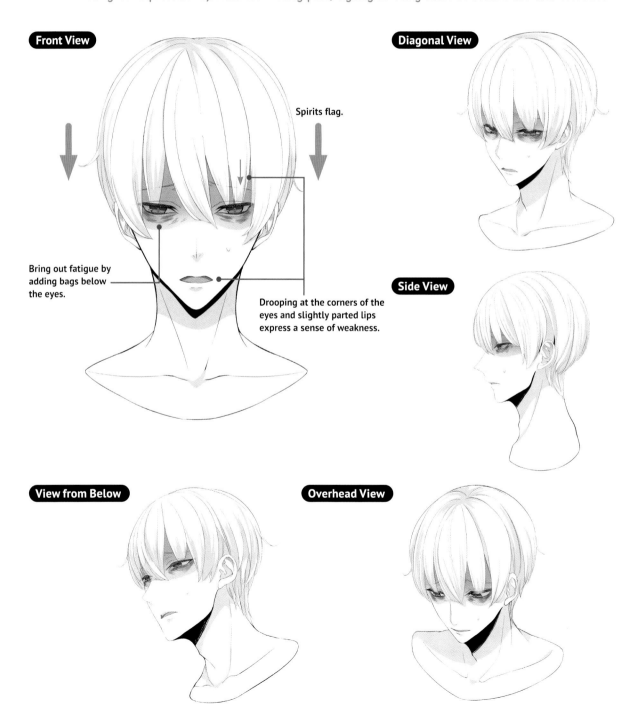

Front View

Spirits flag.

Bring out fatigue by adding bags below the eyes.

Drooping at the corners of the eyes and slightly parted lips express a sense of weakness.

Diagonal View

Side View

View from Below

Overhead View

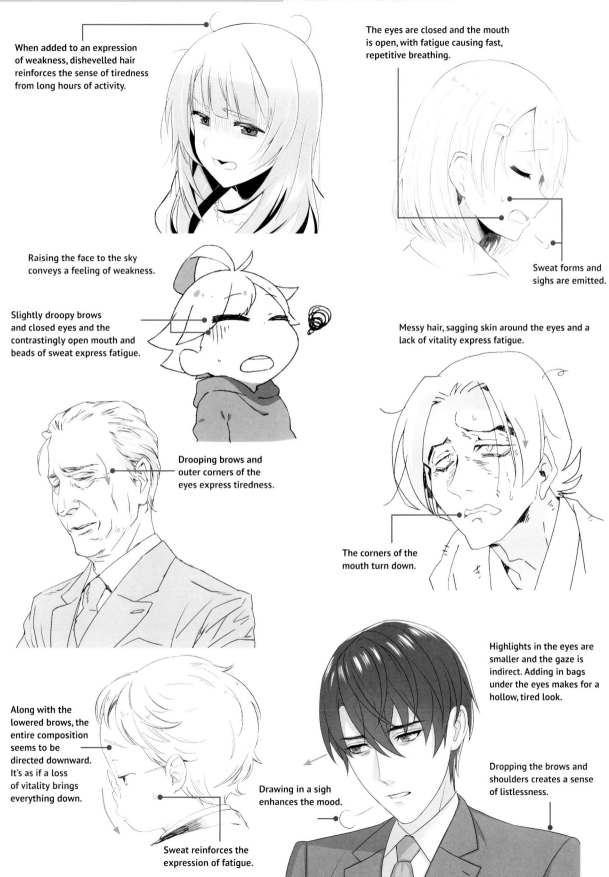

When added to an expression of weakness, dishevelled hair reinforces the sense of tiredness from long hours of activity.

The eyes are closed and the mouth is open, with fatigue causing fast, repetitive breathing.

Sweat forms and sighs are emitted.

Raising the face to the sky conveys a feeling of weakness.

Slightly droopy brows and closed eyes and the contrastingly open mouth and beads of sweat express fatigue.

Messy hair, sagging skin around the eyes and a lack of vitality express fatigue.

Drooping brows and outer corners of the eyes express tiredness.

The corners of the mouth turn down.

Along with the lowered brows, the entire composition seems to be directed downward. It's as if a loss of vitality brings everything down.

Highlights in the eyes are smaller and the gaze is indirect. Adding in bags under the eyes makes for a hollow, tired look.

Drawing in a sigh enhances the mood.

Dropping the brows and shoulders creates a sense of listlessness.

Sweat reinforces the expression of fatigue.

117

Variations

▶ Being short of breath

Tiring after running or breathing hard from excitement are some of the reasons for this expression. When breathing heavily, the mouth opens wide and the chin points up in an effort to make breathing easier.

When excited, breathing becomes shallow or it may become hard to breathe, with breathing getting heavier. This expression is used to express enthusiasm.

The heaving shoulders communicate heavy breathing.

Raising the brows and opening the eyes expresses excitement.

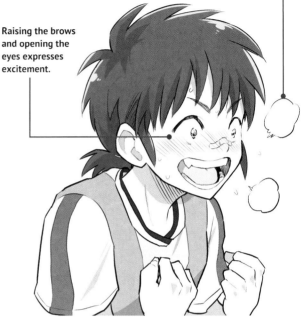

The drooping brows and inner corners of the eyes and the sagging corners of the mouth express fatigue.

▶ Anxiety

Rather than being tired physically, this is an expression of mental fatigue or being overwrought with worry. Wrinkles form between the brows and the eyes tend to droop.

Adding shadow to the entire face creates the look of the character turning his back to the light, as if averting his eyes from brightness.

This expression conjures the image of a long, thin sigh escaping. It resembles a troubled face, but the wrinkles between the brows evoke fatigue.

Wrinkles between the brows and a downturned mouth reinforce the sense of an emotional exhaustion so great that the character can no longer raise his face.

▶ Feeling drained

This is a dazed expression caused by a loss of strength. The face goes slack and the mouth and eyes are only half open.

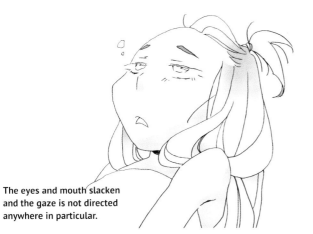

The eyes and mouth slacken and the gaze is not directed anywhere in particular.

The brows and outer corners of the eyes droop and the open mouth emits a big sigh.

The body slackens and slumps onto the desk.

DISCUSSION / Characters' Personalities and Expressions

Personality plays an important role when considering character's expressions. Personality can guide expression, with a quiet person giggling softly when they laugh, whereas a character with an exciting personality would laugh with a wide-open mouth. Conversely, it would be a major departure from character for a cool person of few words to laugh boldly, resulting in a sense of something being not right. It's easier to work out the character's expressions if his or her personality is decided in advance, using the personality as a guide for drawing expressions.

Of course, it's also possible to create a sense of awkwardness on purpose with expressions that don't match the character's personality, or to use this device to reveal his or her true personality. Let's look at an example of establishing a character's personality.

"Oh, you!"

"Really?"

Notes for establishing character
- about 25 years old
- on the eve of college graduation, discovered that her boyfriend was cheating and they split up after a huge fight
- went through the recruitment process and began working in an office, dating one to two people in that time without success
- straight after this, becomes interested in a younger man
- her expressions during interactions with him are the concept for the drawings
- as he is younger, she tries to appear sexy in a more mature way (sort of how a younger person would perceive a sophisticated young woman who is older than he)
- she is transitioning from a child to an adult, gathering life experiences

Asleep

When asleep, the face relaxes, creating a looser expression overall. It alters depending on whether the character is having a pleasant dream or a disturbing toss-and-turn nightmare.

TIP The basic expression is formed by a relaxed face with the outer corners of the eyes and the corners of the mouth turning down. The brows are generally depicted as neither raised nor lowered, but rather as flat or neutral. Portraying the mouth as half-open with drool trailing out enhances the sense of weariness. When wanting to express discomfort in sleep, add wrinkles between the brows, with a slight smile used to express sleeping deeply.

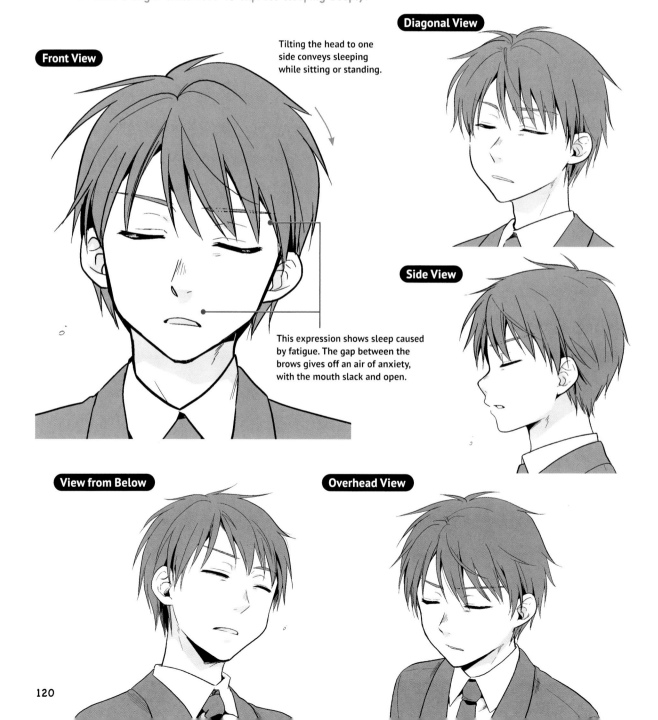

Diagonal View

Tilting the head to one side conveys sleeping while sitting or standing.

Front View

This expression shows sleep caused by fatigue. The gap between the brows gives off an air of anxiety, with the mouth slack and open.

Side View

View from Below

Overhead View

A slightly erotic look gives the impression of dreaming about a love interest.

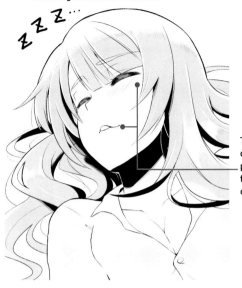

The flushed cheeks and lightly parted lips make for the appearance of a faint smile.

Fluffy round symbols express sleep.

Closed eyes positioned far from the brows create a calm sleeping face.

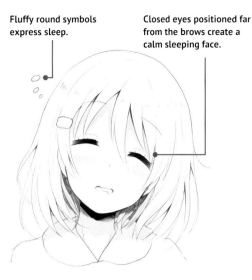

Not adding too much detail makes for a natural, relaxed look.

Adding sleep symbols enhances the atmosphere.

Distance the gently curved brows from the closed eyes and gently part the lips to create a relaxed sleeping expression.

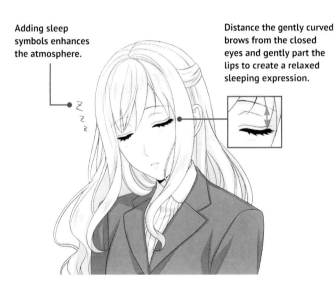

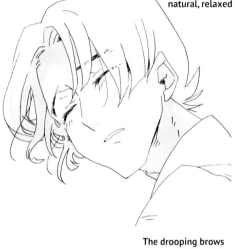

The drooping brows are in a slightly higher position than usual and the eyes are curved more loosely than in a regular smile to create an expression of sleeping innocence.

The slightly upturned face expresses a lack of tension in the body.

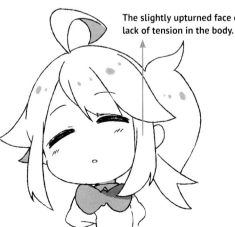

Depicting the hands as being halfway between open and clenched communicates the sense of sleeping soundly.

Variations

▶ Dozing

Falling into a doze causes a vacant expression, as consciousness is slipping away. The brows and eyes droop naturally as the muscles relax.

The eyes are vacant and there is a distance between the brows and eyes. The nodding head creates the air of being just about to fall asleep.

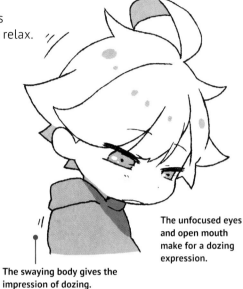

The unfocused eyes and open mouth make for a dozing expression.

The swaying body gives the impression of dozing.

▶ Having a pleasant dream

When having a pleasant dream, the expression is one of peaceful sleep and happiness. A loose smile works too.

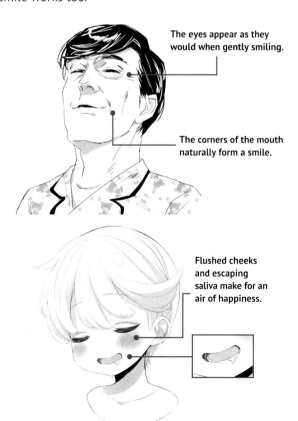

The eyes appear as they would when gently smiling.

The corners of the mouth naturally form a smile.

Flushed cheeks and escaping saliva make for an air of happiness.

▶ Having a bad dream

When having a bad dream, wrinkles form between the brows and the jaws clench to form an expression of pain.

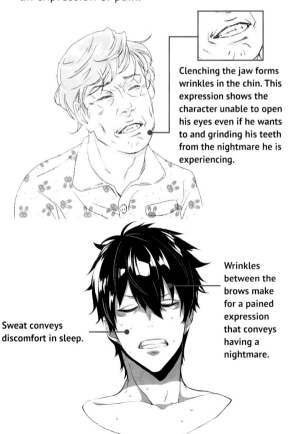

Clenching the jaw forms wrinkles in the chin. This expression shows the character unable to open his eyes even if he wants to and grinding his teeth from the nightmare he is experiencing.

Sweat conveys discomfort in sleep.

Wrinkles between the brows make for a pained expression that conveys having a nightmare.

▶ Trying not to fall asleep

This expression conveys desperately trying to keep the eyes open to stop from falling asleep. Having the eyes open but not looking anywhere in particular lends a realistic look.

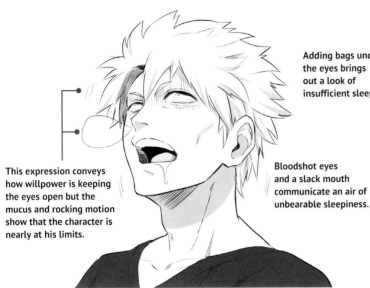

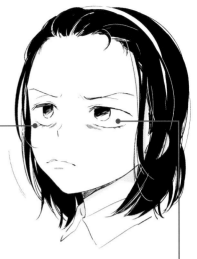

Adding bags under the eyes brings out a look of insufficient sleep.

This expression conveys how willpower is keeping the eyes open but the mucus and rocking motion show that the character is nearly at his limits.

Bloodshot eyes and a slack mouth communicate an air of unbearable sleepiness.

Wrinkles between the brows and showing the whites of the eyes more than usual convey trying not to close the eyes.

▶ Too wakeful to sleep

This expression shows being unable to sleep after drinking a strong energy drink or seeing something that stimulates the mind.

When wrinkles form between the brows, the eyes appear as if sprung open.

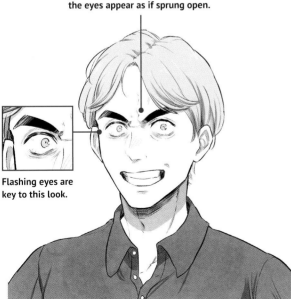

Flashing eyes are key to this look.

The pained expression communicates being unable to fall asleep.

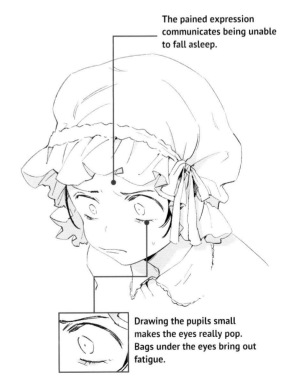

Drawing the pupils small makes the eyes really pop. Bags under the eyes bring out fatigue.

Just Woken Up

A sense of a lack of strength and a vacant look create the expression of having just woken up. The expression changes depending on how much fatigue still lingers, so consider this when drawing this expression.

TIP | Lowered brows, half-open eyes and a naturally open mouth are standard elements in a vacant expression that depicts having just woken up. There are various ways of adding to the look to show that the character is still sleepy, such as drawing the mouth wide open in a yawn or messing up the hair to show that she was asleep until a little while ago.

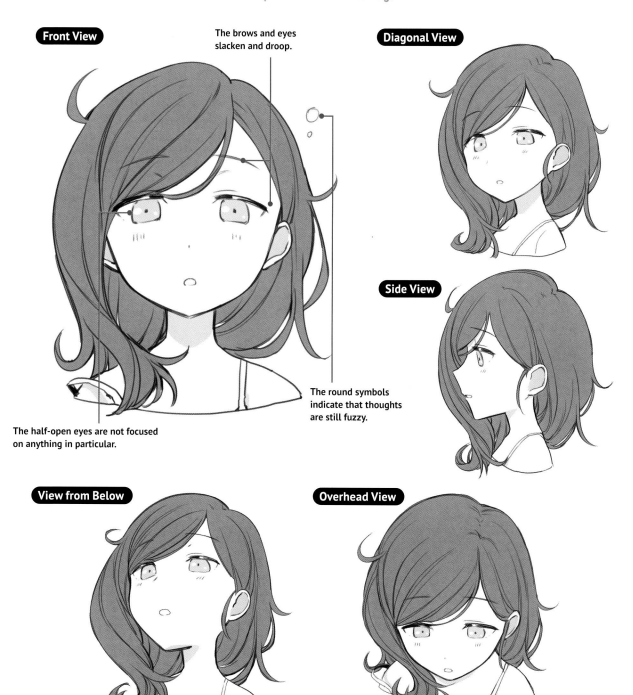

Front View

The brows and eyes slacken and droop.

The half-open eyes are not focused on anything in particular.

Diagonal View

Side View

The round symbols indicate that thoughts are still fuzzy.

View from Below

Overhead View

Lack of concern about bed head and dishevelled clothes point to a degree of intimacy with the other person.

The dozy expression and messy hair create the appearance of having just woken up.

The brows rise as the character attempts to open her eyes, but the eyelids remain not fully open.

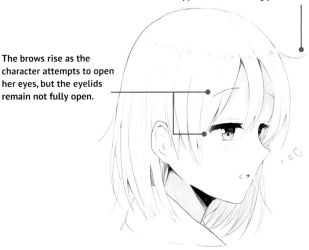

The muscles around the eyes are still not moving, making for a drowsy look.

The messy hair and the gesture of scratching the head bring out the sense of having just woken up.

The closed eyes, wide-open mouth and watery eyes accompany a yawn.

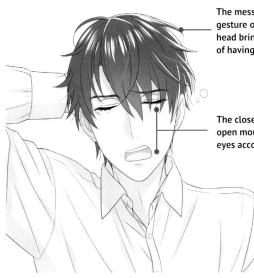

Yawns are frequent when still sleepy but trying to force oneself to wake up.

The slack mouth, tilted head and half-open eyes convey the feeling of inertia when not fully awake but having to get up anyway.

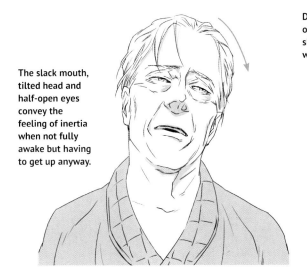

Drawing hair sticking out as if it has been slept on in a strange way is also effective.

The half-open eyes and round symbols express the vacant feeling when one is not fully awake.

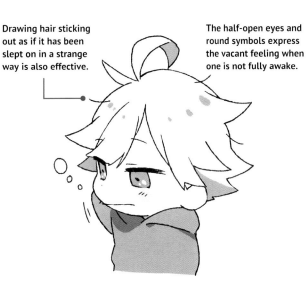

Variations

▶ Yawning

Yawns form unintentionally when someone is sleepy. The facial muscles involved in yawning stimulate the tear ducts, thereby causing tears to form.

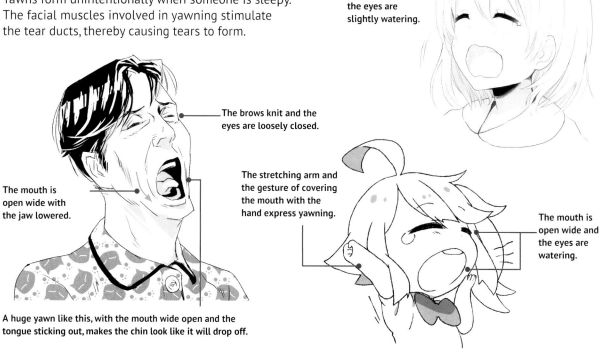

The mouth is open wide and the eyes are slightly watering.

The brows knit and the eyes are loosely closed.

The mouth is open wide with the jaw lowered.

The stretching arm and the gesture of covering the mouth with the hand express yawning.

The mouth is open wide and the eyes are watering.

A huge yawn like this, with the mouth wide open and the tongue sticking out, makes the chin look like it will drop off.

▶ Brushing the teeth

There are various expressions for brushing the teeth. In the morning, aim for a fresh look, while at night a sleepy appearance is more fitting. Many women brush their teeth before applying makeup or showering, so keeping the brows and eyelashes simple is effective in achieving a realistic look.

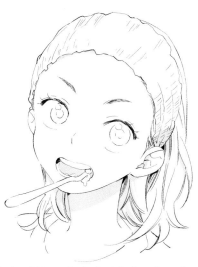

The face is cheerful to evoke the fresh feeling of morning. The mouth is loosely open and the teeth are visible.

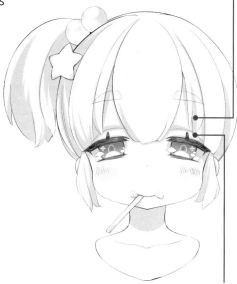

Distancing the brows and eyes makes for a zoned-out expression.

Widening the folds above the eyes creates drowsy-looking eyes to express sleepiness when having just woken up or just before going to bed.

▶ Dazed

Having just woken up, the expression takes on a slightly dazed look. The eyes are not quite open and the brows and corners of the mouth turn down to enhance this expression.

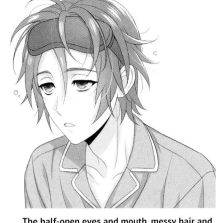

The half-open eyes and mouth, messy hair and slumped shoulders make for the look of being dazed after waking up.

Slightly lowering the parts of the face creates a relaxed, dazed impression.

Half-open eyes and an innocent expression conjure a sense of being in a trance.

▶ Waking up enthusiastically

The expression of waking up refreshed is similar to that of a smiling face. The eyes are open properly and there is an air of breeziness.

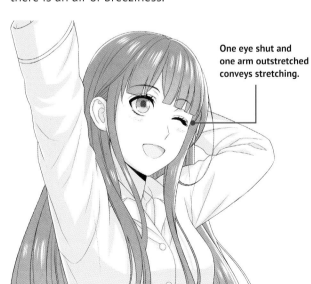

One eye shut and one arm outstretched conveys stretching.

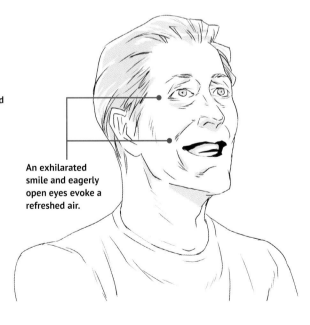

An exhilarated smile and eagerly open eyes evoke a refreshed air.

The raised brows, eagerly open eyes and wide-open mouth express waking up refreshed and feeling good.

References: Refreshed (Page 140)

Adding Subtle Effects

Just as "tears" denote sadness and "sweat" represents panic, there are various items such as symbolic expressions that can be used to express emotions. The same expression can appear quite different depending on the items added to it. Here we look at examples of how six different items can affect faces with no facial expressions as well as those with happy, angry, sad, surprised and scared expressions.

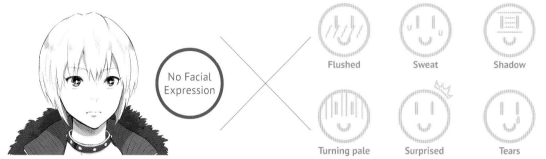

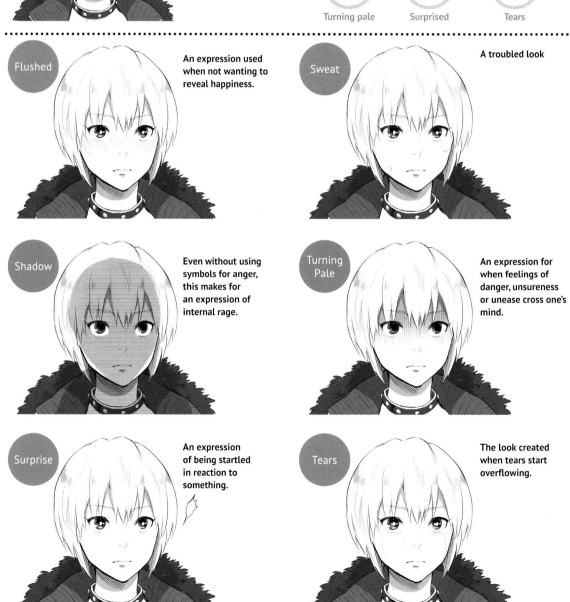

Flushed
An expression used when not wanting to reveal happiness.

Sweat
A troubled look

Shadow
Even without using symbols for anger, this makes for an expression of internal rage.

Turning Pale
An expression for when feelings of danger, unsureness or unease cross one's mind.

Surprise
An expression of being startled in reaction to something.

Tears
The look created when tears start overflowing.

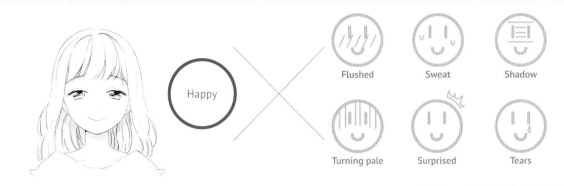

Happy

Flushed · Sweat · Shadow · Turning pale · Surprised · Tears

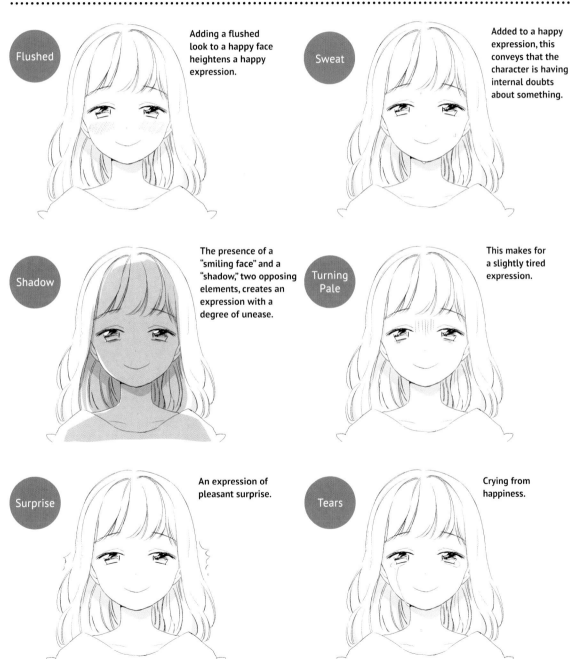

Flushed
Adding a flushed look to a happy face heightens a happy expression.

Sweat
Added to a happy expression, this conveys that the character is having internal doubts about something.

Shadow
The presence of a "smiling face" and a "shadow," two opposing elements, creates an expression with a degree of unease.

Turning Pale
This makes for a slightly tired expression.

Surprise
An expression of pleasant surprise.

Tears
Crying from happiness.

Angry

Flushed

Sweat

Shadow

Turning pale

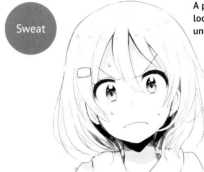
Surprised

Tears

Flushed
Attempting to conceal embarrassment.

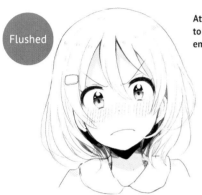

Sweat
A panicked look expressing uncertainty.

Shadow
An expression of extreme anger.

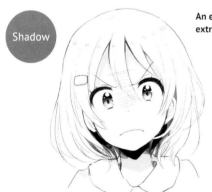

Turning Pale
Being driven into a corner.

Surprise
An expression evoking a sudden burst of anger.

Tears
Crying from regret.

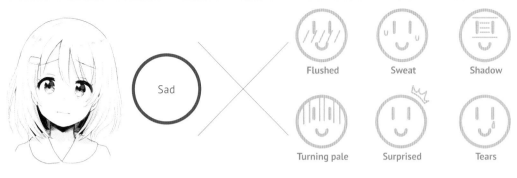

Sad

Flushed Sweat Shadow

Turning pale Surprised Tears

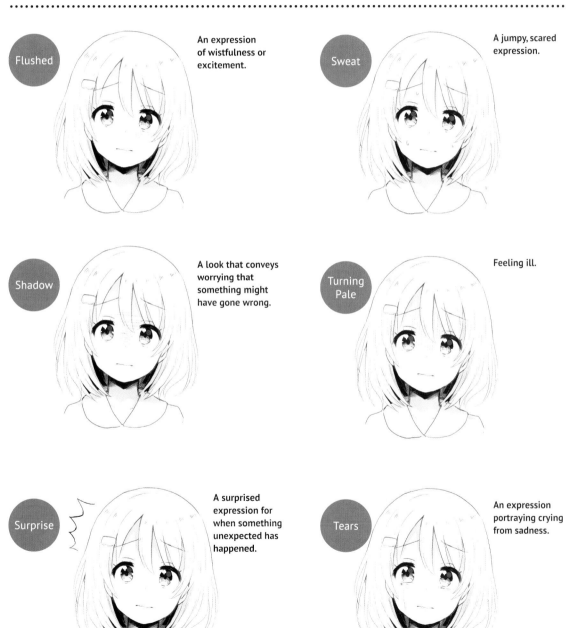

Flushed

An expression of wistfulness or excitement.

Sweat

A jumpy, scared expression.

Shadow

A look that conveys worrying that something might have gone wrong.

Turning Pale

Feeling ill.

Surprise

A surprised expression for when something unexpected has happened.

Tears

An expression portraying crying from sadness.

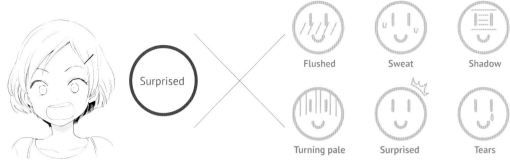

Surprised

Flushed Sweat Shadow

Turning pale Surprised Tears

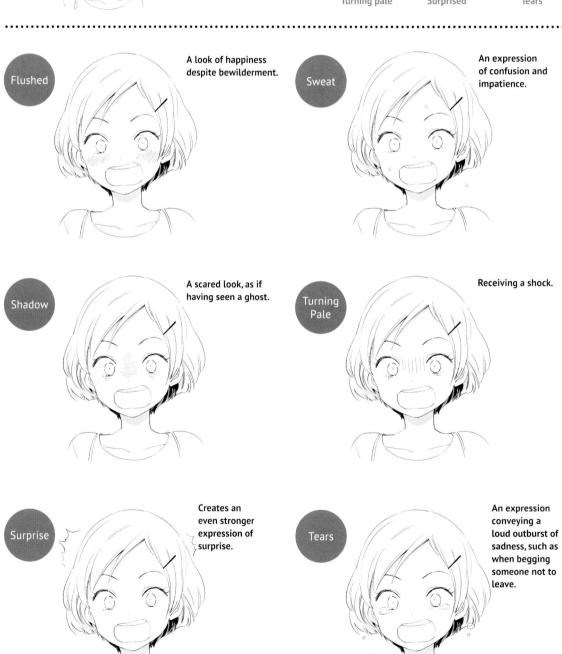

Flushed

A look of happiness despite bewilderment.

Sweat

An expression of confusion and impatience.

Shadow

A scared look, as if having seen a ghost.

Turning Pale

Receiving a shock.

Surprise

Creates an even stronger expression of surprise.

Tears

An expression conveying a loud outburst of sadness, such as when begging someone not to leave.

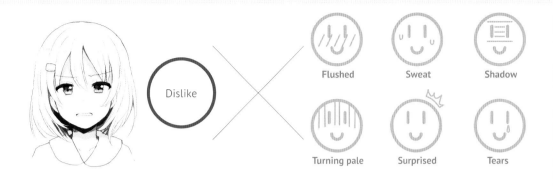

Dislike

Flushed Sweat Shadow

Turning pale Surprised Tears

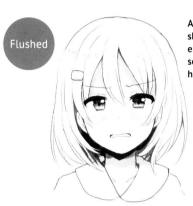

Flushed

An expression showing embarrassment after something unpleasant has happened.

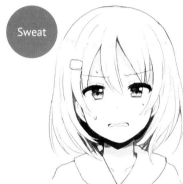

Sweat

A look of panic created when rattled or upset.

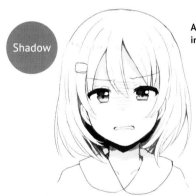

Shadow

A look of loathing and irritation.

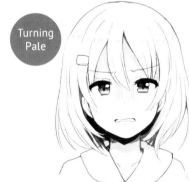

Turning Pale

Drawing away from someone in repulsion.

Surprise

A look created when realizing something unpleasant.

Tears

An expression created when held-back tears start to overflow.

133

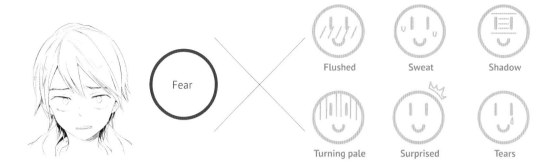

Fear × Flushed, Sweat, Shadow, Turning pale, Surprised, Tears

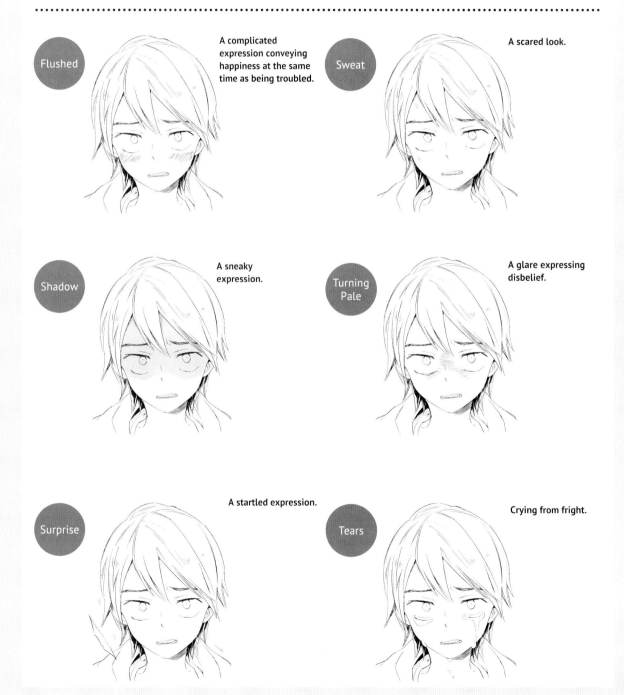

Flushed — A complicated expression conveying happiness at the same time as being troubled.

Sweat — A scared look.

Shadow — A sneaky expression.

Turning Pale — A glare expressing disbelief.

Surprise — A startled expression.

Tears — Crying from fright.

Animated Expressions

POSITIVITY

Earnest
Joking
Refreshed
Smugness
Being Moved
Contentment
Pleading

NEGATIVITY

Exasperation
Endurance
Pain
Madness
Plotting
Scoffing
Hiding Something

Earnest

An earnest expression conveys that one is serious, not joking around, so it's important to remove any playful elements. It's a go-to look for portraying the seriousness of situations such as when a character is involved in something requiring intense concentration or conveying trustworthiness to someone.

..

TIP | The gaze directed straight at the object and the firm mouth form the standard expression of earnestness. Raising the brows and adding wrinkles between them to create an intense look is also common.

Front View

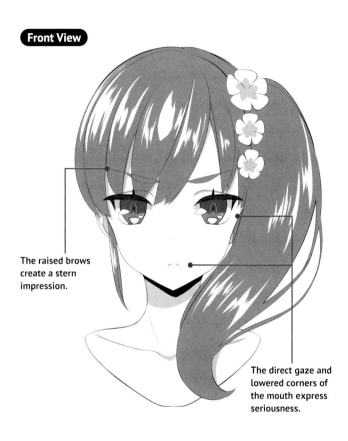

The raised brows create a stern impression.

The direct gaze and lowered corners of the mouth express seriousness.

Diagonal View

Side View

View from Below

Overhead View

Adding tension around the eyes and focusing the gaze forward accentuates the impression of seriousness.

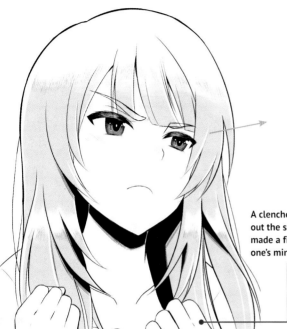

The lightly closed mouth and raised brows form a clearly defined look.

A clenched fist brings out the sense of having made a firm decision in one's mind.

The brows are not raised much and the mouth forms a straight line, making for a tense look.

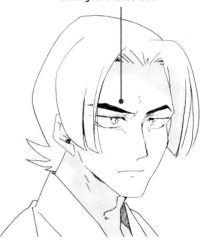

The clear-cut expression formed by creating tension around the brows, eyes and mouth conveys seriousness.

Straightening the back makes for an earnest impression.

The clearly raised brows and firmly pursed lips create an earnest expression.

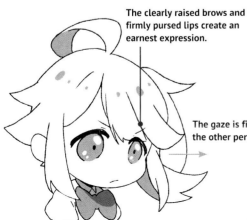

The gaze is firmly directed at the other person.

The mouth is drawn firmly shut and the outer corners of the eyes are subtly raised. The gaze directed straight in front conveys diligence and earnestness.

Joking

This expression conveys playfulness. Reducing the serious elements present enhances the impression of playfulness. It's a particularly useful expression for adding comedic touches such as when a character is trying to make people laugh by joking around.

TIP | Personality plays a strong role in forming this expression. Depending on the character's personality, gestures such as winking or sticking out the tongue may be used to create a cheerful, comical impression. Try combining it with various other expressions.

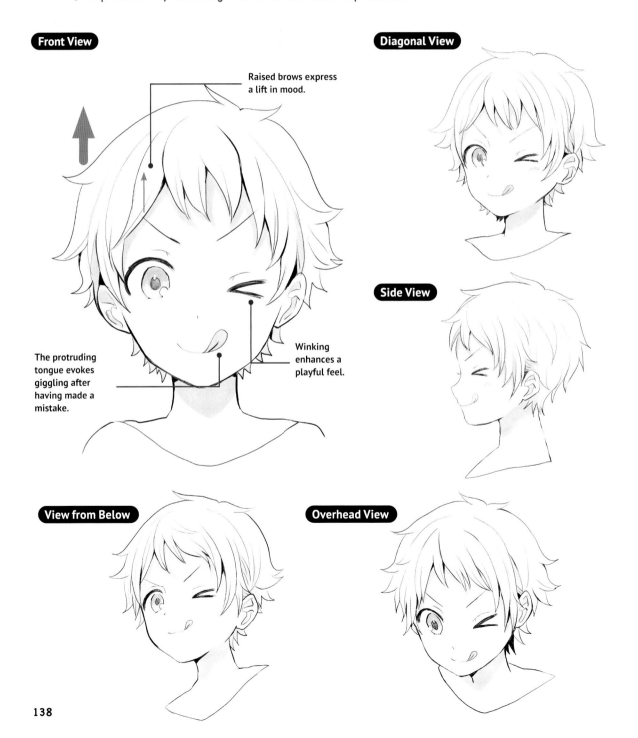

Front View

Raised brows express a lift in mood.

The protruding tongue evokes giggling after having made a mistake.

Winking enhances a playful feel.

Diagonal View

Side View

View from Below

Overhead View

138

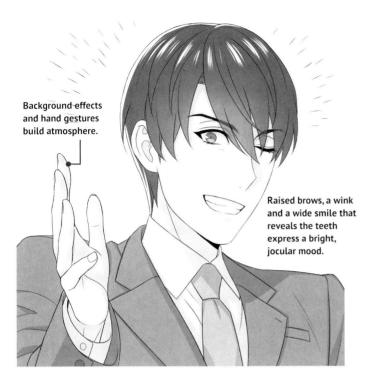

Background effects and hand gestures build atmosphere.

Raised brows, a wink and a wide smile that reveals the teeth express a bright, jocular mood.

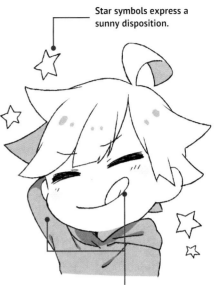

Star symbols express a sunny disposition.

A protruding tongue and the gesture of scratching the head make for a look that is clearly playful.

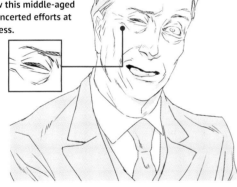

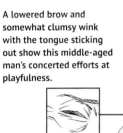

A lowered brow and somewhat clumsy wink with the tongue sticking out show this middle-aged man's concerted efforts at playfulness.

Adding a touch of laughter to the eyes to contrast with the concerned look formed by the lowered brows evokes a sense of devilish jocularity.

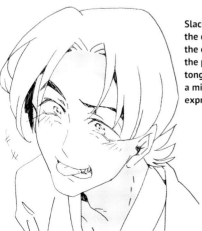

Slackening around the corners of the eyes and the protruding tongue produce a mischievous expression.

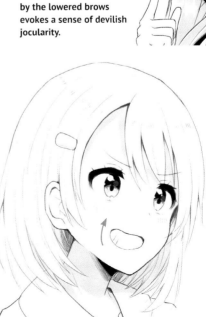

Drawn-up brows and the raised corners of the mouth revealing the teeth make for a slightly teasing, playful expression.

Refreshed

This breezy look captures the feeling of being rejuvenated and energized. It's often used to express the exhilarated mood that results from an intense workout or the feeling of liberation after completing a stressful job or task.

TIP | A smiling face forms the basis for this expression. There are various ways to depict it, with eagerly open eyes lending a sense of achievement, while closed eyes convey a feeling of exhilaration. Hair fluttering in the breeze and symbols for shine and sparkle add to the effect.

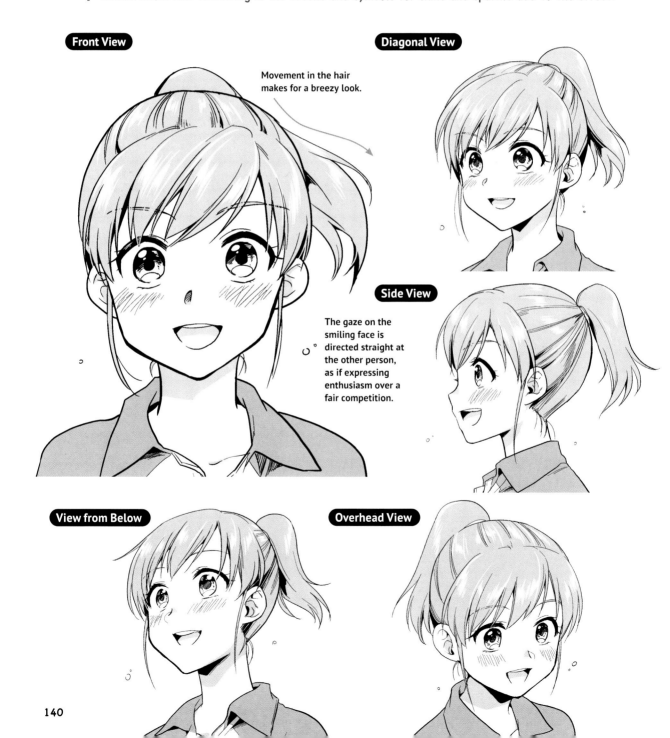

Front View

Movement in the hair makes for a breezy look.

Diagonal View

Side View

The gaze on the smiling face is directed straight at the other person, as if expressing enthusiasm over a fair competition.

View from Below

Overhead View

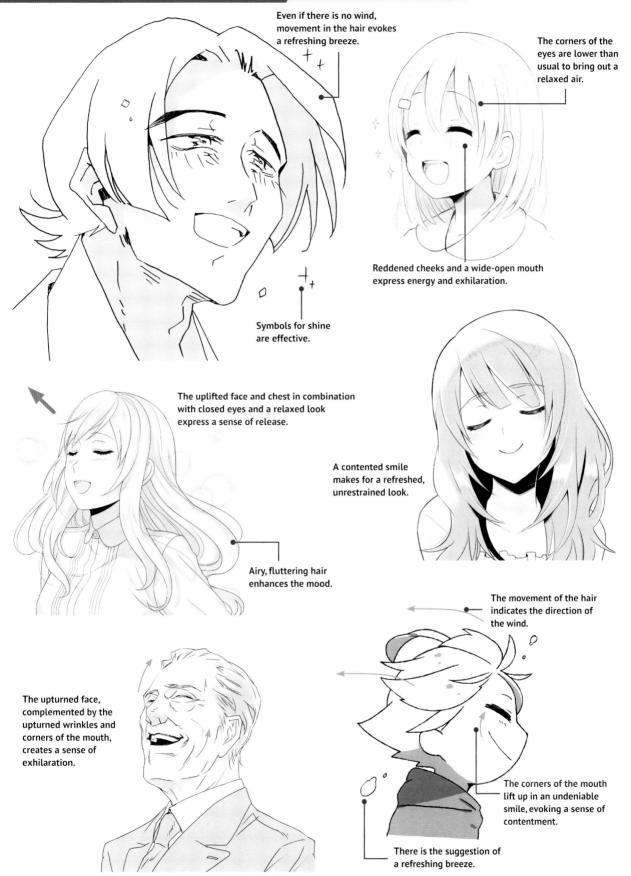

Even if there is no wind, movement in the hair evokes a refreshing breeze.

The corners of the eyes are lower than usual to bring out a relaxed air.

Reddened cheeks and a wide-open mouth express energy and exhilaration.

Symbols for shine are effective.

The uplifted face and chest in combination with closed eyes and a relaxed look express a sense of release.

A contented smile makes for a refreshed, unrestrained look.

Airy, fluttering hair enhances the mood.

The movement of the hair indicates the direction of the wind.

The upturned face, complemented by the upturned wrinkles and corners of the mouth, creates a sense of exhilaration.

The corners of the mouth lift up in an undeniable smile, evoking a sense of contentment.

There is the suggestion of a refreshing breeze.

Smugness

A smug face expresses excessive self-confidence, so it's fine to overexaggerate when you draw it. It can be used not only to express self-confidence but also to depict a boastful attitude.

!TIP Raising the brows and the corners of the mouth is standard for this expression, which has all the facial features directed upward. Overdefining the eyes and adding shine symbols are also effective. Apart from the facial expression, the appearance of having self-confidence can be expressed by lifting the head up and straightening the back.

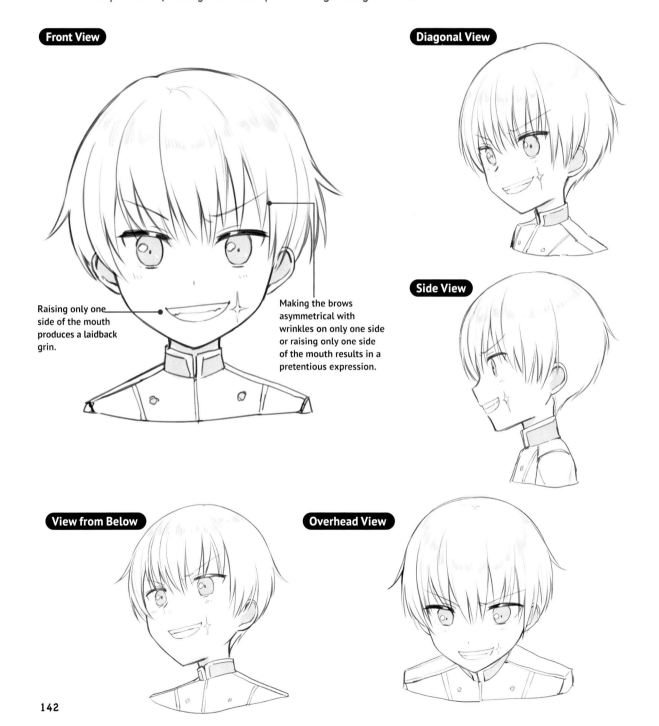

Front View

Raising only one side of the mouth produces a laidback grin.

Making the brows asymmetrical with wrinkles on only one side or raising only one side of the mouth results in a pretentious expression.

Diagonal View

Side View

View from Below

Overhead View

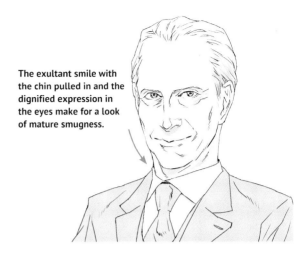

The exultant smile with the chin pulled in and the dignified expression in the eyes make for a look of mature smugness.

A symbol like a speech bubble represents a boastful snort, adding emphasis to the expression.

The hands on the hips create a boastful look. The figure is depicted as being viewed from a slightly low angle and leaning back.

The facial features are all lifted upward.

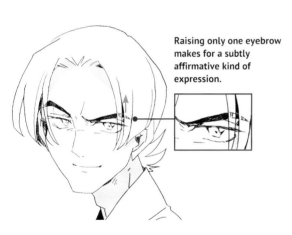

Raising only one eyebrow makes for a subtly affirmative kind of expression.

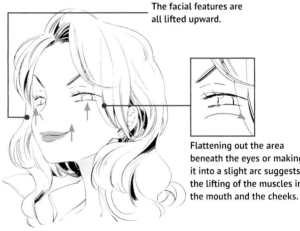

Flattening out the area beneath the eyes or making it into a slight arc suggests the lifting of the muscles in the mouth and the cheeks.

The caricaturized curved mouth drawn boldly onto the base of a clearly defined facial expression adds a slightly comical feel that brings out a character's charm.

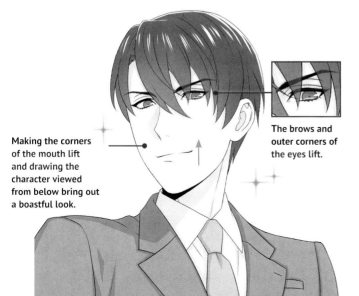

Making the corners of the mouth lift and drawing the character viewed from below bring out a boastful look.

The brows and outer corners of the eyes lift.

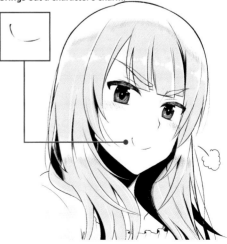

Being Moved

A heartfelt gesture or a swooning sense of inspiration can be the causes of this expression. The source of the emotion alters the expression, so consider the character and the scenario when fine-tuning this particular expression.

✏ TIP When expressing a combination of respect and admiration, this expression is often portrayed by adding highlights in the eyes to create shine. If the expression is one of being extremely touched, it's typical to incorporate tears and blush to the cheeks. The key to this expression is knowing why the character feels so moved.

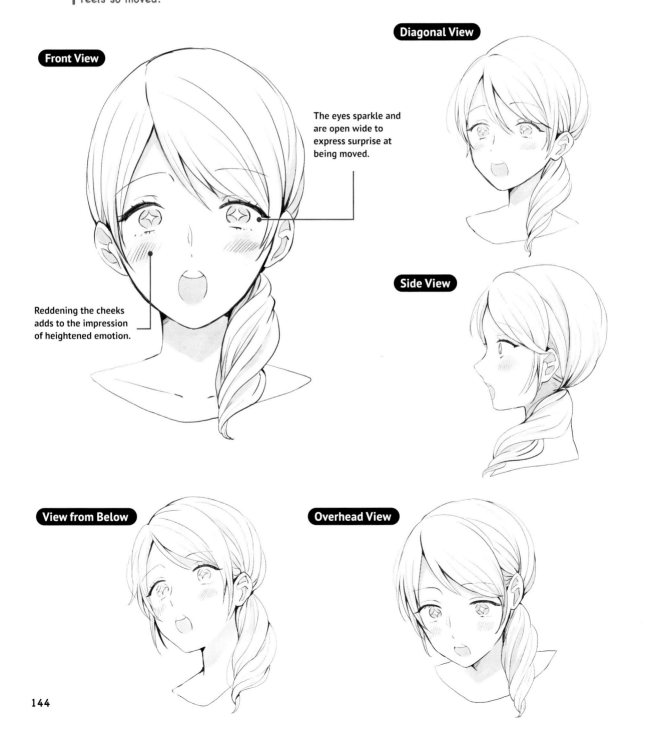

Diagonal View

Front View

The eyes sparkle and are open wide to express surprise at being moved.

Reddening the cheeks adds to the impression of heightened emotion.

Side View

View from Below

Overhead View

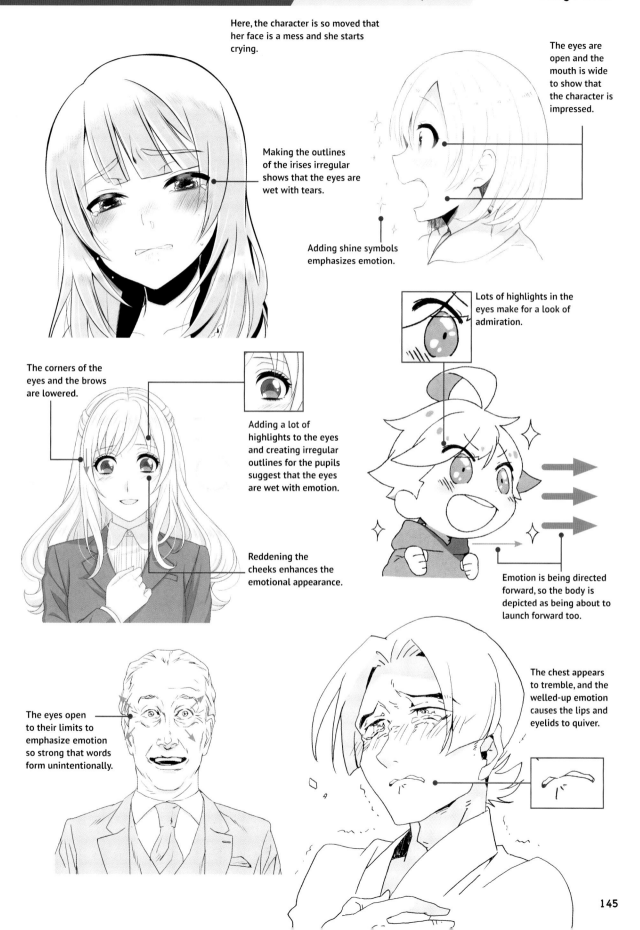

Here, the character is so moved that her face is a mess and she starts crying.

The eyes are open and the mouth is wide to show that the character is impressed.

Making the outlines of the irises irregular shows that the eyes are wet with tears.

Adding shine symbols emphasizes emotion.

Lots of highlights in the eyes make for a look of admiration.

The corners of the eyes and the brows are lowered.

Adding a lot of highlights to the eyes and creating irregular outlines for the pupils suggest that the eyes are wet with emotion.

Reddening the cheeks enhances the emotional appearance.

Emotion is being directed forward, so the body is depicted as being about to launch forward too.

The eyes open to their limits to emphasize emotion so strong that words form unintentionally.

The chest appears to tremble, and the welled-up emotion causes the lips and eyelids to quiver.

Contentment

The feelings of calmness and pleasure associated with contentment often arise from physical stimulation, such as when having a massage, or may be internally caused, such as when someone is being praised for a job well done.

TIP | One can feel good physically or mentally, but either way, it's typical to depict this expression as slightly untidy, with the cheeks flushed and the brows lowered. Adding saliva dripping from the mouth can be effective for emphasizing the untidy look.

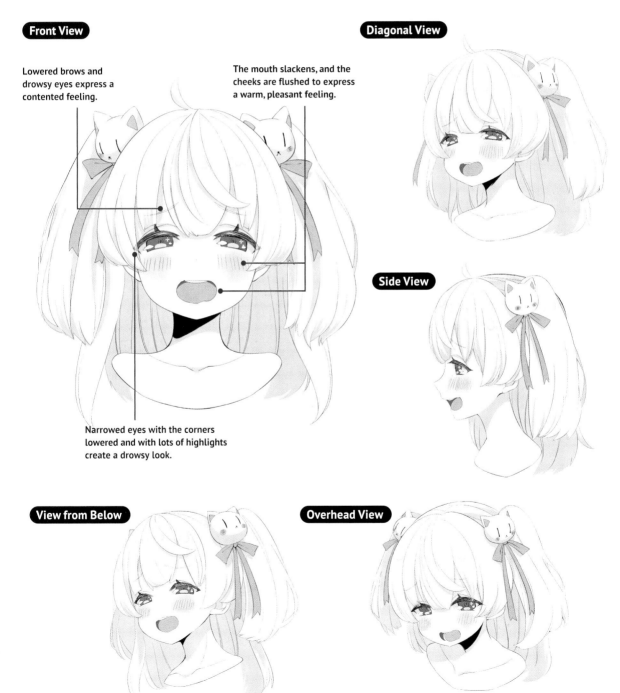

Front View

Lowered brows and drowsy eyes express a contented feeling.

The mouth slackens, and the cheeks are flushed to express a warm, pleasant feeling.

Narrowed eyes with the corners lowered and with lots of highlights create a drowsy look.

Diagonal View

Side View

View from Below

Overhead View

146

Differing degrees of slackness in the muscles between the brows and eyes express differing levels of contentment. This is an expression that can be used across various genres.

The lowered brows and outer corners of the eyes make for an expression of rapture.

A ragged outline for the lips creates the appearance of trembling and emitting sounds of delight.

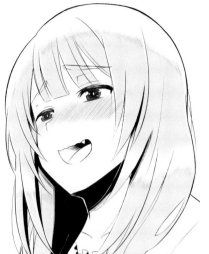

The loosely relaxed brows and mouth and flushed cheeks make for a contented expression.

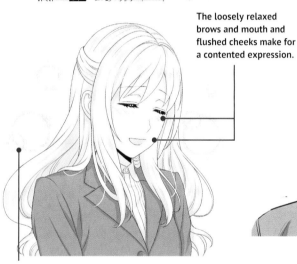

Fuzzy circles as a background effect create a light, airy impression.

The brows forming a /\ shape, downcast eyes and wide-open mouth from which saliva is escaping evoke an expression of savoring feelings of irrepressible ecstasy.

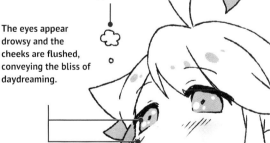

A flower symbol adds an air of happiness.

The eyes appear drowsy and the cheeks are flushed, conveying the bliss of daydreaming.

Both the eyes and mouth are half-open, expressing such feelings of contentment that the mind starts to wander.

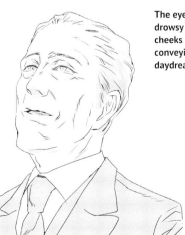

Pleading

This expression forms when asking a favor of someone. Depending on the level of importance, the expression changes greatly: small requests evoking a different facial register from a matter of life and death. Here, we look at small and massive favors separately.

..

▶ Asking a small favor

TIP | This expression is used when asking a friend for a small favor in a carefree manner. A smiling face is used as the base for the expression, with brows slightly lowered in apology and gestures portraying a request effective in building the look.

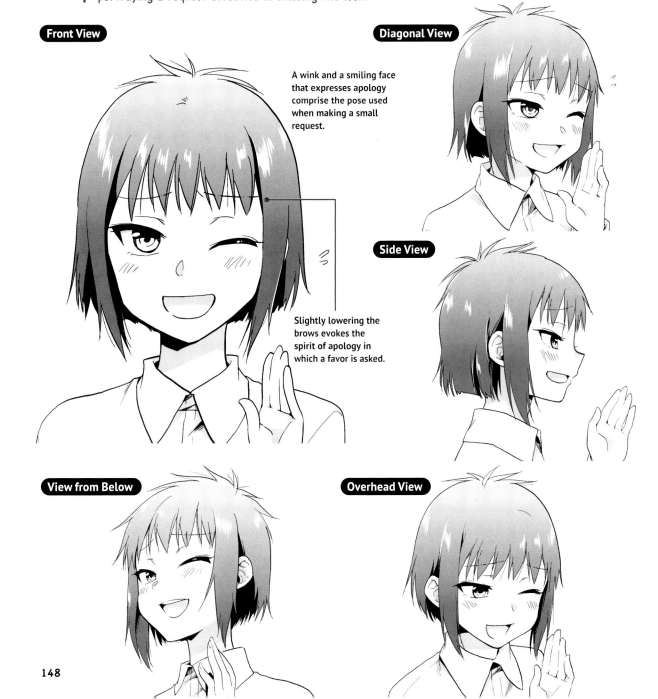

Front View

Diagonal View

A wink and a smiling face that expresses apology comprise the pose used when making a small request.

Side View

Slightly lowering the brows evokes the spirit of apology in which a favor is asked.

View from Below

Overhead View

148

Lowered brows and a smile evoke a sense of worry, with the pose that has the character looking up from below evoking a calculating feeling.

The eagerly open eyes and brows forming a /\ shape convey using cuteness to plead one's case.

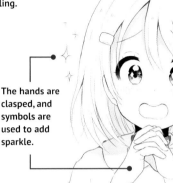

The hands are clasped, and symbols are used to add sparkle.

A troubled yet smiling face creates the impression of trying to curry favor.

In addition to using highlights, adding moisture to the eyes builds a look brimming with hope.

Slightly tilting the head conveys the air of pleading sweetly.

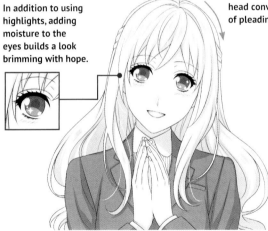

This look conveys asking a small favor of a friend or someone close.

A caricaturized version of the eyes brings out the carefree nature of the request.

Asking a favor in a casual way enables the expression of cuteness.

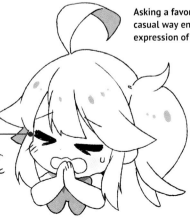

The raised brows make for an apologetic air.

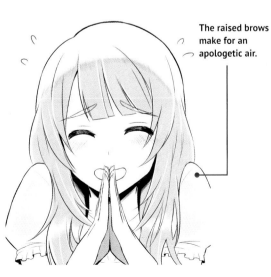

▶ Asking a huge favor

✏ TIP | This expression conveys pleading in a life-and-death situation. The base expression is one of earnestness or a troubled look. Intensely flushed cheeks are effective in conveying the degree of seriousness.

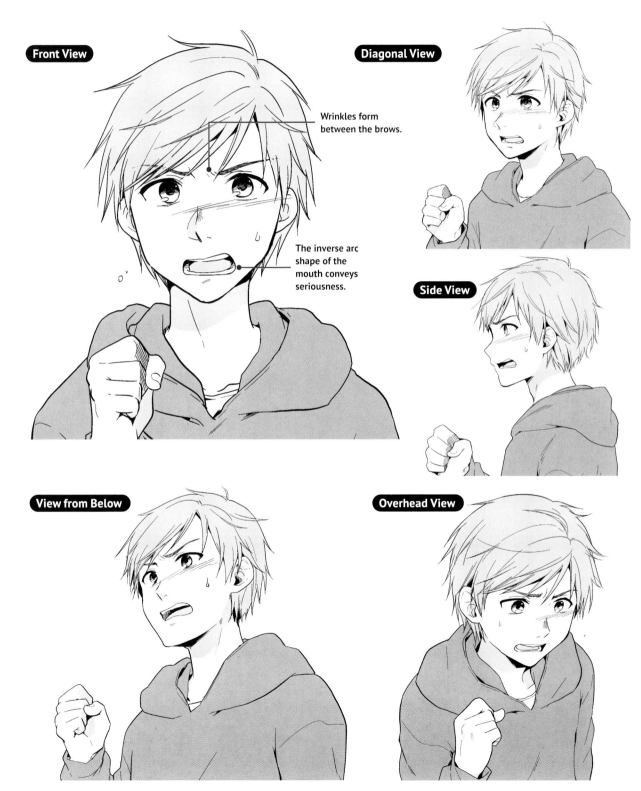

Front View

Wrinkles form between the brows.

The inverse arc shape of the mouth conveys seriousness.

Diagonal View

Side View

View from Below

Overhead View

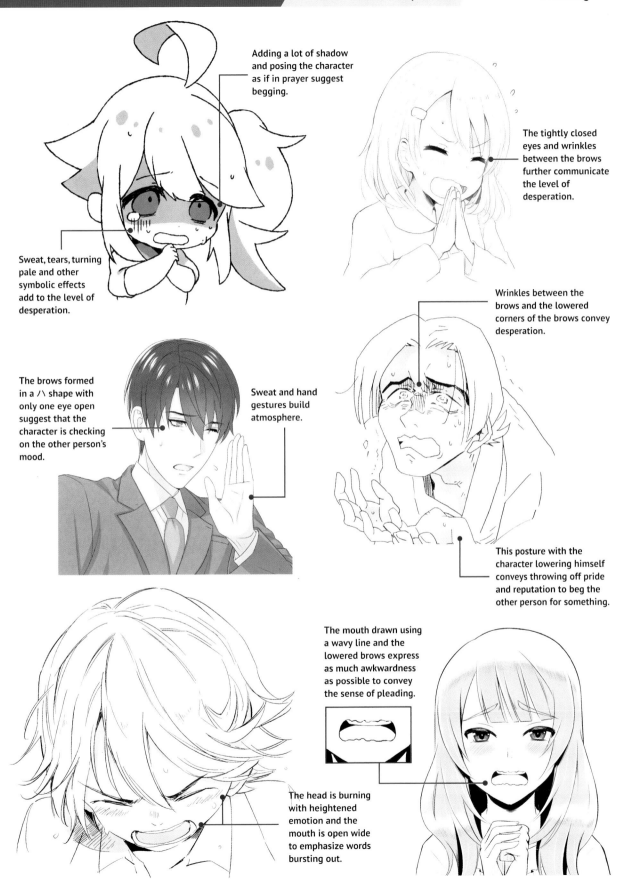

Adding a lot of shadow and posing the character as if in prayer suggest begging.

Sweat, tears, turning pale and other symbolic effects add to the level of desperation.

The tightly closed eyes and wrinkles between the brows further communicate the level of desperation.

Wrinkles between the brows and the lowered corners of the brows convey desperation.

The brows formed in a /\ shape with only one eye open suggest that the character is checking on the other person's mood.

Sweat and hand gestures build atmosphere.

This posture with the character lowering himself conveys throwing off pride and reputation to beg the other person for something.

The mouth drawn using a wavy line and the lowered brows express as much awkwardness as possible to convey the sense of pleading.

The head is burning with heightened emotion and the mouth is open wide to emphasize words bursting out.

Exasperation

Exasperation lends itself to a troubled look, but disappointment and a slight sense of mocking can also come into play. Initial reactions of surprise or anger can also resolve themselves into the more subtle modes of exasperation.

TIP | A troubled face with slackened brows and eyes forms the base for this expression. When anger is mixed in, raising the brows is a way to create a look of annoyance. Slackening the mouth so that it is half-open, adding wrinkles between the brows and adding symbols for sighs and sweat are also effective.

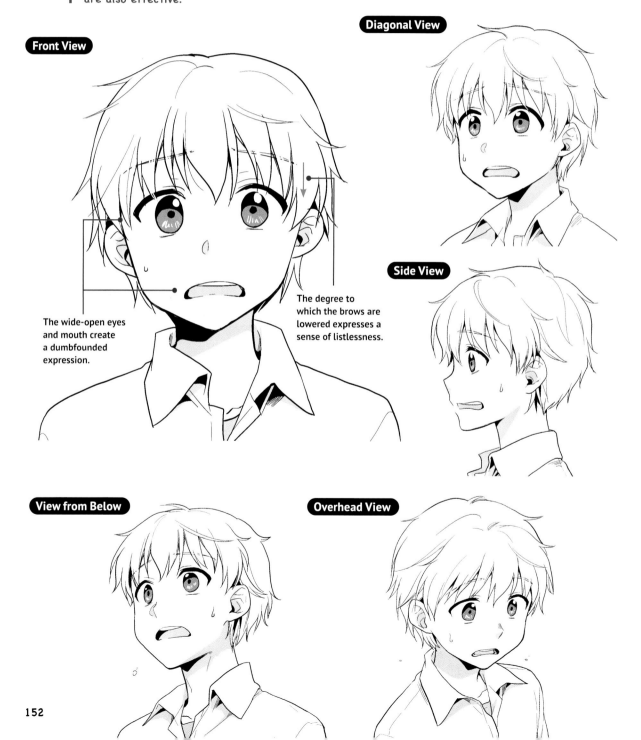

Diagonal View

Front View

Side View

The wide-open eyes and mouth create a dumbfounded expression.

The degree to which the brows are lowered expresses a sense of listlessness.

View from Below

Overhead View

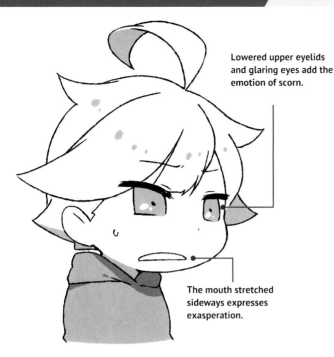

Lowered upper eyelids and glaring eyes add the emotion of scorn.

The mouth stretched sideways expresses exasperation.

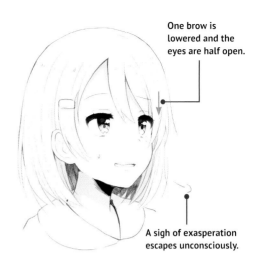

One brow is lowered and the eyes are half open.

A sigh of exasperation escapes unconsciously.

The eyebrows knit together and the eyes narrow, with wrinkles forming in the lower eyelids.

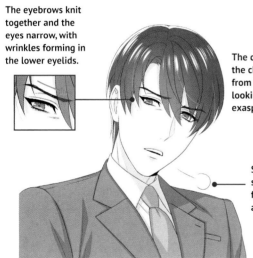

The composition with the character viewed from below suggests looking down with an exasperated expression.

Sighs and other symbols serve to further enhance the atmosphere.

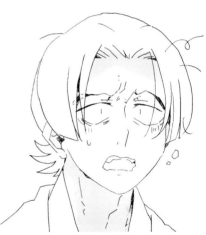

Dumbfounded at the turn of events, the character appears frozen.

Troubled eyebrows and a twisted mouth express feelings of exasperation.

Adding shadow around the eyes heightens the sense of the character looking down from above.

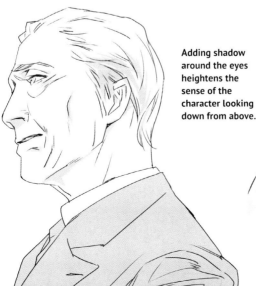

Lowering the brows and directing the gaze down at the other person bring out a sense of disappointment.

Endurance

We all have to put up with unpleasant situations, the face and body tensing in the effort that endurance or acceptance requires. Tolerating or humoring someone can also produce similar slightly pained expressions.

TIP | Furrowed brows with wrinkles between them are standard in this expression. The eyes and mouth are rendered differently depending on the level of forbearance being depicted. If it's only a slight degree of tolerance, the eyes narrow and the mouth is slightly tense, but strong forbearance is evoked in tightly shut eyes and a clenched jaw.

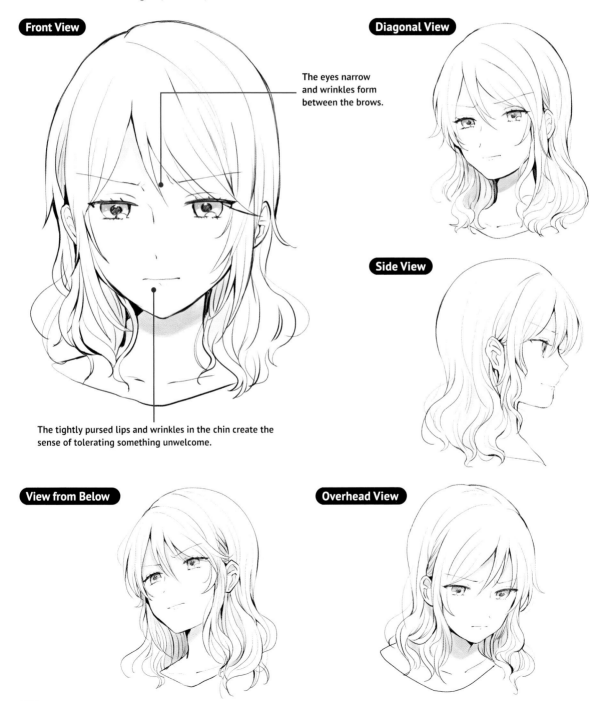

Front View

The eyes narrow and wrinkles form between the brows.

The tightly pursed lips and wrinkles in the chin create the sense of tolerating something unwelcome.

Diagonal View

Side View

View from Below

Overhead View

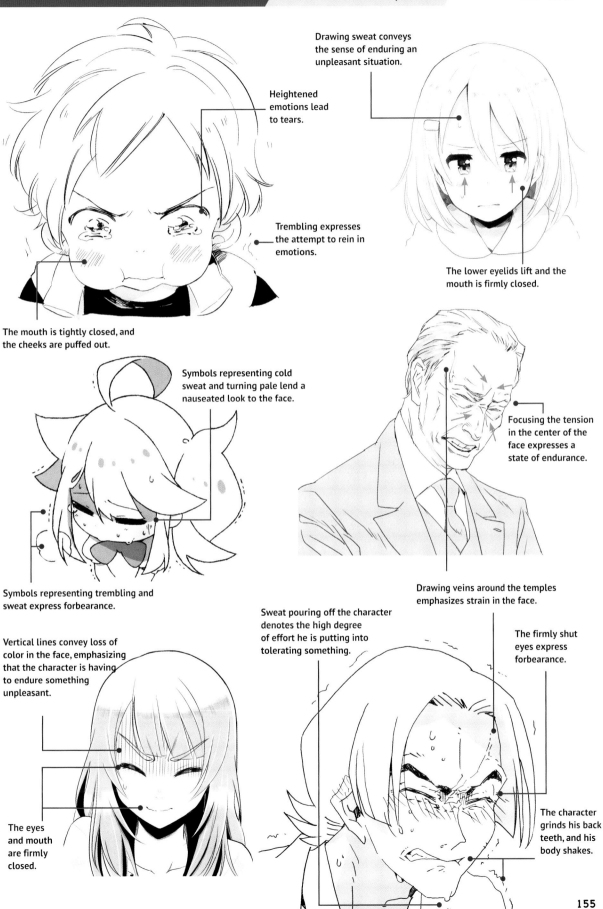

Drawing sweat conveys the sense of enduring an unpleasant situation.

Heightened emotions lead to tears.

Trembling expresses the attempt to rein in emotions.

The lower eyelids lift and the mouth is firmly closed.

The mouth is tightly closed, and the cheeks are puffed out.

Symbols representing cold sweat and turning pale lend a nauseated look to the face.

Focusing the tension in the center of the face expresses a state of endurance.

Symbols representing trembling and sweat express forbearance.

Drawing veins around the temples emphasizes strain in the face.

Vertical lines convey loss of color in the face, emphasizing that the character is having to endure something unpleasant.

Sweat pouring off the character denotes the high degree of effort he is putting into tolerating something.

The firmly shut eyes express forbearance.

The eyes and mouth are firmly closed.

The character grinds his back teeth, and his body shakes.

Pain

This expression can be used for emotional pain as well, but the examples shown here are in reaction to physical duress. Experiencing sudden pain causes bold facial expressions and sharp body movements, while enduring chronic pain turns the face pale.

TIP | When experiencing a moment of pain, breath is inhaled sharply, causing the eyebrows to tense and the mouth and eyes to twist in an obvious grimace. When experiencing chronic pain, the brows lower and the jaws clench in an expression similar to that of forbearance. Vary the expression depending on the level of pain and the situation.

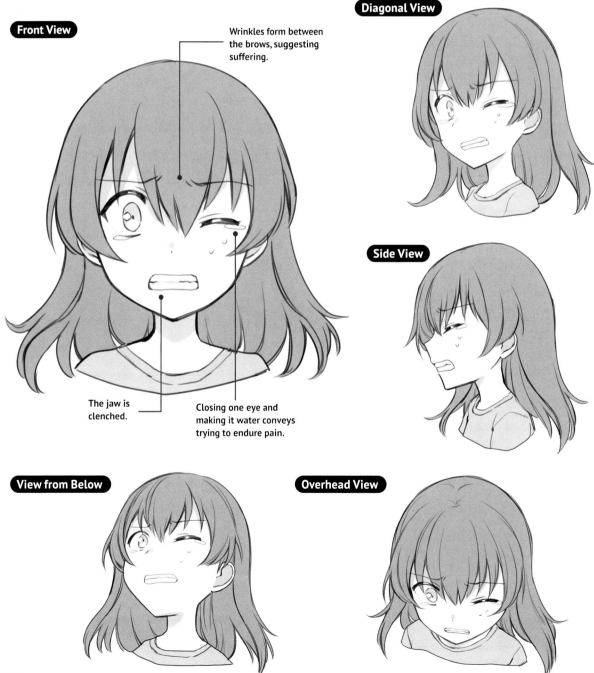

Front View

Wrinkles form between the brows, suggesting suffering.

The jaw is clenched.

Closing one eye and making it water conveys trying to endure pain.

Diagonal View

Side View

View from Below

Overhead View

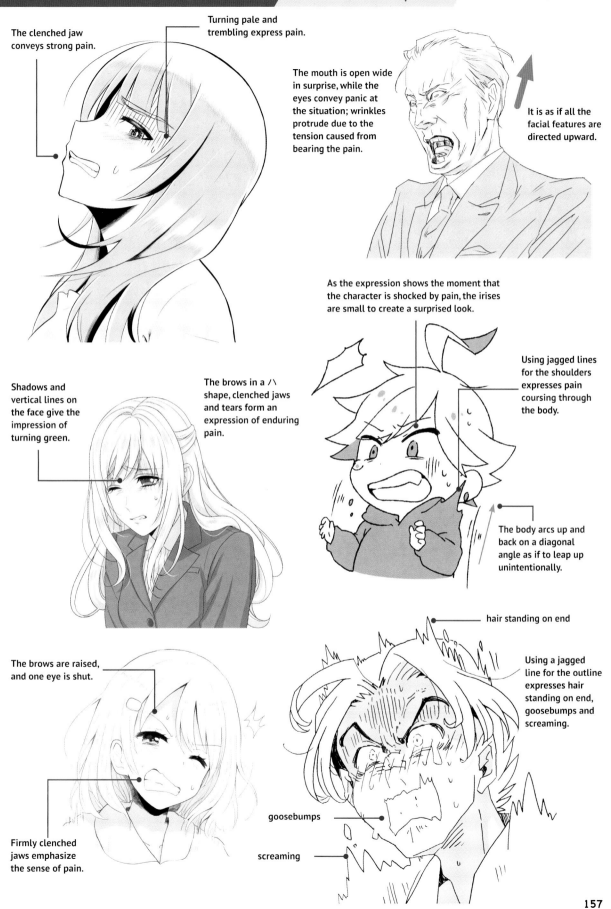

The clenched jaw conveys strong pain.

Turning pale and trembling express pain.

The mouth is open wide in surprise, while the eyes convey panic at the situation; wrinkles protrude due to the tension caused from bearing the pain.

It is as if all the facial features are directed upward.

As the expression shows the moment that the character is shocked by pain, the irises are small to create a surprised look.

Shadows and vertical lines on the face give the impression of turning green.

The brows in a ∧ shape, clenched jaws and tears form an expression of enduring pain.

Using jagged lines for the shoulders expresses pain coursing through the body.

The body arcs up and back on a diagonal angle as if to leap up unintentionally.

hair standing on end

Using a jagged line for the outline expresses hair standing on end, goosebumps and screaming.

The brows are raised, and one eye is shut.

Firmly clenched jaws emphasize the sense of pain.

goosebumps

screaming

Variations

▶ Touching something hot

This expression is an immediate reaction to touching something hot. It is similar to that depicting pain, but as it is an expression caused in a fleeting moment, it's fine to overexaggerate it somewhat.

The character is shocked at having touched something hot, with this expression capturing the moment of saying "ouch!"

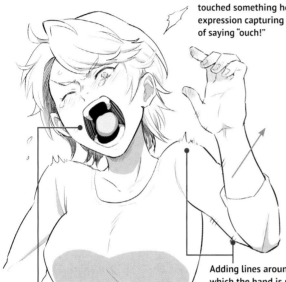

Shocked at having touched something hot, the facial features lift up and the expression is tense with surprise.

Exaggerating the expression of surprise makes the item touched appear hotter.

Adding lines around the body conveys the speed with which the hand is pulled back.

The mouth is open wide as if to scream "ouch!"

▶ Fainting

This resembles the expression of being asleep, but showing the whites of the eyes and using comic elements help to build the look.

Slightly lowering the position of the mouth and adding wrinkles between the brows gives the face a slightly tense look.

The soul leaving the body is the most classic way to express fainting.

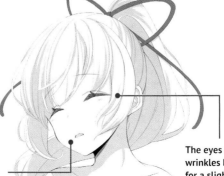

The whites of the eyes show and the body appears to stiffen as the character loses consciousness.

Slightly parted lips make for a limp look.

The eyes are closed but the wrinkles between the brows make for a slightly pained expression that suggests fainting.

DISCUSSION / How Temperature Affects Expressions

▶ Heat

When it's hot, facial muscles appear to slacken, with an open mouth, ragged breath, flushed cheeks and glistening skin creating the impression of heat. The brows may droop from loss of strength due to the heat or may be raised in irritation at it.

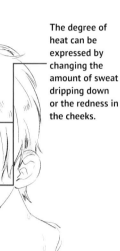

Making the pupils blurry creates the impression that the heat is causing dizziness and a complete lack of focus.

Sweat pours off the skin, and the hair sticks to the face.

One closed eye and a slightly raised gaze suggest strong sunlight.

The degree of heat can be expressed by changing the amount of sweat dripping down or the redness in the cheeks.

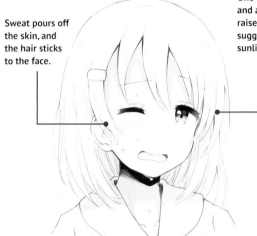

The mouth is open to expel heat.

▶ Cold

Cold creates the expression of tension in the facial muscles. Wrinkles form between the brows and the jaws clench. Symbols to express turning pale and trembling are also effective.

Wrinkles between the brows convey trying to endure the cold.

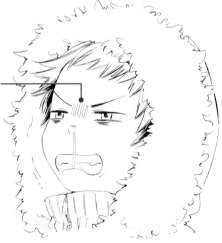

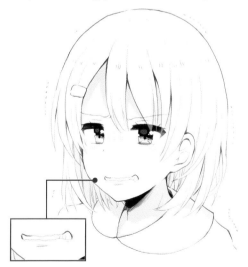

The mouth stretches sideways, and the jaws clench. Using a wavy line for the mouth denotes trembling.

Lines are angular to evoke images of cold such as ice. The clenched jaws create the impression of teeth chattering from the cold.

Madness

Various emotions fuse to form the erratic instability that accompanies madness. Rage, loathing as well as the derangements of intense love can all lead to the face of a madman.

TIP | The eyes are often key to creating different expressions of madness, with exaggeratedly open eyes, asymmetrical eyes, unfocused eyes and eyes with small pupils just a few of the examples. Combining expressions for opposing emotions is also effective, such as using an expression of fear as the base and then adding a laughing mouth.

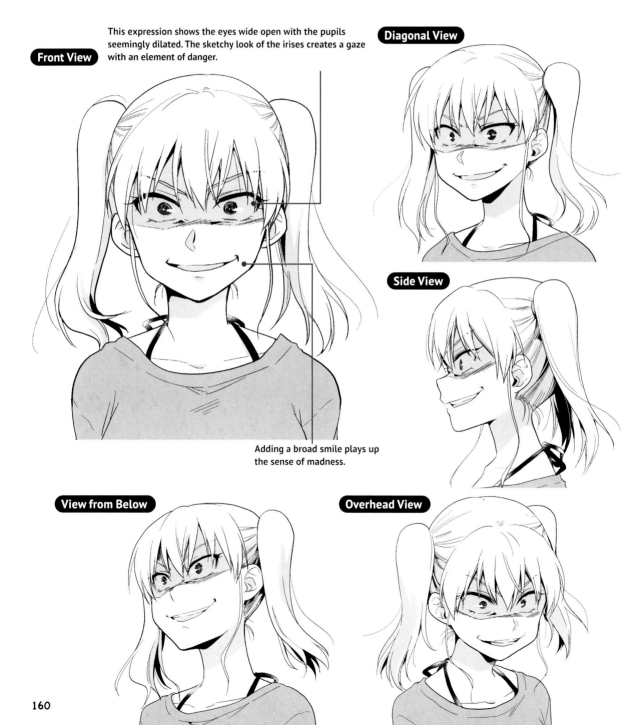

This expression shows the eyes wide open with the pupils seemingly dilated. The sketchy look of the irises creates a gaze with an element of danger.

Front View

Diagonal View

Side View

Adding a broad smile plays up the sense of madness.

View from Below

Overhead View

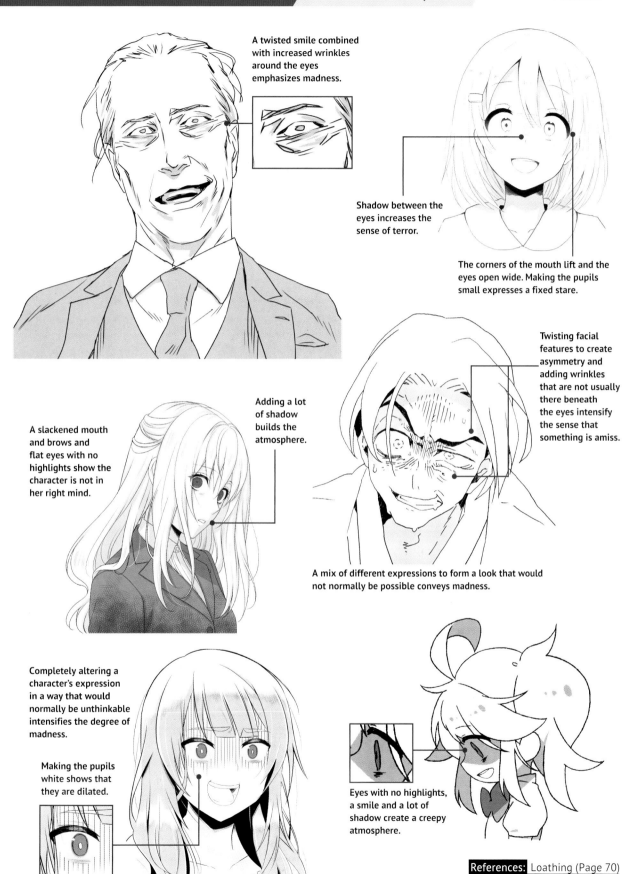

A twisted smile combined with increased wrinkles around the eyes emphasizes madness.

Shadow between the eyes increases the sense of terror.

The corners of the mouth lift and the eyes open wide. Making the pupils small expresses a fixed stare.

Twisting facial features to create asymmetry and adding wrinkles that are not usually there beneath the eyes intensify the sense that something is amiss.

A slackened mouth and brows and flat eyes with no highlights show the character is not in her right mind.

Adding a lot of shadow builds the atmosphere.

A mix of different expressions to form a look that would not normally be possible conveys madness.

Completely altering a character's expression in a way that would normally be unthinkable intensifies the degree of madness.

Making the pupils white shows that they are dilated.

Eyes with no highlights, a smile and a lot of shadow create a creepy atmosphere.

References: Loathing (Page 70)

Plotting

This expression is used when a character is planning something evil. This is a go-to expression for villains as it captures not only the conjuring of bad thoughts but the accompanying anticipation and enjoyment, as the nefarious scheme starts to take on life.

TIP | Raising the brows and creating an asymmetrical expression brings out the look of a villain. The eyes are often depicted as looking up in order to suggest thoughts being taken over by evil schemes.

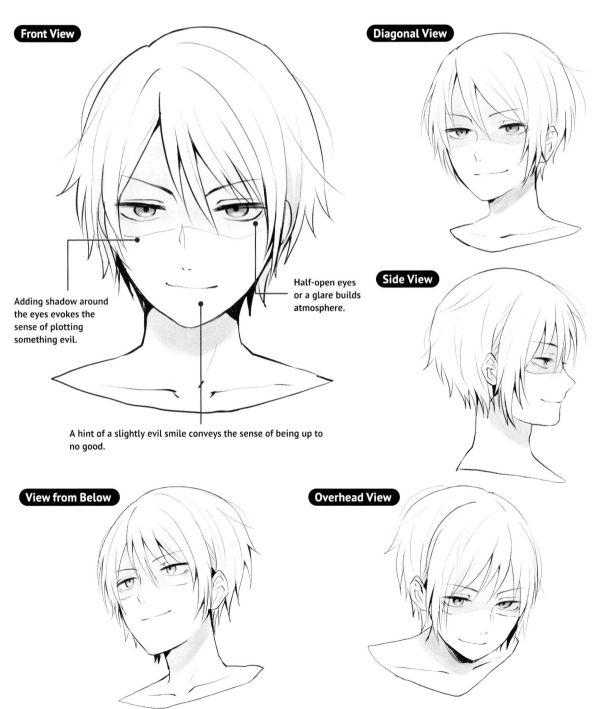

Front View

Adding shadow around the eyes evokes the sense of plotting something evil.

Half-open eyes or a glare builds atmosphere.

A hint of a slightly evil smile conveys the sense of being up to no good.

Diagonal View

Side View

View from Below

Overhead View

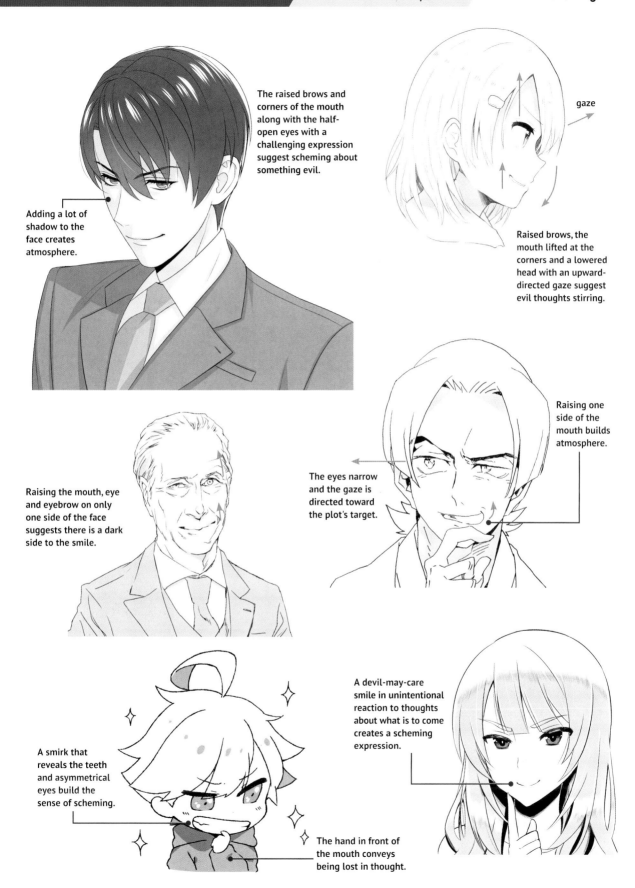

The raised brows and corners of the mouth along with the half-open eyes with a challenging expression suggest scheming about something evil.

Adding a lot of shadow to the face creates atmosphere.

gaze

Raised brows, the mouth lifted at the corners and a lowered head with an upward-directed gaze suggest evil thoughts stirring.

Raising one side of the mouth builds atmosphere.

Raising the mouth, eye and eyebrow on only one side of the face suggests there is a dark side to the smile.

The eyes narrow and the gaze is directed toward the plot's target.

A smirk that reveals the teeth and asymmetrical eyes build the sense of scheming.

A devil-may-care smile in unintentional reaction to thoughts about what is to come creates a scheming expression.

The hand in front of the mouth conveys being lost in thought.

Scoffing

This expression conveys condescension and contempt. As it is an expression of ridicule, it makes the other person feel uncomfortable. It's often used in situations when a character is asserting superiority over another.

TIP | Wrinkles between the brows and twisted facial features are often used to form this expression. When wanting to show one's own strength, the brows are raised, but when there is even only a little compassion for the other person, they are lowered. As the other person is being ridiculed, the mouth forms a smile, creating an expression of overconfident pride.

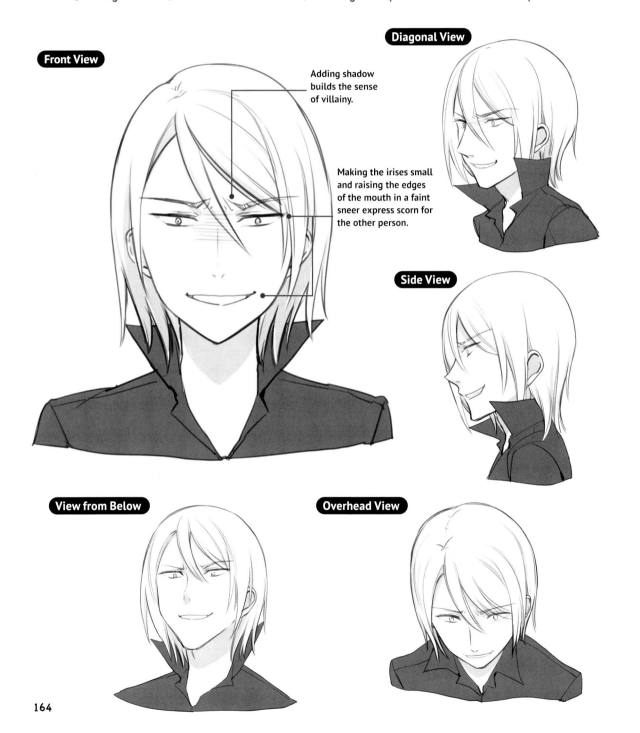

Diagonal View

Front View

Adding shadow builds the sense of villainy.

Making the irises small and raising the edges of the mouth in a faint sneer express scorn for the other person.

Side View

View from Below

Overhead View

The brows twist into a /\ shape, intentionally forming a contemptuous expression ready to offer an insult.

Shadow symbols express villainy.

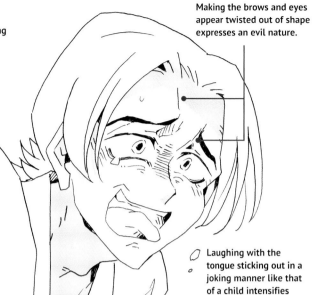

Making the brows and eyes appear twisted out of shape expresses an evil nature.

Laughing with the tongue sticking out in a joking manner like that of a child intensifies the sense of insult.

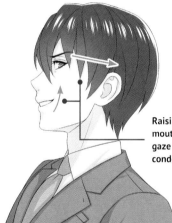

Raising the edge of the mouth and directing the gaze back expresses condescension.

Raising the corners of the mouth and brows creates the impression of provocation.

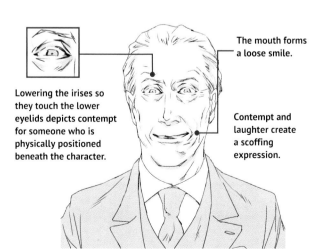

Lowering the irises so they touch the lower eyelids depicts contempt for someone who is physically positioned beneath the character.

The mouth forms a loose smile.

Contempt and laughter create a scoffing expression.

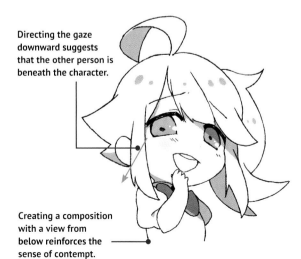

Directing the gaze downward suggests that the other person is beneath the character.

Creating a composition with a view from below reinforces the sense of contempt.

Variations

▶ Guffawing

This expression depicts boisterous laughter such as may come from gloating. Raising the face adds to the effect.

Opening up the eyes to direct the gaze downward makes for a more twisted expression.

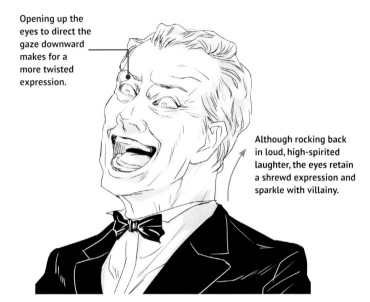

Although rocking back in loud, high-spirited laughter, the eyes retain a shrewd expression and sparkle with villainy.

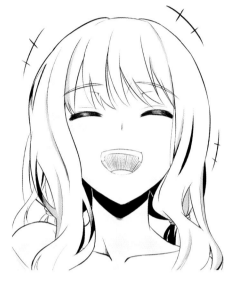

The chin jutting out while laughing conveys hearty laughter.

Creating the composition as if viewed from below builds the sense of intimidation.

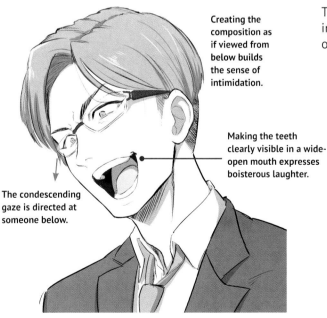

Making the teeth clearly visible in a wide-open mouth expresses boisterous laughter.

The condescending gaze is directed at someone below.

▶ Sniggering

This expression conveys laughing at an inappropriate moment. The smiling face takes on a worried look.

The brows form a /\ shape and breath escapes from the mouth to express laughing unintentionally in an inappropriate situation.

▶ A cold smile

A cold smile expresses both disgust and detachment from someone. Twisting the corners of the mouth and slightly altering the eyebrows creates a smile of derision.

The nose and mouth expel a snort of air and although the mouth is smiling, the eyes are narrowed and the brows are raised. Laughter ceases, leaving a cold smile.

Darkening the pupils creates an air of negativity, adding a feeling of contempt to a smiling face.

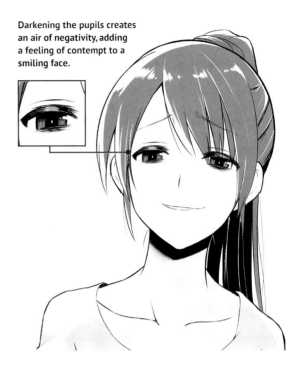

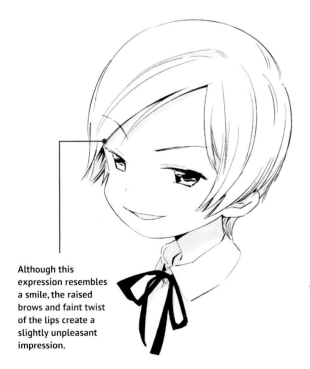

Although this expression resembles a smile, the raised brows and faint twist of the lips create a slightly unpleasant impression.

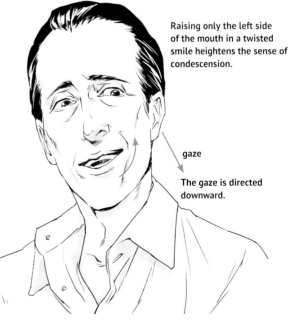

Raising only the left side of the mouth in a twisted smile heightens the sense of condescension.

gaze

The gaze is directed downward.

References: Exasperation (Page 152)

Hiding Something

This expression conveys a sense of concealment. It differs markedly depending on the situation, with the look of trying to hide something insignificant being quite different from the expression of desperately covering up something of extreme importance that must not be discovered. Choose the right look for the situation.

▶ Hiding something insignificant

 TIP This expression of slight deception is used when hiding something small. It's common to depict the character feigning innocence by grinning while someone walks past, with other comical effects such as whistling also used.

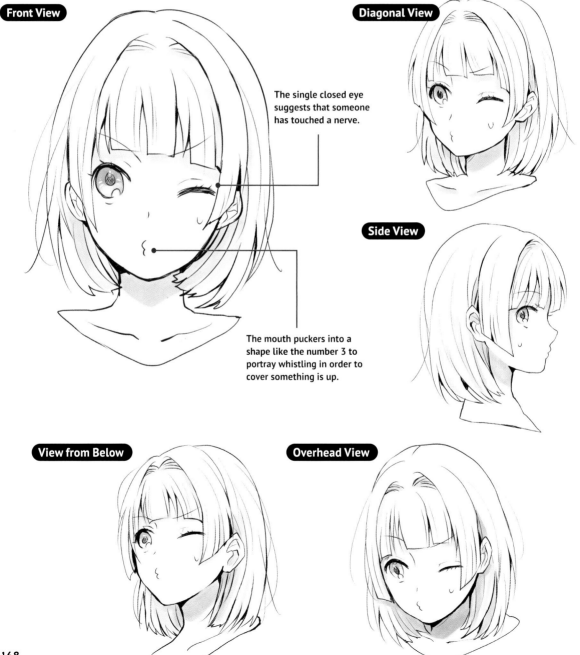

Front View

Diagonal View

The single closed eye suggests that someone has touched a nerve.

Side View

The mouth puckers into a shape like the number 3 to portray whistling in order to cover something is up.

View from Below

Overhead View

168

The embarrassed look and gesture of denial allow for an expression of cuteness.

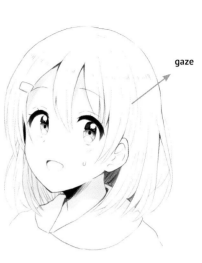

gaze

The gaze shifted upward and cold sweat running down the face convey that something is being hidden.

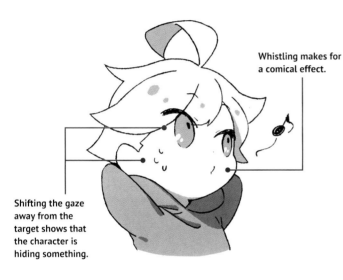

Whistling makes for a comical effect.

Shifting the gaze away from the target shows that the character is hiding something.

The corners of the mouth are drawn up and the brows are raised, expressing being on edge.

The eyes are open slightly larger than usual to create a humorous impression.

The slightly jocular look puts the other person off-guard, with the smile covering something up.

The raised brows, eyes crinkled at the corners and raised corners of the mouth form a fake smile that conveys something hidden.

▶ Covering up something big

TIP | This expression conveys covering up something extremely significant. The brows lowered in a troubled expression or raised in a slightly angry expression along with symbols for sweat bring out the air of panicking to conceal something important.

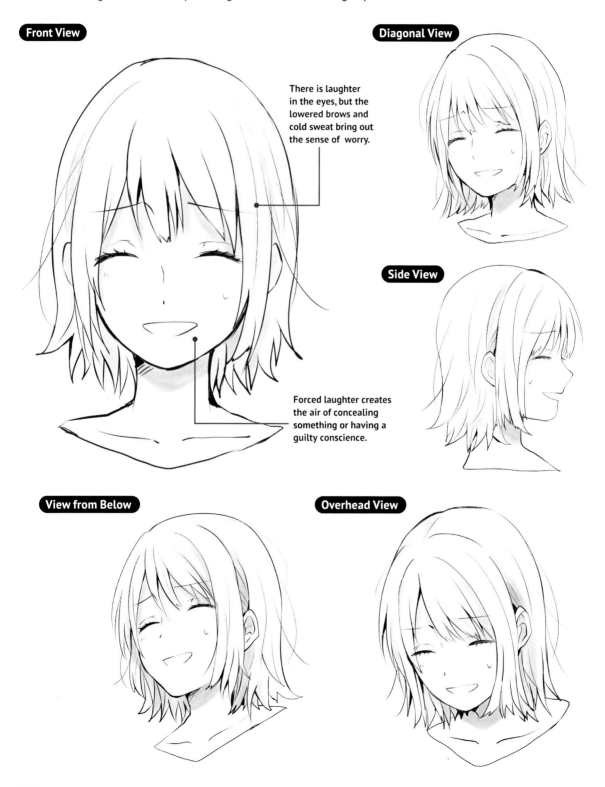

Front View

There is laughter in the eyes, but the lowered brows and cold sweat bring out the sense of worry.

Forced laughter creates the air of concealing something or having a guilty conscience.

Diagonal View

Side View

View from Below

Overhead View

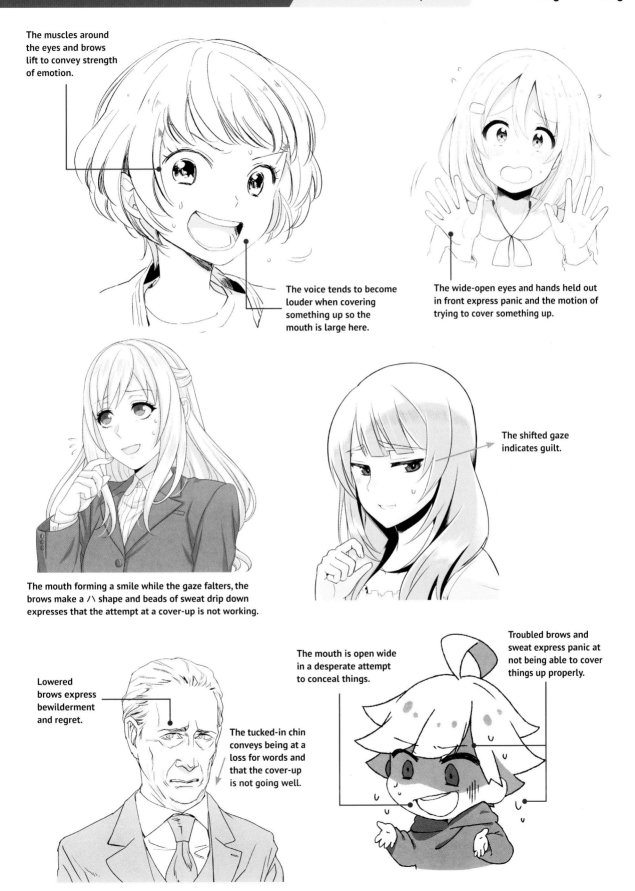

The muscles around the eyes and brows lift to convey strength of emotion.

The voice tends to become louder when covering something up so the mouth is large here.

The wide-open eyes and hands held out in front express panic and the motion of trying to cover something up.

The mouth forming a smile while the gaze falters, the brows make a /\ shape and beads of sweat drip down expresses that the attempt at a cover-up is not working.

The shifted gaze indicates guilt.

Lowered brows express bewilderment and regret.

The tucked-in chin conveys being at a loss for words and that the cover-up is not going well.

The mouth is open wide in a desperate attempt to conceal things.

Troubled brows and sweat express panic at not being able to cover things up properly.

Index

Illustrator profiles

平井太朗
Hey Taroh spends his days doing housework and drawing manga and illustrations peopled exclusively by middle-aged men; he sometimes also teaching at schools or in seminars.

URL https://heytaroh.com/ **Twitter** @heytaroh

イラスト・コメント（50 音順）

エイチ
Eichi freelances as a manga assistant and in card game production, focusing on amateur association activities.

URL http://wildchicken.x.fc2.com/
Twitter @45ichi

風観ヒスイ
Hisui Kazami is an award-winning manga artist and illustrator who specializes in amateur association activities.

Pixiv 3992497
Twitter @KazaHisu

くろでこ
Kurodeko's range of professional interests include picture books and character design.

Pixiv 1426321
Twitter @ymtm28

佐倉おりこ
Oriko Sakura is the creator of the full-color digital manga periodical *Swing!*, published regularly on the internet, who also works on illustration how-to guides, card illustrations and a range of other design activities.

URL https://www.sakuraoriko.com/
Pixiv 1616936 **Twitter** @sakura_oriko

諏岸マリエ
Marie Sugishi is a desktop publishing designer and illustrator whose work centers on depicting middle-aged men, ranging from illustrations for card games to work on Kaigai Drama Board, AXN Japan, and LINE's Thinkware.

URL http://sugishi-the.fool.jp/

鈴穂ほたる

Hotaru Suzuho is an illustrator whose work centers on strip column manga, illustration and game character design.

Pixiv 11486018 **Twitter** @suzuhohotaru

禾

Nogi specializes in social game illustrations and was the winner of the grand prize in the Ichi Appu Course second anniversary personification illustration contest.

URL http://noooog.tumblr.com/
Pixiv 2463250 **Twitter** @noo_oog

はたけみち

Hatakemichi creates illustrations for books and card games.

URL http://ebako.sakura.ne.jp/ **Twitter** @hatakemiti

ひげ紳士

Higesinsi is a manga artist and active member of the Hya-ZokuSEi writers' and illustrators' circle.

URL http://hya-zokusei2.sblo.jp/
Pixiv https://pixiv.me/higesinsi
Twitter @higesinsi

みさき樹里

Juri Misaki's Suzume Musume manga appears regularly in Manga Time Jumbo; she is the creator of Clannad Manga (Jive) and Little Busters! Ecstasy Wonderbit Wondering (Kadokawa) and also illustrates cards for smartphone games.

URL http://misakichi.eek.jp/ **Twitter** @misakichin

みらくるる

Mirakururu designs characters for social games and is the guest illustrator of Hobunsha's Manga Time Kirara Kyarat and the designer of Bike8 Candy Character (Masuya).

Pixiv 790821 **Twitter** @mirakuru_rodeo

百合原明

Aki Yurihara is a manga artist, illustrator and designer whose main works include Betsukiss (Hobunsha) and Ecstasy from Socks (Magazine Magazine).

Published by Tuttle Publishing, an imprint of
Periplus Editions (HK) Ltd.

www.tuttlepublishing.com

Digital Illust no "Hyojo" Kakikatajiten
Copyright © 2017 NextCreator Dept.
English translation rights arranged with SB Creative Corp.
through Japan UNI Agency, Inc., Tokyo

ISBN 978-4-8053-1562-0

English Translation ©2020 Periplus Editions (HK) Ltd

Distributed by
North America, Latin America & Europe
Tuttle Publishing
364 Innovation Drive
North Clarendon, VT 05759-9436 U.S.A.
Tel: 1 (802) 773-8930; Fax: 1 (802) 773-6993
info@tuttlepublishing.com
www.tuttlepublishing.com

Japan
Tuttle Publishing
Yaekari Building, 3rd Floor
5-4-12 Osaki
Shinagawa-ku
Tokyo 141 0032
Tel: (81) 3 5437-0171; Fax: (81) 3 5437-0755
sales@tuttle.co.jp
www.tuttle.co.jp

Asia Pacific
Berkeley Books Pte. Ltd.
3 Kallang Sector, #04-01
Singapore 349278
Tel: (65) 6741-2178; Fax: (65) 6741-2179
inquiries@periplus.com.sg
www.tuttlepublishing.com

25 24 23 22 11 10 9 8 7 6

Printed in China 2205EP

"Books to Span the East and West"

Tuttle Publishing was founded in 1832 in the small New England town of Rutland, Vermont [USA]. Our core values remain as strong today as they were then—to publish best-in-class books which bring people together one page at a time. In 1948, we established a publishing office in Japan—and Tuttle is now a leader in publishing English-language books about the arts, languages and cultures of Asia. The world has become a much smaller place today and Asia's economic and cultural influence has grown. Yet the need for meaningful dialogue and information about this diverse region has never been greater. Over the past seven decades, Tuttle has published thousands of books on subjects ranging from martial arts and paper crafts to language learning and literature—and our talented authors, illustrators, designers and photographers have won many prestigious awards. We welcome you to explore the wealth of information available on Asia at **www.tuttlepublishing.com**.